NORTH OCEAN BOULEVARD
PALM BEACH, FLORIDA

THE WHITE HOUSE
WASHINGTON

THE WHITE HOUSE

THE WHITE HOUSE
WASHINGTON

Mr. Oleg Cassini
626 Seventh Avenue
New York 34, New York

Feb 17 1961

Dear Oleg —

a thousand days of magic

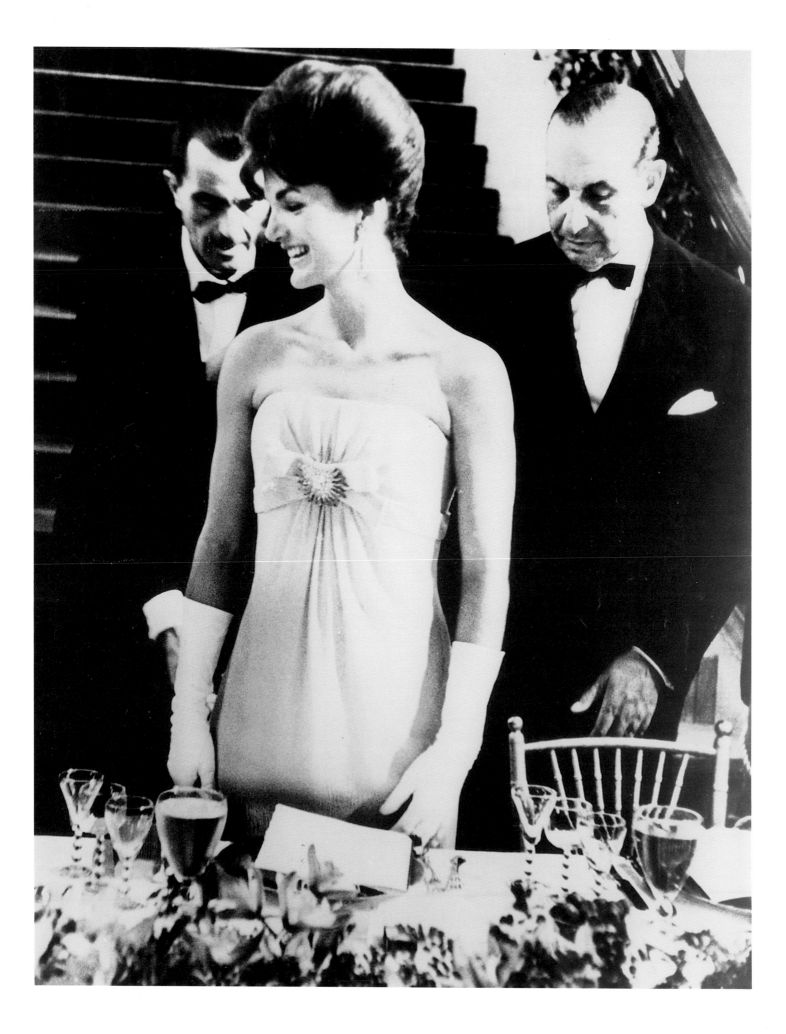

a

thousand

days of

magic

Dressing
Jacqueline Kennedy
for the White House

by

RIZZOLI
NEW YORK

First published in the United States of America in 1995 by

Rizzoli International Publications, Inc.

300 Park Avenue South,

New York, New York 10010

Library of Congress Cataloging-in-Publication Data

Cassini, Oleg, 1913–

 A thousand days of magic: dressing Jackie Kennedy for the White
House / by Oleg Cassini.

 p. cm

 ISBN 0-8478-1900-0 (hc)

 1. Cassini, Oleg, 1913– . 2. Fashion designers—United States—
Biography. 3. Onassis, Jacqueline Kennedy, 1929– —Clothing.
4. Costume design—United States—History—20th century. I. Title.

TT505.C39A3 1995

746.9'2'092—dc20

[B] 95-15119

 CIP

Design by Leslie Pirtle

Printed in Japan

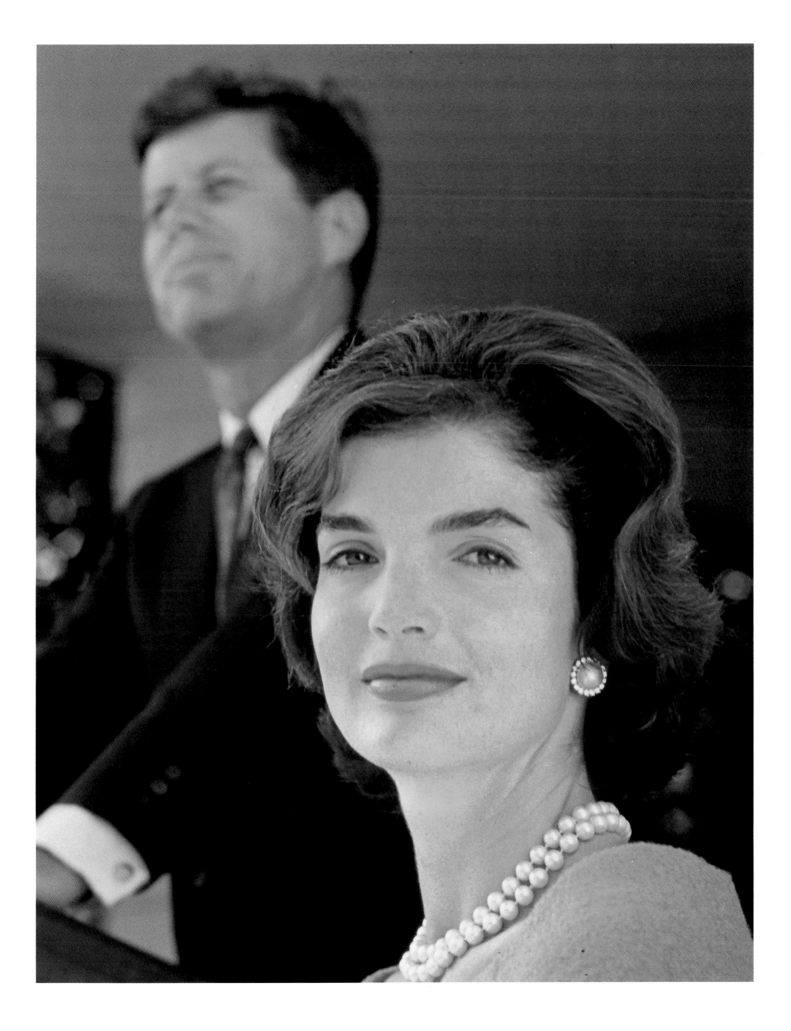

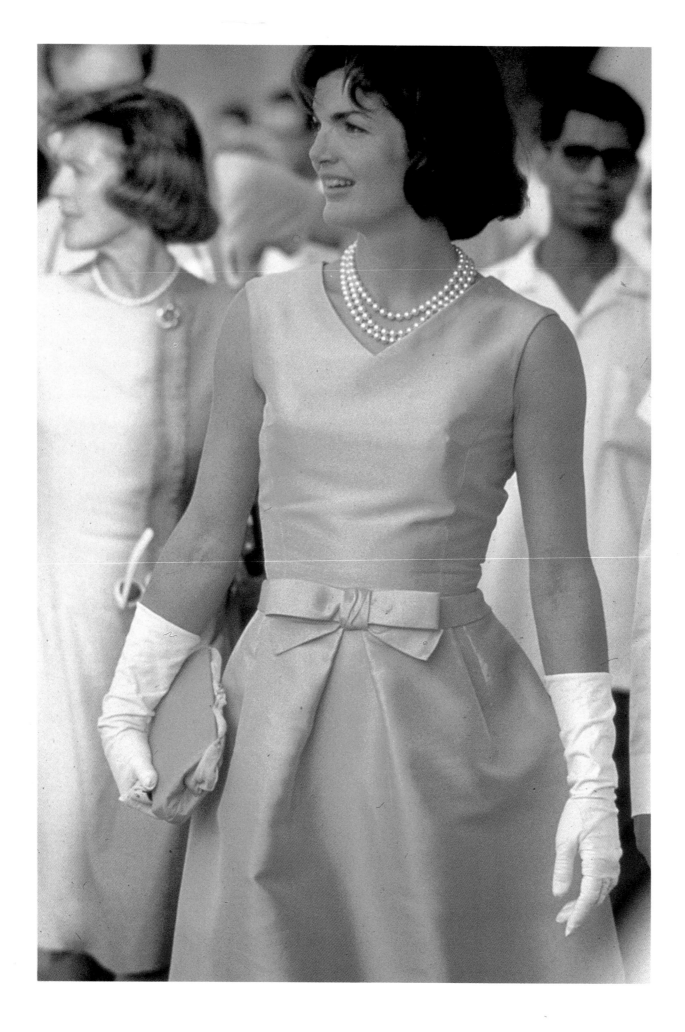

contents

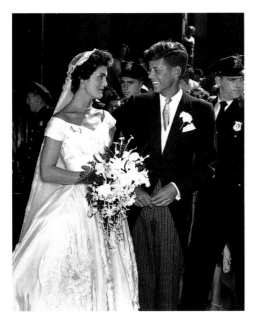

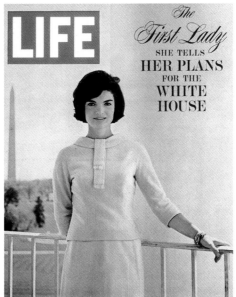

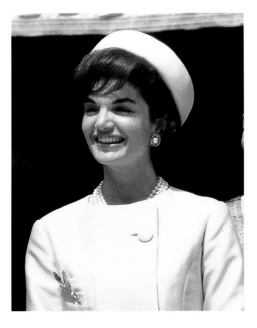

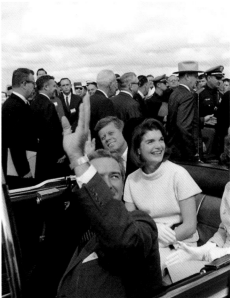

the
early
years

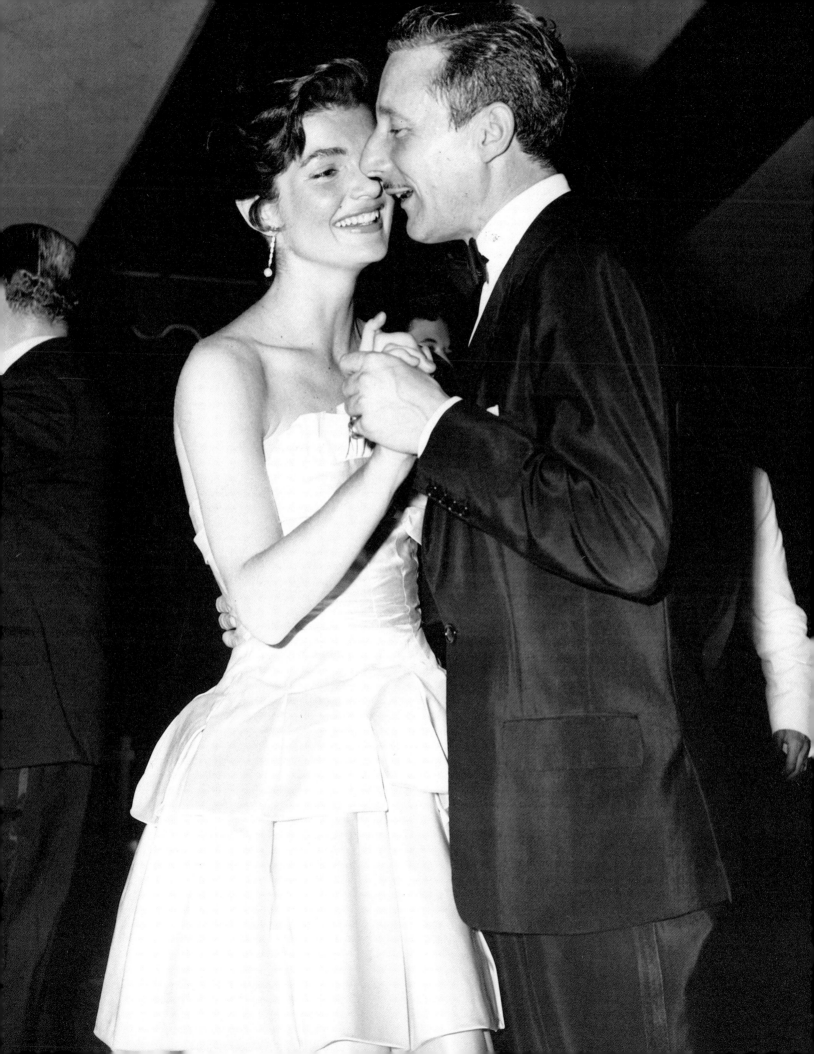

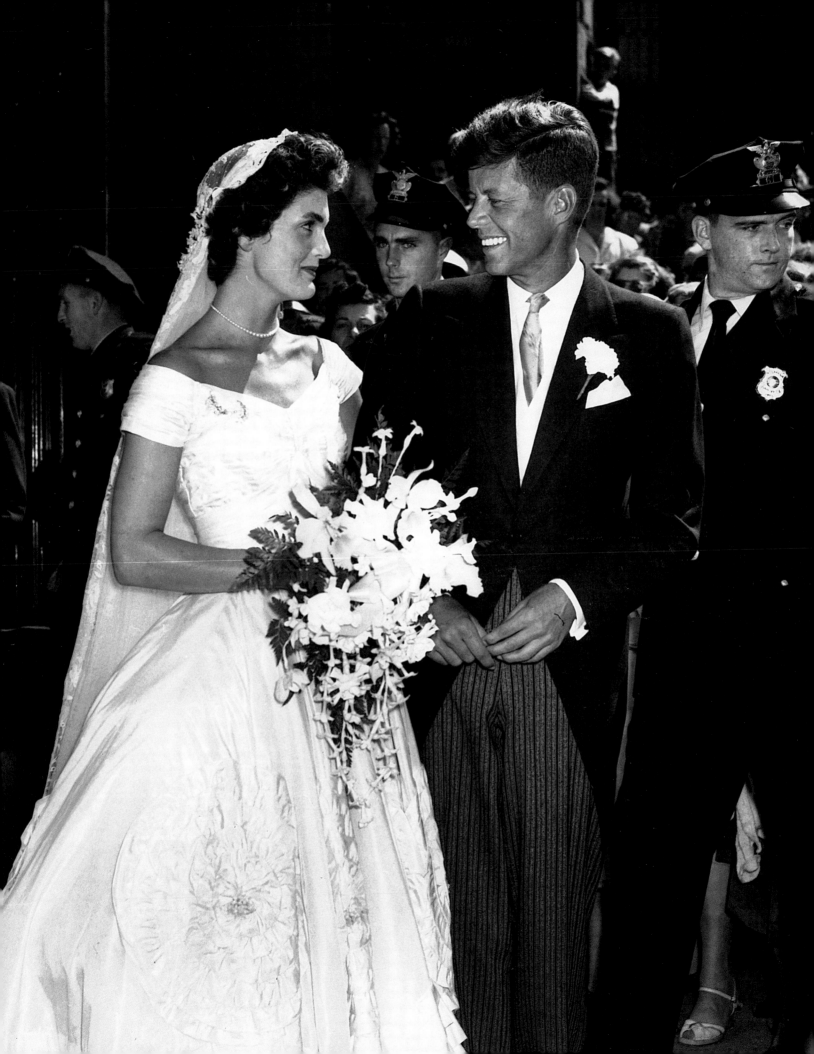

I first met Jacqueline Bouvier several weeks before she married Senator John Kennedy in September of 1953. I had been friendly with the Kennedy family for years and knew them all so I was naturally very curious about the young lady Jack had chosen to marry.

When I was introduced to Jackie at El Morocco, a nightclub in New York, it was obvious that she was somebody, she had a presence, a star quality. She appeared to be the classic debutante—charming, attractive, and well-educated, but she had a little something extra, too. People were drawn to her even then.

Some years earlier, in 1947, Jackie had been named Queen Debutante of the Year by my brother, Igor Cassini, who was the society columnist for the *New York Journal American*, writing as Cholly Knickerbocker. To quote from that column:

The Queen of the Year for 1947 is Jacqueline Bouvier, a regal brunette who has classic features and the daintiness of Dresden porcelain. She has poise, is softspoken and intelligent, everything the leading debutante should be. Her background is strictly 'Old Guard' . . . Jacqueline is now studying at Vassar. You don't have to read a batch of press clippings to be aware of her qualities.

That she was special I knew, but I never suspected how important she would become in my life. When I was around

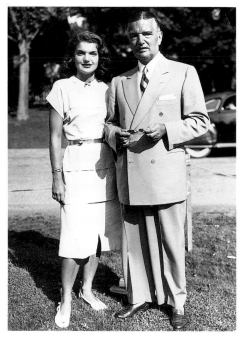

ABOVE:
Jackie with her father, John Vernon Bouvier, known as Black Jack, at Belmont in 1947, the year of her debut.

RIGHT:
Jackie worked as an inquiring photographer for the Washington Times *in 1952. Here she photographs someone feeding goldfish on the rooftop cooling pool of the Times-Herald building.*

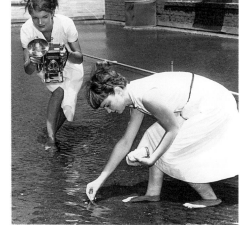

her, I always felt the need to be at my cleverest. She had wit, an intellectual curiosity, and the ability to make people feel as though they were part of a small, privileged circle. She could be the most charming person you had ever met, and at other times, she was famous for her elusiveness. She was a complete original. I always thought of her as quite a challenge. Despite her shy public presence and her whispery voice, privately she had a strong personality. She was someone who always demanded excellence. To paraphrase Oscar Wilde, Jackie's taste was very simple—she liked only the very best.

Some time after they were married, Senator Kennedy had to have surgery on his back, and I was asked by the family to escort Jackie to several parties around Palm Beach, where the Kennedys had a house not far from my brother's in-laws, Charles (known as C. B.) and Jayne Wrightsman. Traditionally, the Kennedys spent New Year's Eve at the Wrightsmans' annual party, held at their beachfront mansion.

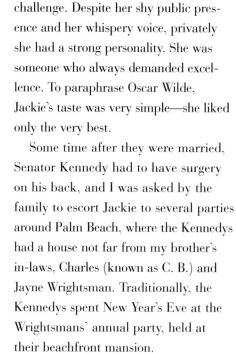

Over the years, I had also developed a friendship with Ambassador Joseph Kennedy, and usually dined with him every Tuesday at his favorite French restaurant, La Caravelle. Joe Kennedy had been the American ambassador to England before World War II, and my grandfather, Count Arthur Cassini, had been the Russian ambassador to Washington during the terms of President McKinley and President Theodore Roosevelt. So we both understood the diplomatic world very well. Later on, at Joe Kennedy's recommendation, the chef from La Caravelle, Rene Verdon, became the chef at the White House.

Rose Kennedy and I were also friendly. I made clothes for her and I found her *joie de vivre* fascinating. She loved to go to parties and made no bones about it. I once had her invited to the Bachelor's Ball in New York. She came alone and danced all night long.

When Jack Kennedy ran for president, many people didn't think he was going to win. One day I had lunch with the columnist Drew Pearson in Washington. He was married to the daughter of Eleanor "Cissy" Patterson, the influential publisher of the Washington *Times-Herald*, who was also the granddaughter of the owner of the Chicago *Tribune* and the sister of the founder of the New York *Daily News*. She was not only my former boss and Jackie's, but she had been my mother's best friend thirty years earlier. Drew told me, "Symington has the nomination locked up." I wasn't so sure and I told him, "I'm going for Kennedy." He said, "Well, that's the difference between the people and the pros. You'll see what happens." I certainly did.

Right after the election in the fall of 1960, I was taking a vacation in Nassau

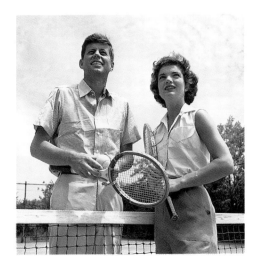

LEFT:
Jack and Jackie
relaxed at the
Kennedy compound
in Hyannisport,
Massachusetts,
just a few days
after they
announced their
engagement in June
of 1953.

ABOVE:
In Palm Beach I visited
my brother, Igor, his
wife, Charlene
Wrightsman, and a
friend, Denny
Boardman. Palm
Beach was always a
favorite spot with the
Kennedys, as it was
for me.

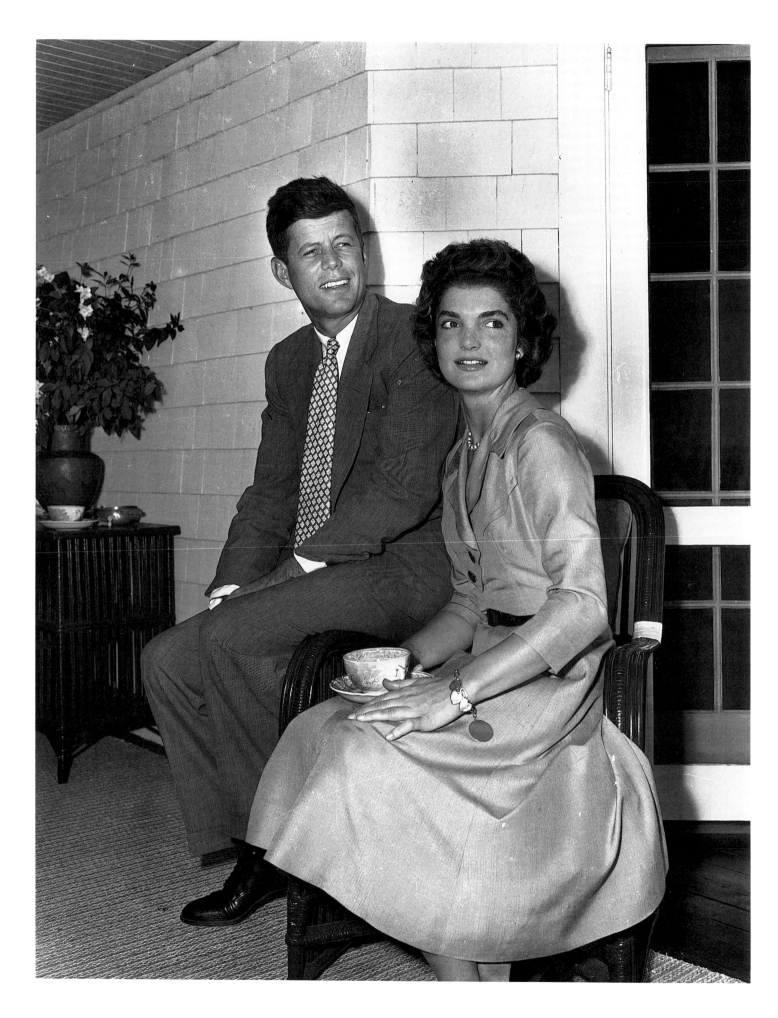

when the President-elect's secretary called me. Before the election, I had written Jackie a note to say that I hoped she would consider me as she went through the process of choosing someone to design her wardrobe for the White House. I knew that every designer in America and the world was vying for the opportunity. When there was no reply to my note, I didn't pursue the matter.

So it was a complete surprise to me when the President-elect's secretary said, "Mrs. Kennedy is planning her new wardrobe and she would like to know if you would be kind enough to come see her next Monday at the hospital and maybe bring along some of your sketches." (Jackie was in Georgetown Hospital convalescing after the birth of her son John.) I replied that I would be delighted.

As soon as I hung up, I realized what I had gotten myself into. I had only two days before my appointment. I had no pencils, no paper—and in Nassau, it was not altogether easy to find these things. Finally, with a sketch pad and lots of sharp pencils in hand, I got to work. Nothing, not one idea! I had just been given an enormous opportunity, and my mind was blank. I tried to relax. "Oleg," I said to myself, "just think about Jackie. You know her better than any of the other designers. You know how she is. Think!"

Suddenly, it came to me. this is like a film and you have the opportunity to dress the female star. This was not so different from my old job in Hollywood,

designing for motion pictures. As soon as I felt on familiar ground, I calmed down and the ideas started to flow. I was thinking about the role she was going to play and my sketches started filling up the empty sheets. It was a daunting proposition, but I began to take what I knew about her, about her taste, and create the first outlines of a wardrobe on the flight back from Nassau to New York.

When I was designing for motion pictures, I always tried to make the silhouette similar to the person I worked for in my sketches. So in broad outlines, I designed a concept.

Jackie reminded me of an ancient Egyptian princess—very geometric, even hieroglyphic, with the sphinx-like quality of her eyes, her long neck, slim torso, broad shoulders, narrow hips, and regal carriage. One can never underestimate the importance of good shoulders. Good shoulders and a long waist are a great asset when it comes to wearing clothes, and Jackie had both. She was the perfect model for very simple lines—a minimalist *par excellence*.

I wanted to dress her cleanly, architecturally, in style. I would use the most sumptuous fabrics in the purest interpretations. I called it the "A-line." Of course, the designs also had to take into consideration Jackie's own preferences as well as her role as a public figure whose life was governed by strict protocol.

When I arrived in New York, I rushed into my office with about twenty sketches to see what fabrics and colors I had available. After amplifying the working

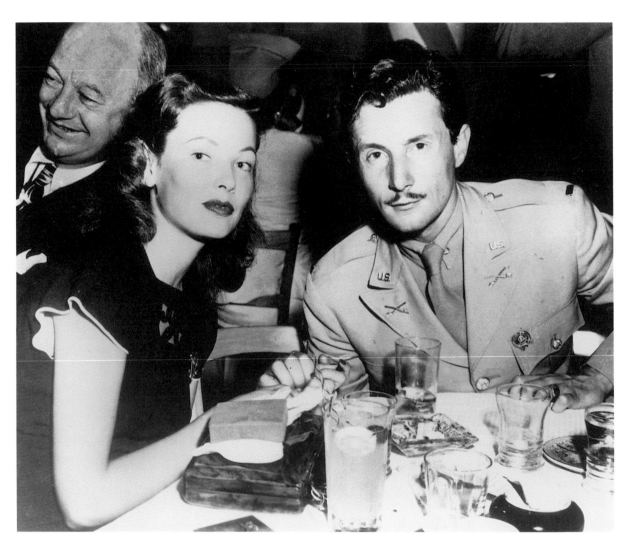

RIGHT:
I spent much of my marriage to Gene Tierney as an Army First Lieutenant during World War II. Although I was stationed in Kansas, Gene and I got together often. Here we are at the popular Hollywood nightclub Mogambo.

RIGHT:
I accompanied Grace Kelly to the premiere of Rear Window. *She wore a black peau de soie dress with a large white collar that I had created for her. Using white around the neck is a technique I utilized when design- ing for motion pictures because it sets off the face so beautifully.*

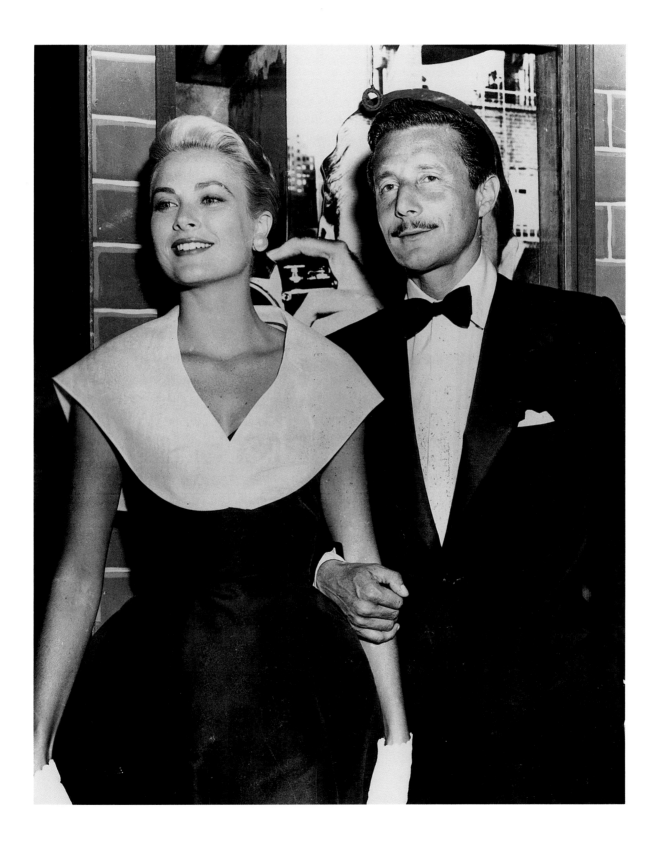

RIGHT:
At the end of the 1960
campaign the Kennedys
were greeted by cheer-
ing crowds during a
tickertape parade in
New York.

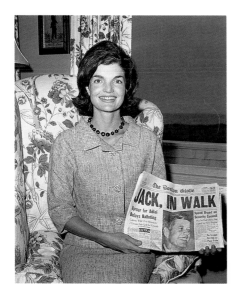

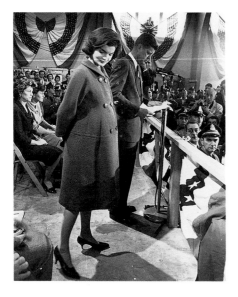

TOP:
In the mid-fifties, I had
a strong sense that Jack
might be President. I
remember telling him,
"Senator, I think you're
going to do it. You'll get
the women's vote."
Despite our friendship,
I always addressed him
formally as Senator,
and, later, as Mr.
President.

sketches, I put the fabric swatches along with five or six of my most powerful drawings into a portfolio and got on a plane for Washington.

Upon arriving, I headed to Georgetown Hospital. When I walked into her room, Jackie was sitting up in bed looking cheerful and pretty. I found her surrounded by sketches from some of the most famous designers of the moment—American, French, Italian.

"How was Nassau?" she asked, turning our meeting into a friendly chat rather than a business discussion. "Did you have a good time? You have a great tan."

While I was recounting one or two of my adventures during the trip, I casually cast an eye over my fellow designers' work. What was this? Not one of them had really bothered to think about the First Lady. Instead, they had sent her the best of their latest collections.

"So Oleg," she said at last, "would you like to work with me? Jack and I would love to have you around."

"No thank you," I replied.

"But why?" she asked, a little surprised by my answer.

"I'm very grateful to you for thinking of me, but no. Look around you," I said, pointing at the various sketches. "All these people are dying to dress you and as far as I am concerned, they are all good. If this is what you want, then you don't need me. But if you use them, do you know what will happen to your life? It will become a never-ending fitting, with people coming and going and no time for anything else. In my opinion,

you need to stick with one person, someone who can create a look just for you. Make your own statement rather than being a model for someone's pretty dresses. If you take my advice, choose one of these people, whichever one you like best, because that's the only way you'll save time and worries. So thanks for inviting me here, but I don't think it would be a good idea . . ."

"Well, since you are here," she suggested with a puzzled look, "would you mind showing me some of your ideas?"

What I was proposing was something much more elaborate than any single sketch hanging on the walls. I was proposing a new look, a new concept, my interpretation of how Jacqueline Bouvier Kennedy should appear in her role as First Lady. I had not merely selected from my current collection, I had created a concept for her. I talked to her like a movie star, and told her that she needed a story, a scenario as First Lady.

I said, "I want you to be the most elegant woman in the world. I think that you should start from scratch with a look . . . a look that will set trends and not follow them."

And she replied, "You are absolutely right."

I opened the portfolio; the first sketch, for the inaugural ball, was of a full-length evening gown of graphic simplicity, but fashioned of a sumptuous white Swiss double satin. It was a "covered up" look for evening that was totally new and very well suited to her. The luxury of the material and innovative

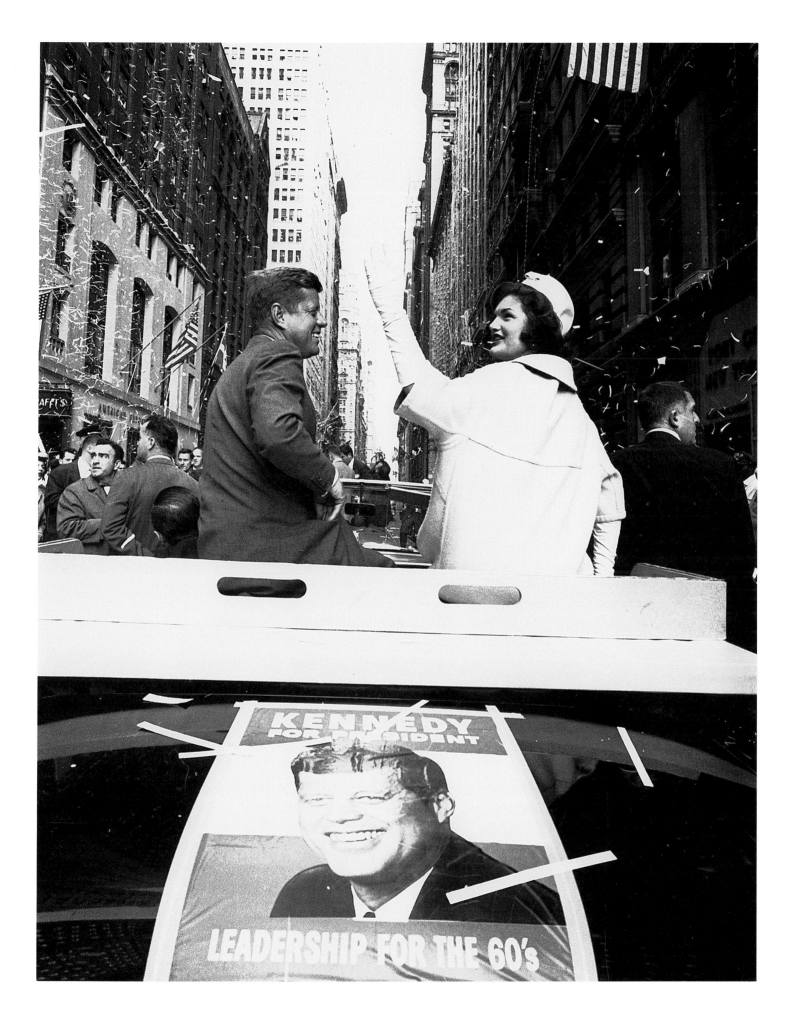

ABOVE:
My mother,
Countess
Marguerite
Cassini, acted as
my grandfather's
official hostess
in Washington.

cut would make it regal and totally memorable. The only decoration was a French *cocarde* (cockade) in the same fabric at the waistline. I told her that the design would set the trend for her new look.

Her reaction was immediate, visceral. "Absolutely right," she said.

From that moment on, there was no stopping me. We spoke of how fashion is a mirror of history; we discussed the message her clothes would send— simple, youthful, elegant—and how she would reinforce the image of her husband's administration through her presence. "You have an opportunity here," I said, "for an American Versailles."

We spoke of other Presidents and First Ladies, and I mentioned how my mother, Countess Marguerite Cassini, had been the hostess at the Russian embassy for my grandfather, the last czarist ambassador. I discussed my mother's high profile in the press at the time, when she, Alice Roosevelt (daughter of President Theodore Roosevelt), and Cissy Patterson set the trends, and were known in the press as the Three Graces.

We also discussed how the Theodore Roosevelts entertained at the time. Jackie was particularly interested in the White House restoration, undertaken under the financial auspices and critical eye of Teddy Roosevelt and executed by the architect Stanford White.

The French courts of Napoleon I and II were also a topic, and how Eugenie, wife of Napoleon III, always had the most beautiful and intriguing men and women present because it amused the

emperor. Jackie had a great sense of history and a keen historical perspective. It was always tremendously interesting to discuss history with her, as she was well read and was always curious and interested.

She began to talk about the need to create a new atmosphere at the White House. Her eyes shone with excitement. "The White House needs to be completely restored," she said. "It is a historical house and belongs to the American people. It should reflect the whole history of the presidency, and contain reminders of the great Americans who lived in the mansion during its 160 years.

"I want the White House to have original pieces of furniture—from the period, no copies—and to make the White House a museum of American culture. I want American art prominently displayed along with the finest pieces of American furniture. The White House must be restored and be a monument to American history. It was built in the early 1800s, but there is hardly anything in it dated prior to 1948." I was impressed by Jackie's plans and her commitment. In my opinion, it was she who began the movement in America to restore the architectural treasures of the past.

She also felt that with all the important people visiting the *Maison Blanche*, sophisticated international cuisine was absolutely necessary. She wanted the White House to become the social and intellectual capital of the nation. She wanted to invite the most important writers, musicians, and artists, the most interesting and influential people. She would

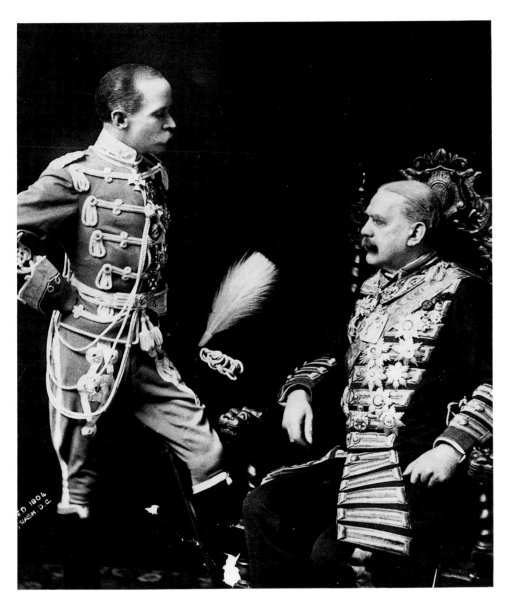

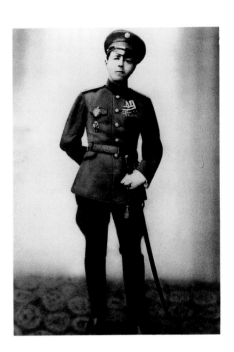

ABOVE:
My father, Count
Alexander Loiewski.

ABOVE:
Count Arthur Cassini
(seated). My grand-
father was the Russian
Czar Nicholas's
ambassador to
Washington during the
McKinley and
Theodore Roosevelt
administrations.

RIGHT:
I dressed in a
sailor suit like
many other
young children in
Pre-Revolutionary
Imperial Russia.

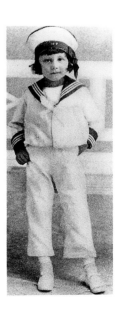

entertain in impeccable style, setting new standards of elegance. The White House would become brighter, more interesting, and, in keeping with the youth of its inhabitants, more fun. The Camelot myth had begun and it was created by Jackie, who began a revolution in good taste.

Coming back to our immediate surroundings, I pulled out the next sketch— the inauguration ensemble, a simple fawn wool coat with a circlet of sable at the neck and a coordinating dress and hat in the same fawn color. "Yes," she said. "Absolutely right." Jackie was spreading the sketches out, saying, "Yes, yes, yes," and finally, "Well, I'm convinced. You're the one."

"But I'll only do it if I am the only one," I told her, "otherwise it's too much of a logistical problem."

"Can you do it by yourself, though?" she asked. "I'm going to need an awful lot of clothes."

"Sure I can," I replied, putting on a show of confidence, and only then beginning to realize what a tremendous undertaking this would be.

Jackie and I wanted to create an American-International fashion look, and at the same time give a boost to the American fashion industry. At that time, people were looking to Europe for trends, and American fashion was not even considered. But Jackie was to change all that. American fashion design was thrust into the world arena as the "Jackie Kennedy look" became a worldwide trendsetter.

Jackie especially loved the inaugural dress. There was a problem, however, as she had already ordered a dress for the inaugural from Bergdorf Goodman in New York City, one of the finest specialty stores in the country.

Jackie said, "I'm going to call Bergdorf's and tell them you're my only designer. You will design the clothes and they can make them." I had nothing against that, so I said, "Whatever you want to do."

Jackie called Bergdorf's right then and they were not happy with the proposed arrangement. So Jackie said, "In that case, Mr. Cassini will use his own workrooms."

Shortly thereafter, on December 14, Jackie sent me a copy of a telegram she had sent from Palm Beach, advising Bergdorf's to send me her measurements.

Jackie's solution was to wear my dress to the inaugural gala, the fabulous show that Frank Sinatra organized for the night before the inauguration, and to wear the Bergdorf's dress to the inaugural ball itself. She was later quoted as saying that "the inaugural gala dress was my favorite dress of all time."

Her secretary, Mary Gallagher, wrote in her memoir:

I can tell you that the inaugural ball gown was not Jackie's favorite. She much preferred the gala gown, the utterly simple white one—unrelieved except for a geometric design, of the same material, at the waist—which had been made by Oleg Cassini . . . In fact, Jackie wanted to have the Smithsonian Institution display her gala gown instead of the inaugural one, and I was still fighting that battle for a long time after the Kennedys moved into the White House.

Oleg Cassini
inc.

FOLLOWING ARE Mrs. KENNEDY MEASUREMENTS FOR DRESSES AND COATS.
IMPORTANT: REMEMBER THAT ALL MEASUREMENTS GIVEN ARE IN INCHES
AND SHOULD BE TRANSLATED INTO THE DECIMAL SYSTEM
ERGO CENTIMETERS.

DRESS: BUST 35½" WAIST LINE TO HEM ON SIDE 25½XXXXX
 WAIST 26" 3/4 SLEEVE FROM NECK 21 1/4"
 HIPS 38" small sleeve 6"
 width of small sleeve 12"
 BACK OF DRESS NECK TO WAIST 17 ½"
 SHOULDER FROM CENTER-BACK TO ARMHOLE 7 3/4"
 FROM BACK OF NECK TO FLOOR 61"

COAT: BUST 35½" LENGTH OF COAT FROM NECK FRONT 40½"
 WAIST 26" FROM NECK TO SHOULDER 6"
 HIPS 38½" FROM CENTER-BACK TO SHOULDER 8"
 LENGTH OF SLEEVE 17½"
 WIDTH OF SLEEVE AT WRIST 13"
 WIDTH OF COAT AT HEMLINE 66"
 LENGTH OF COAT FROM BACK OF NECK TO HEM 41"

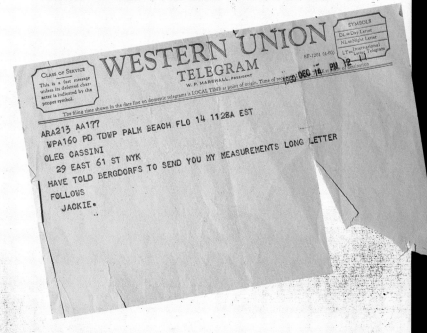

WESTERN UNION TELEGRAM

W. P. MARSHALL, PRESIDENT

SYMBOLS
DL = Day Letter
NL = Night Letter
LT = International Letter Telegram

SF-1201 (4-60)

CLASS OF SERVICE
This is a fast message
unless its deferred char-
acter is indicated by the
proper symbol.

The filing time shown in the date line on domestic telegrams is LOCAL TIME at point of origin. Time of receipt is STANDARD TIME at point of destination

DEC 14 PM 12 11

ARA213 AA177
WPA160 PD TDWP PALM BEACH FLO 14 1128A EST

OLEG CASSINI
29 EAST 61 ST NYK

HAVE TOLD BERGDORFS TO SEND YOU MY MEASUREMENTS LONG LETTER

FOLLOWS

JACKIE.

"The 'Jacqueline Kennedy Look' By Cassini"

Top Secret
No Longer

Jackie Likes'em, So Does Jack

**Designer Says
JFK Has Plenty to
Say About Wife's
Wardrobe**

Jackie's Wardrobe Simple, Uncluttered

**Fashions For
Mrs. Kennedy
Declassified**

Inaugural
Clothes
Unveiled

**Revealed By
Oleg Cassini**

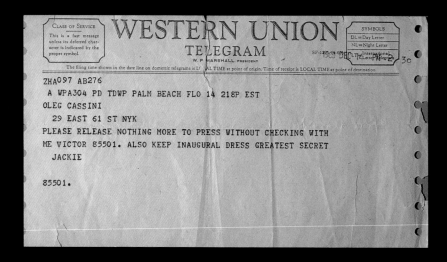

First Sketches of First Lady's Wardrobe !

*Editors
See Attire
For Mrs.
Kennedy*

Designer Greatly Honored

***Jackie's Elegance
'Caught' By Cassini***

Designer calls
Jackie "Ideal"
Model

**White Satin, Fawn Beige
Gowns to Influence Styles**

So Chic!

Cassini Shows First Sketches

*"To the delight of fashion editors, Mr. Cassini is a serious designer
who never seems to take himself seriously. A prototype of handsome male elegance. . .
Mr. Cassini will design not only dresses, coats and suits—size 9 or a small 10—for Mrs. Kennedy,
he will coordinate her wardrobe with hats, furs, gloves, shoes and handbags. . . .
His new job Mr. Cassini regards as 'a great honor, a tremendous responsibility and a formidable opportunity.'
He has long contended that new ideas for the silhouette of fashion go from America abroad, rather than the reverse,
and he hopes that with Mrs. Kennedy's leadership this truth will be recognized."*

ARKANSAS GAZETTE
1/20/61

25

RIGHT:
Part of the press kit,
issued with Jackie's
approval, introduced
me as "Mr. Oleg
Cassini, newly
appointed official
and personal design-
er for the First Lady,
Mrs. John F. Kennedy.
Mr. Cassini, born in
Paris, educated in
Italy, is one of
America's foremost
designers." In the
press release, I wrote,
"Mrs. Kennedy is well
on her way to becom-
ing the outstanding
fashion influence of
the world"—how
prophetic that was.

BELOW:
"The Dress":
A one-piece soft
wool dress in fawn,
a subdued beige.
The silhouette gently
draped the figure
with a natural
shoulder and simple
rounded neckline.
The matching silk
serge at the waistline
and cuffs was the
only accent. The
dress was to be worn
with a matching
coat.

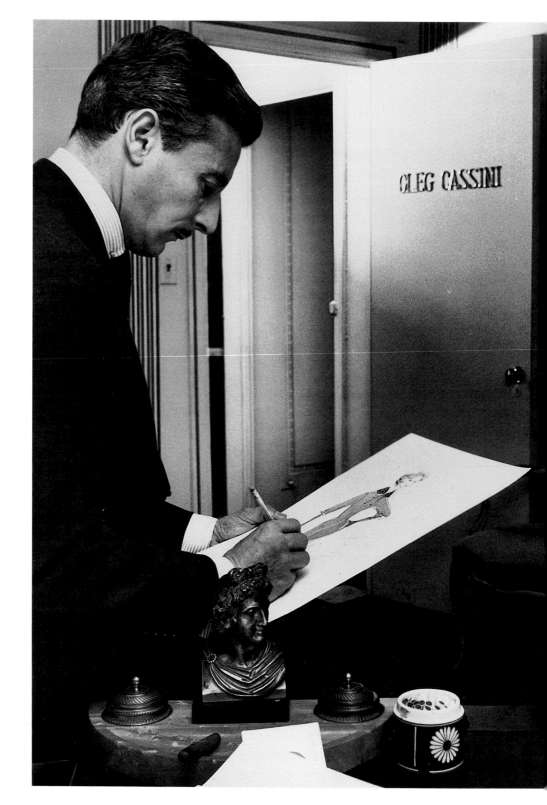

The Smithsonian, however, stood firmly on tradition, and it was only after a lengthy exchange of letters between the Smithsonian and Jackie over a period of ten months that the inaugural ball dress was reluctantly sent by Jackie to the Smithsonian.

When she gave me the commission to do her wardrobe, she said, "I am concerned, can you do it all in time?" "Don't worry," I replied. She would always say, "You're gallant, and you're trustworthy." There was no need for me to change my personality in order to sell. In fact, she appreciated the fact that I was laid back.

She was concerned because, as she said, "Oleg, you are going to have to do so much more. You're going to have to be the master of elegance because you have to coordinate everything—the shoes, the gloves, everything." Jackie wore very little jewelry, she did not want to look too opulent.

After I left the hospital, the car took me to the Kennedy residence in Georgetown on N Street, where the President-elect was reviewing candidates for Secretary of State.

"Well Oleg," he said, "how did things go with Jackie?" "Very well, I think Mr. President," I replied. "She asked me to design all her clothes." He smiled. "And you're sure that's what you want? You wouldn't rather be named Commissioner of Indian Affairs?" he said, referring to my life-long interest in Indian causes and my friendship with the various tribes. "No, Mr. President," I replied, "the Indians will have to wait . . . although you shouldn't neglect them either."

RIGHT:
"The Coat": A soft-finish wool coat in a matching fawn color had a semi-fitted shape with a restrained flared hemline, a natural shoulder, and a simple rounded neckline. An appliquéd band followed the fluid shape from neck to hem. Complementing the fawn color was a removable circlet of Russian sable. The fawn silk serge accent on the dress was repeated in the coat lining.

Phone Victor 8—5501

NORTH OCEAN BOULEVARD
PALM BEACH, FLORIDA

Dec 13—1960

Dear Oleg—

Thank heavens all the furor is over — and done without breaking my word to you or Bergdorfs — Now I know how poor Jack feels when he has told 3 people they can be Sec. of State!

But I do think it turned out nicely for you — no? — and you were charming + gallant + a gentleman + everything you should be + are —

This letter is just a series of incoherent thoughts that I must get settled — so I can spend these next weeks truly recuperating — + not have to think

A few days after our meeting at the hospital, I received the following letter from Jackie:

DECEMBER 13, 1960
Dear Oleg,

Thank heavens all the furor is over—and done without breaking my word to you or Bergdorf's. Now I know how poor Jack feels when he has told 3 people they can be Secy. of State.

But I do think it turned out nicely for you—no?—and you were charming & gallant & a gentleman & everything you should be and are.

This letter is just a series of incoherent thoughts that I must get settled so I can spend these next weeks truly recuperating & not have to think about details, otherwise I will be a wreck & not strong enough to do everything I have to do.

1) I wired Bergdorf to send you measurements so you can go ahead with clothes . . .

2) For every evening dress I order from you, will you please send a color swatch to a) Mario—at Eugenia of Florence to have evening shoes made—State if shoes should be satin or faille—if necessary send material to make shoes in—& tell him to hurry. b) to KORET—some man there . . . makes me matching evening bags, simple envelopes or squares . . . Send him same material as dress—If you can do these 2 things you don't know the headaches it will save me. c) also to Marita— Custom Hats at Bergdorf Goodman's—send color swatch . . . She does my hats and gloves—tell her what color for each.

3) Diana Vreeland will call you about . . . dress she wants for Bazaar—If I can't have fitting before they can always pin it in with clothes pegs for marvelous Avedon picture.

4) Do send me sketches of cape or coat to wear with your white dress for Inaugural Gala Jan 19. It must be just as pure and regal as the dress.

5) Check with me before you cut orange organza dress—It is the only one I am not completely sure of—remember I thought of pink . . .

6) I seem to be all set for evening. Now would you put your brilliant mind to work for day—Coats—dresses for public appearances—lunch & afternoon that I would wear if Jack were President of FRANCE—très Princesse de Rethy mais jeune . . .

ARE YOU SURE YOU ARE UP TO IT, OLEG? Please say yes—There is so much detail about one's wardrobe once one is in the public eye. I simply cannot spend the time on it any more than I have this fall—I will never see my children or my husband or be able to do the million things I'll have to do—I am counting on you to be a superb Wardrobe Mistress—every glove, shoe, hat, etc.—& all delivered on time. You are organized for that—being in New York—better than I—If you need to hire another secretary just for me do it and we'll settle the financial end together.

7) PUBLICITY—One reason I am so happy to be working with you is that I have some control over my fashion publicity which has gotten so vulgarly out of hand—I don't mind your saying now the dresses I have chosen from you—as I am so happy if it has done you any good—& proud to have you, a gentleman, doing clothes for the wife of the President. I will never become stuffy—but there is a dignity to the office which suddenly hits one . . .

BUT—you realize I know that I am so much more of fashion interest than other First Ladies—I refuse to have Jack's administration plagued by fashion stories of a sensational nature—& to be the Marie Antoinette or Josephine of the 1960's—So I will have to go over it with you before we release future things—because I don't want to seem to be buying too much—You can make the stories available—but with my approval first—There just may be a few things we won't tell them about! But if I look impeccable the next four years everyone will know it is you . . .

8) COPIES—Just make sure no one has exactly the same dress I do—the same color or material—Imagine you will want to put some of my dresses in your collection—but I want all mine to be original and no fat little women hopping around in the same dress. You know better than I how to protect yourself against other manufacturers running up cheap copies—I really don't care what happens later as long as when I wear it first, it is new & the only one in the room . . .

Now poor Oleg you don't have to read any more—Just some tiny last things to say to you.

1) Forgive me for not coming to you from the very beginning. I am so happy now.

2) Protect me—as I seem so mercilessly exposed & don't know how to cope with it (I read tonight I dye my hair because it is mousy gray!)

3) Be efficient—by getting everything on time & relieving me of worry about detail.

4) Plan to stay for dinner every time you come to D.C. with sketches—& amuse the poor President & his wife in that dreary Maison Blanche—& be discreet about us—though I don't have to tell you that—you have too much tact to be any other way.

5) I always thought if Jack & I went on an official trip to France I would secretly get Givenchy to design my clothes so I wouldn't be ashamed—but now I know I won't have to—yours will be so beautiful—That is le plus grand compliment I can give you—as a designer anyway!

XO

Jackie

*BELOW:
Sketch for the
inaugural gala gown.*

As this letter reveals, Jackie had a very organized mind and a fantastic memory for details. She had a great awareness of the minor problems that could arise in any given situation. So much in her letter predicted events to come, the many visits to Washington, the fashion stories. We had the same frame of reference, both socially and intellectually.

Jackie arrived at the White House with a limited wardrobe for her new role as First Lady, and we worked feverishly to prepare everything she needed in time. In the beginning, before the couture workroom was in place, I sent her some things from my ready-to-wear collection. She had bought clothing from me previously, so she was comfortable.

In a matter of days, my New York office had been completely revolutionized. I put my best staff together to work on this formidable new project. I personally oversaw every detail. We had a tailor, a specialist in materials and colors, as well as eight seamstresses, and a premiere, Maria, along with one of my staff designers designated for the project, and they had their own workroom exclusively devoted to Jackie. Three mannequins with Jackie's exact measurements, plus one live model in Jackie's size, were available whenever I needed them for fittings. When a dress or ensemble was finished, I would have the model put it on and walk around in it so I could decide what accessories to suggest and make sure everything appeared in order.

My assistant supervised the fittings in Washington and acted as the liaison between Jackie and me. I also had someone in Europe looking for the most beautiful and interesting fabrics, particularly in France, Italy, and Switzerland. There was no limit to the money I could spend for the materials. This was haute couture at its highest level.

Maria, an Austrian woman who had worked with me for many years, was an excellent premiere. I could phone her and give detailed instructions. I could say, "The skirt should have this, and remember to do that to the shoulder." I could describe what I had envisioned, what changes had to be made, what designs had to be put into production, and what to prepare for fittings. She understood the nuances.

Sometimes the fabrics would arrive late because of customs problems, or there were late shipments of special fabrics. The suppliers would say, "Yes, it will be there tomorrow," but sometimes that meant late nights for the seamstresses. No one complained, because everyone enjoyed being part of the team.

Often, we had to work very, very quickly, because suddenly I would hear from Jackie's secretary that she was changing her schedule. Sometimes we had to go back to what we had put aside, and certain designs had to be made up immediately. We still used impeccable fabrics, and I was not going to spare any expense.

Like everyone else, Jackie had her favorite colors. Black and white were always safe with her. She also loved brilliant color, historical colors, and the colors of Old Master paintings—green, blue, pink, yellow, burgundy, and red—but her favorite color was white. When we spoke of a palette of color, we would speak in terms of Italian masters and eighteenth-century France. A mention of "Veronese green" or "Nattier blue" was immediately understood.

We discussed other designers and how Chanel had been greatly inspired by French Napoleonic military uniforms. We were able to take trips into history and fashion, as she was most curious about France in the eighteenth and nineteenth centuries. Jackie was definitely a Francophile, and we often conversed in French, which was my first language. My inspirations have always been based on history, and I have read many books about *l'histoire du costume*, military battles, ancient civilizations, armaments, weaponry, and particularly the First Empire period in France. I advised Jackie to read *The Memoirs of Casanova* for a detailed and brilliant description of life in the eighteenth century.

When I first suggested it, she said, "Oleg, are you kidding? Casanova was a rogue and an inveterate womanizer." I protested. "Jackie," I said, "not only did he adore women, but he was a very learned scholar who could speak with Voltaire on equal terms and who wrote treatises, librettos, books, *mises-en-scènes*.

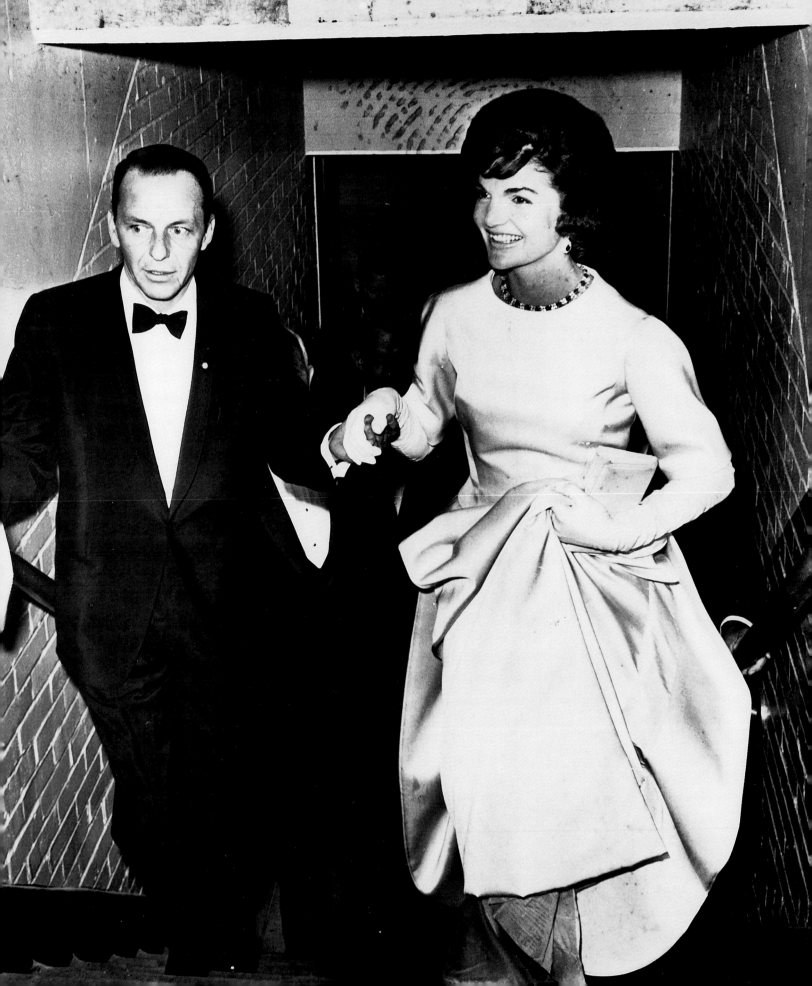
STAIR-4

Casanova was a mason and knew the Cabala. Catherine the Great, Louis XV, and Frederick the Great all received him at court. He even describes in vivid detail (he was on the balcony) the execution of Damien, who was drawn and quartered for attempting to kill Louis XV, and he has given us the best description of that period to date." She read and liked the books, thanking me in her charming fashion with a lovely note:

Dear Oleg,
I loved the memoirs, and now I know why you wanted me to read them—Casanova reminds me of you.

Best,
J

Historical themes have always been important to me, and military looks a strong concept, particularly in the rich details—the buttons, bows, etc. Some of these themes are what made the little dresses I created for Jackie so original—it was a constant leitmotif and a strong signature.

The job of the designer is to be creative with new ideas, and to realize what is most becoming to a subject. The question was to adapt the inspiration to what was truly becoming to her, and wearability was also key.

This was the philosophy behind the 'Kennedy Look.' For the daytime, there is a bit of the military and menswear approach to the clothes—slightly severe but comfortable. For evening, the Egyptian theme predominated because of the strength of Jackie's shoulders. Often, her chiffon dresses were inspired by hieroglyphics. I saw Jackie as a geometrical goddess.

Jackie was friendly with Diana Vreeland, the editor of *Vogue*, and she asked me to consult with her regarding an upcoming photo session she was going to have with Richard Avedon and what I had planned for her to wear to the inauguration.

So I went to see Mrs. Vreeland in her very colorful apartment on Park Avenue. She complimented me on being chosen by Jackie as her designer. We discussed Jackie's wardrobe and what she should wear on her head for the inauguration. Jackie had begun wearing her hair in a bouffant style and the hat would have to sit toward the back of her head.

"The hat should be an extension of the coat and dress," I said. "It is not a message in itself. It is an afterthought. It has to be a non-hat. The focus should be on Jackie's face." I showed her my sketch for the inauguration clothes. The hat sitting at the back of the head took inspiration from Nefertiti of Egypt. *"Bien sur,"* Mrs. Vreeland said.

Because I didn't have a millinery department, Jackie instructed me to go to Marita at Bergdorf Goodman in New York and have the hat made there. I sent Marita the sketch that I had discussed with Mrs. Vreeland, along with the fabric swatch. Naturally, we called Jackie and she was pleased.

When Jackie wore the hat at the inaugural with her fawn coat ensemble, it was suddenly as if the world knew of no other kind of headgear. My design, which would become known as the pillbox hat, became a national trend a week later. Jackie would wear many different styles of hat—straw rollers, berets, cloches, in addition to pillboxes. She looked good in hats because she had a *tête à chapeau* and hats set off her face.

Nobody suspected back then, not even the President, that Jackie was to become his best public relations tool. All I remember about those days are nerves, and Jackie on the phone: "Hurry, hurry Oleg, I've got nothing to wear." There was a great pressure to provide clothes quickly. We were always rushing, doing more than 100 dresses the first year, and more than 300 during the course of the administration. But it was an exciting time, and it was thrilling to watch the metamorphosis of Jackie into an international superstar.

1961

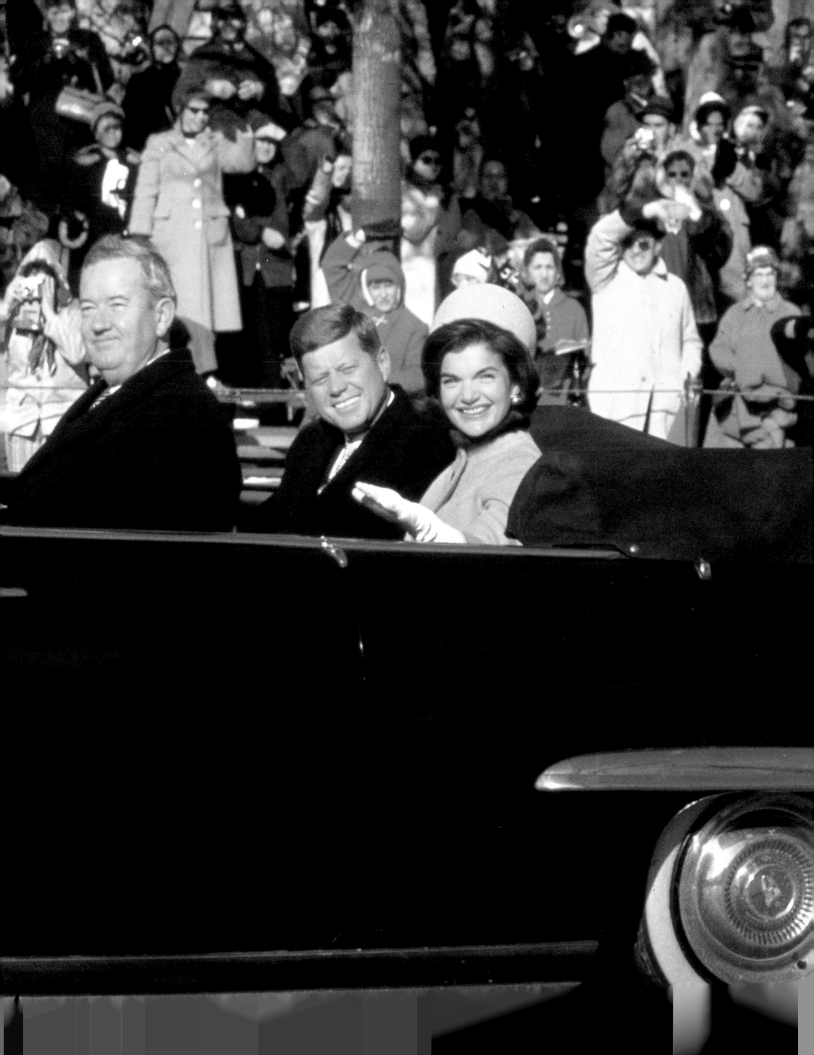

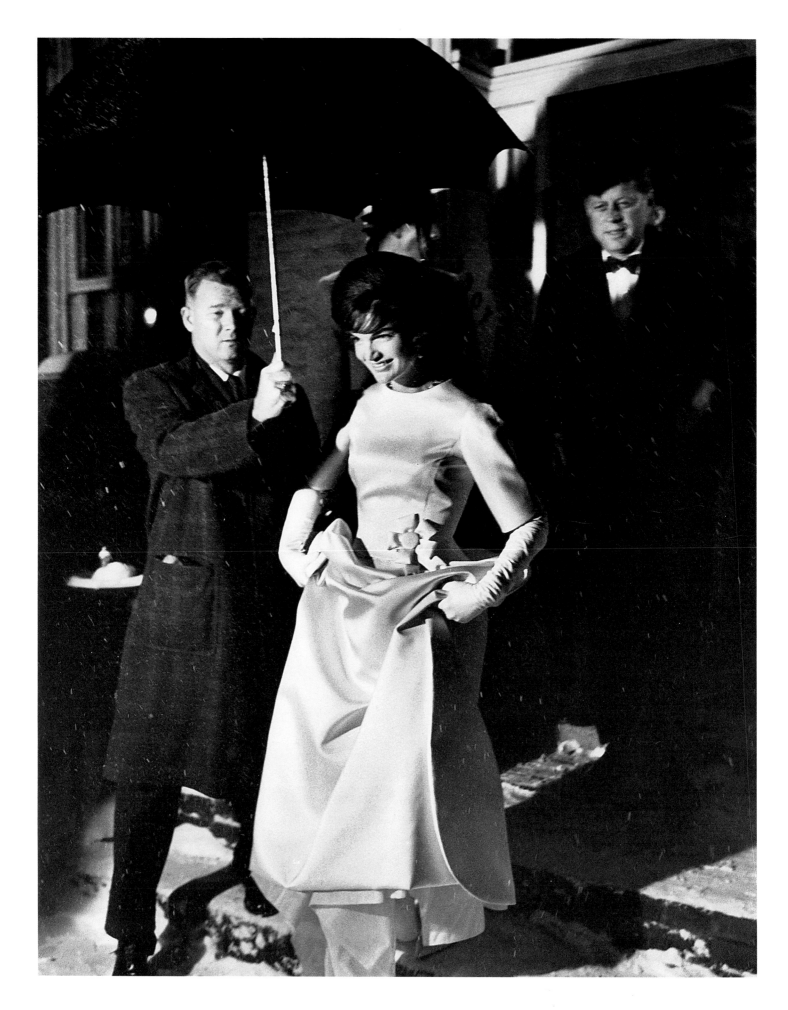

The first official inaugural event of the new administration was the inaugural gala on January 19, the night before the swearing-in ceremony. After dinner at the home of Mr. and Mrs. Philip Graham, the couple who owned *The Washington Post,* and an inaugural concert at Constitution Hall, the Kennedys went to the inaugural gala at the National Guard Armory. En route to the armory, there were quite a few people waiting along the street to see the Kennedys. The President-elect wanted the lights turned on in the limousine "so they can see Jackie." He was very proud of her and how she looked.

The inaugural gala was a lavish black-tie event organized by Frank Sinatra with Peter Lawford, the President-elect's brother-in-law, and his wife, Pat. Attendance was by invitation only, and it was completely sold out. Some of the world's greatest talents performed without pay, including Mahalia Jackson, who sang "The Star Spangled Banner," Ella Fitzgerald, Gene Kelly, Laurence Olivier, Jimmy Durante, Harry Belafonte, Bette Davis, Janet Leigh, Tony Curtis, Joey Bishop, and many others.

Sinatra sang a parody of his hit song "That Old Black Magic," and turned it into "That Old *Jack* Magic." Eleanor Roosevelt joined with Helen Traubel and Frederic March to

FAR RIGHT:
From their house on
N Street in George-
town, the President-
elect and a radiant
Mrs. Kennedy
stopped at the White
House to pick up the
Eisenhowers.
Together they rode to
the swearing-in
ceremony at the
Capitol.

BELOW:
Jackie and I had our
first crisis over the
thin silk lining in the
coat. The day of the
inauguration was
going to be brutally
cold, and there was
no time to send the
coat back to New
York for a warmer
lining. I raced
around Washington
looking for someone
who would line the
coat with flannel,
and I finally found a
store that could make
the change. They
worked on it all
night.

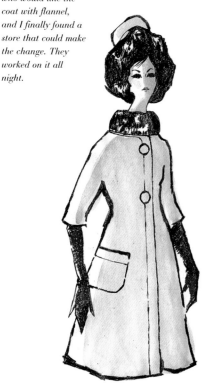

read *A Moment With Lincoln*, and Ethel Merman sang "Everything's Coming Up Roses." Everyone agreed that the entertainment was spectacular. It was a very exciting and glamorous event, which ended in the early morning hours of January 20.

During the night, a raging blizzard left us with 7.7 inches of snow, which practically immobilized the city. The Sanitation Department and Army Corps of Engineers did their best to alleviate the problem with tons of rock salt and flame throwers. It was the worst inaugural weather since the inauguration of William Howard Taft more than 50 years earlier.

The inaugural ensemble had to be special, representative of a new administration, "The New Frontier," and a showcase for America's new First Lady, one of the youngest ever, and certainly the most beautiful. What I wanted for Mrs. Kennedy was a uniquely simple, not ostentatious, fashion statement that would show off her beauty and elegance. I thought a neutral color—a beige because she was so young—would be appropriate. I wanted her to stand out like a flower in a field, which is what happened.

Having studied painting in my youth with Giorgio De Chirico, I was very sensitive to color, balance, and harmony in my creation of Jackie's look, her fashion "portrait." I always thought of her as part of a painting, a *quadro*. I thought of how she would look with other people. I wanted her to stand out—that was the trick.

Weeks before, I had shown Jackie the initial sketches of what I thought would be the perfect ensemble for her first public appearance as the First Lady: a fawn-colored wool coat with sable trim at the collar and matching hat. I had told her, "All the other ladies will be loaded down with furs like a bunch of bears, but dressed like this, you'll stand out." I said, "Not only will you look even younger, but you'll make the President seem more up-to-date." She completely agreed, adding her own touch with a sable muff that she owned.

Inauguration day, January 20, 1961, dawned bright and cold. The snow had stopped falling and the sun shone brightly, but the streets were piled high with snow. The temperature was in the 20s and the winds were bitterly cold.

The President-elect's family was all there. His parents, Ambassador Joseph and Mrs. Rose Kennedy, positively glowed with pride for their son. It was the first time in history that both parents attended the inauguration of their son to the presidency.

Marian Anderson sang "The Star Spangled Banner," and Cardinal Cushing of Boston gave the invocation. At approximately 12:40 p.m., Lyndon Baines Johnson was sworn in as vice president. Afterward, Robert Frost, the patriarchal New England poet, then 86, recited his celebrated poem "The Gift Outright" in a moving, eloquent voice.

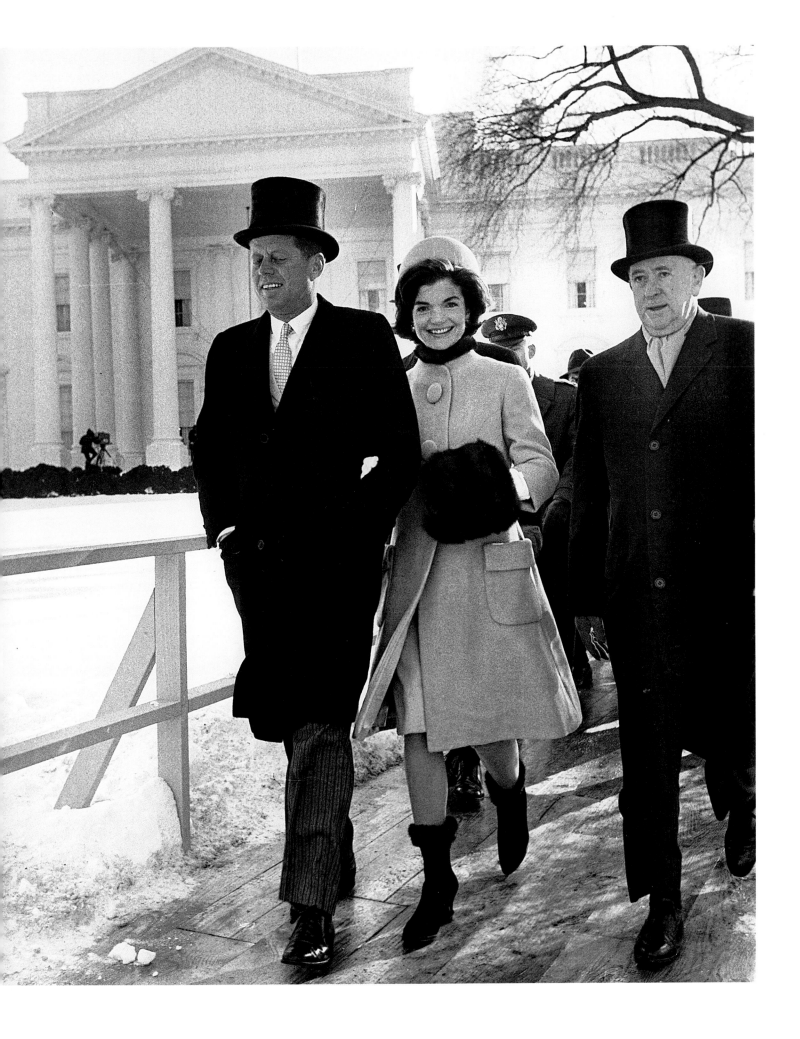

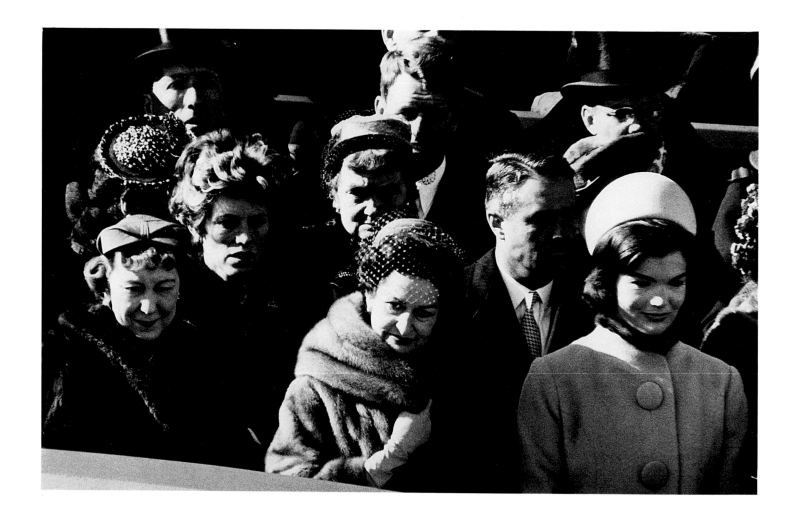

Then it was time for Chief Justice Earl Warren to intone the oath of office and John Fitzgerald Kennedy, his hand resting on the Fitzgerald family Bible, repeated the oath of office, becoming the 35th president at 12:51 p.m. The new president then turned toward his audience and began his brilliant inaugural address, thrilling millions with his words and painting strong visual images. His words came in puffs of frost in the bitter cold.

When the new President delivered his address, hatless and coatless in the freezing cold, he brought inspiration and hope to the world. It was a great inauguration address, revealing an attention to history and clarity of thought rarely found in political statements. Its impact on people everywhere was immediate and impressive.

At 43, John F. Kennedy was the youngest man ever to be elected president. He was the first president born in the twentieth century and the first Roman Catholic to be elected. He was the sixth Harvard graduate, a war hero, and, standing over six feet tall, he was also one of the most handsome.

I remember being at the inaugural ceremony and thinking that Jackie looked radiantly beautiful and perfectly happy. The weather didn't seem to bother her. Her face was aglow and immediately after the ceremony, on her way back to the limousine, in the midst of all the excitement, she touched her husband's face and said, "Jack, you were wonderful."

After a crowded luncheon in the Capitol building, where the new President exchanged autographed menus with former President Harry Truman, JFK and his exquisite First Lady drove up Constitution and Pennsylvania avenues from the Capitol to the White House in an open car. They were cheered by people gathered five and six deep along the route.

The parade and floats followed, and President and Mrs. Kennedy, and Vice President and Lady Bird Johnson reviewed it all with great enthusiasm from their special box. The parade, marshalled by Lieutenant General James Gavin, featured 32,000 marchers, 86 bands, the West Point Corps of Cadets, the Annapolis Brigade of Midshipmen, jets, tanks, guns, missiles, horses, mules, dogs, and a buffalo. The President stayed until the end, saluting the last flag as darkness began to fall, surrounded by his brothers.

There were five inaugural balls that evening and the President visited each one, leaving the last ball at 3:00 a.m. The inaugural festivities were over, and the new President had a 9:00 a.m. meeting the next morning with his staff. A new administration, and a "New Frontier," had begun.

FAR LEFT:
The old and the new meet on a cold January day (from left to right): Mamie Eisenhower, wife of former President Dwight D. Eisenhower; the new Vice President's wife, Lady Bird Johnson; and the new First Lady, Jacqueline Kennedy. Jackie was the only woman not wearing a fur coat.

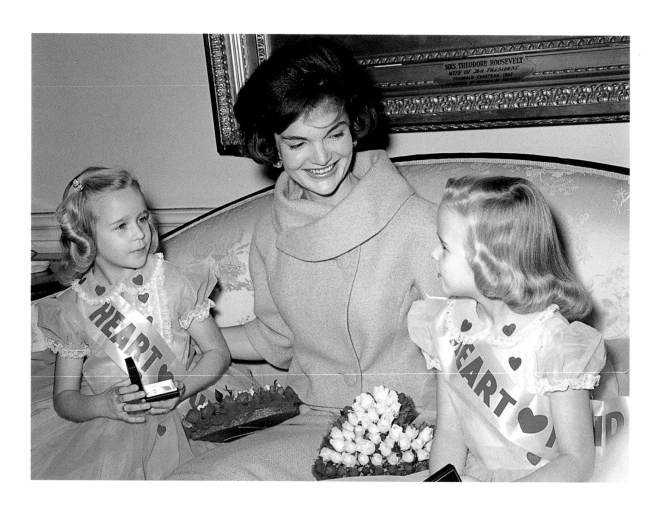

ABOVE:
On Valentine's Day
at the White House,
Jackie posed with twin
girls for the Heart
Drive in a narrow
Nattier pink wool suit.

RIGHT:
The jacket of the
pink wool suit
featured a rounded
overlapping cowl
collar that closed
asymmetrically;
round covered
buttons, and three-
quarter-length sleeves.
The skirt eased at
the waistline and
was shaped with
inseam pockets.

From our initial success with her inauguration ensemble, Jackie and I went on to create magic together. For the first time, an American designer was exclusively clothing a First Lady and exporting a global concept.

Hollywood costume designer Edith Head called Jackie "the greatest single influence in history." Fashion writer Hebe Dorsey said, "Jackie's style changed the existing fashion and helped to break down a certain Puritanism that had always existed in America and that insisted it was wrong to wear jewelry, wrong to wear fancy hairdos, wrong to live elegantly and graciously."

Once they were in the White House, I communicated regularly with Jackie. She was very good at giving me encouragement and compliments—keeping my spirits high. I also had my own business—one of the most successful fashion houses in America—to worry about. I had many moments of concern—I worried we wouldn't meet the deadlines, or that Jackie wouldn't like the sketch, or the dress wouldn't be as good as the sketch. I worried, too, because every appearance was judged, every outfit was scrutinized. In addition to our working relationship, I had a social relationship with the Kennedys. If Jackie had been unhappy about something, it would have been very difficult for me. So those were delicate moments I was living. But they were wonderful, too. The White House days were magical for Jackie, as they were for me. I had the historic opportunity to work with a woman of unprecedented charm and grace. I was part of the creation of a dream.

RIGHT AND
BELOW:
*For the swearing-in
ceremony of the cabinet
officers at the White
House on February 28,
Jackie wore a rich
Watteau rose ensemble
in embossed silk
damask. The narrowed
sheath featured a
deeply cut-out back,
easing at the waist.
Completing the ensem-
ble was a short match-
ing jacket with three
self-covered buttons,
three-quarter-length
sleeves, and a round
neck that looked per-
fect with pearls.*

Once we had our systems in place, everything went smoothly. I would send her sketches in color with swatches and recommendations. The sketches she liked would be made into garments. It was not unusual for her to order ten to twelve outfits at a time. The clothing would be fitted on a model and then taken or sent to Jackie for final fittings.

My telegram to her of January 31 is an example of how we worked together:

Blue wool and velvet dresses arriving Thursday with Marie, also your black suit and hat and also sketches and swatches for you to select and approve. Red hunting pink coat and black dressy silk suit ready early next week. Black broadtail fur coat ready end of the week. Starting February 13 you can receive four outfits per week, thus completing group in short time. Hats and bags with corrected measurements being coordinated for your approval. Everything is shaping up very well so hope you will be satisfied.

Devotedly Yours,

Oleg Cassini

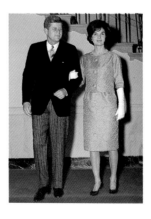

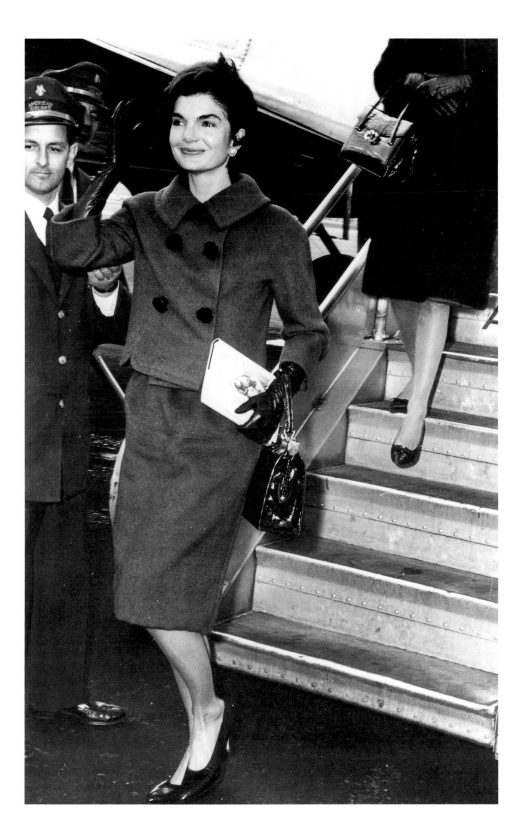

BELOW AND LEFT:
In March, Jackie and her sister, Princess Lee Radziwill, spent a few days in New York. Jackie wore a military-inspired two-piece suit of soft wool. The double-breasted jacket of the suit featured a "great-coat" collar, a four-button closure, and notched rounded lapels. The easy skirt fitted neatly under the waist-length jacket.

FAR RIGHT:
Jackie with Peruvian
ambassador Fernando
Berckemeyer at the
reception for Latin
American diplomats
on March 13.

RIGHT:
The sumptuous gray
peau de soie *dress*
was embroidered
with silver threads in
medallion shapes.
The curved and
extended shoulders
matched the A-line of
the skirt—an inverted
triangle. This was a
shape I would use
frequently for Jackie.

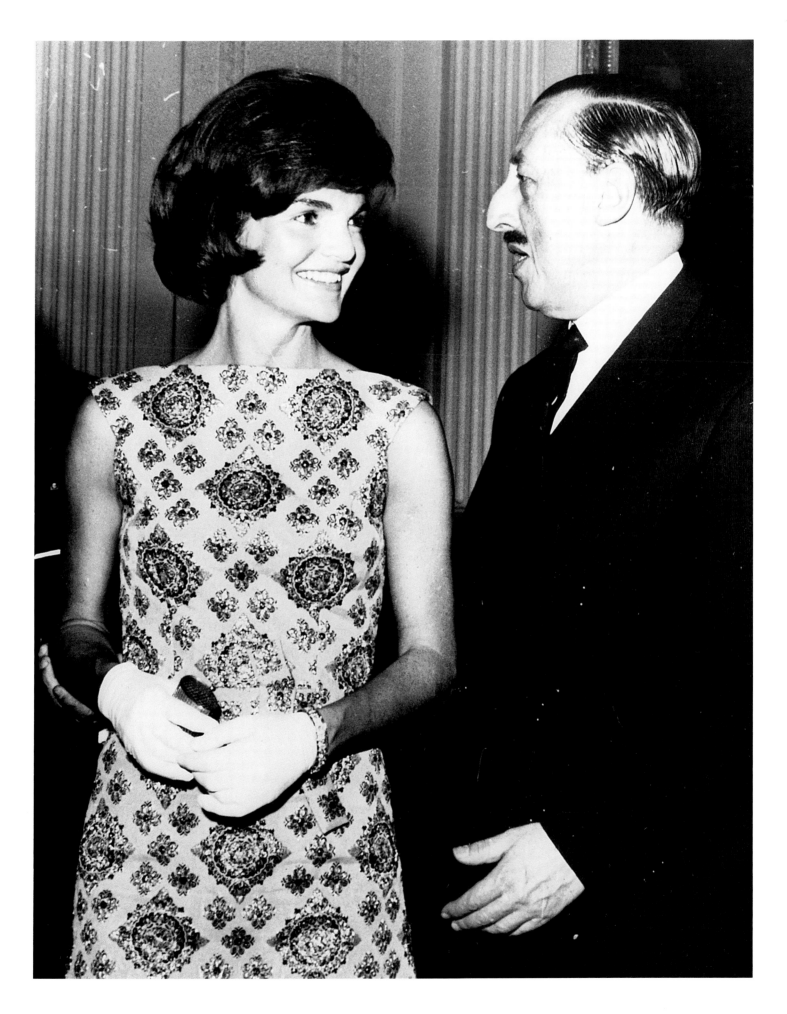

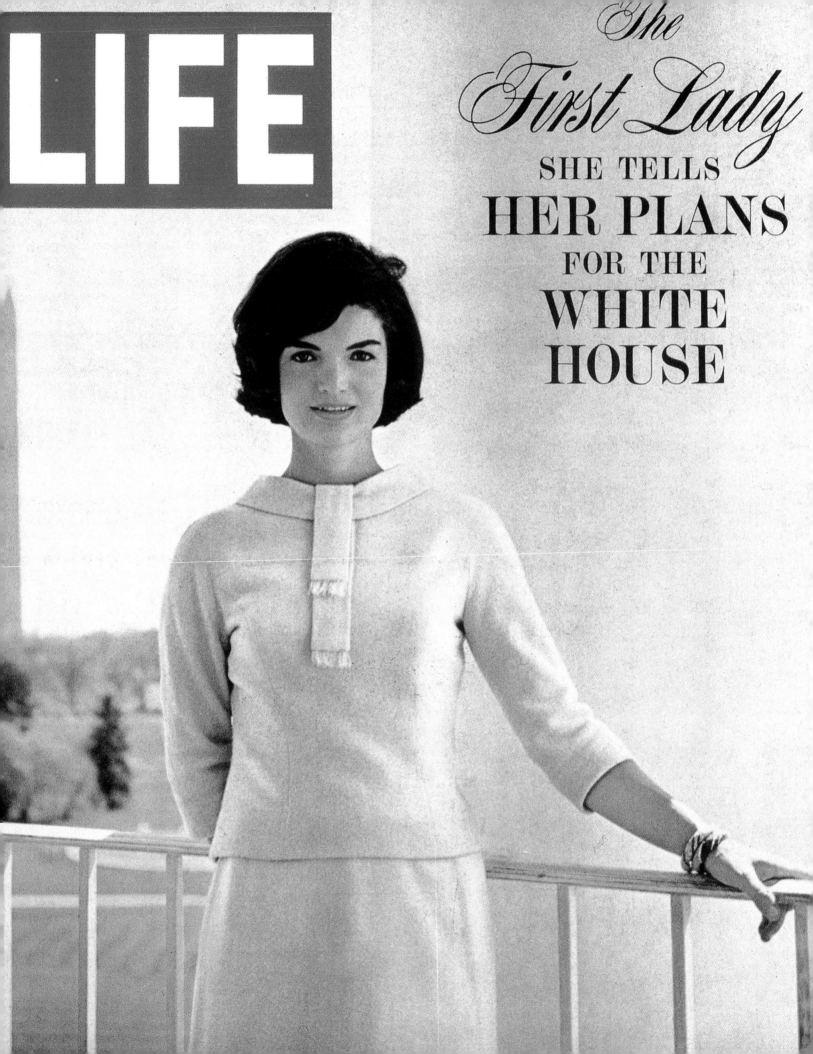

LIFE

The *First Lady*

SHE TELLS HER PLANS FOR THE WHITE HOUSE

Jackie would send me lists of the things she needed. For example, "Three daytime linen or shantung [dresses] one with a jacket, one with nothing, one with a coat? Or maybe two with jackets? Or three dressier afternoon dresses—2 pc shantung with straw hat, white with black polka dots, another not too décolleté." We would talk further, I would send sketches, and she would comment.

Whenever I came to Washington for meetings, she was always precisely on time. Perhaps it was exciting to see the final products as they developed from the sketches and fabric swatches. She never made me wait. She would quote Louis XIV and say, "*C'est la politesse du roi*" (promptness is the politeness of kings), and we would laugh.

I sent the bills to Joe Kennedy, as he instructed. "Don't bother the kids with the bills, just send them to me. I'll take care of it," he said. With great foresight, he wanted to wipe out any possibility that the First Lady's new wardrobe might be used against them politically.

I had offered Jackie one of my horses for hunting at her country retreat in Virginia. In February, Jackie wrote me a thoughtful note from the White House:

FEBRUARY 17, 1961
Dear Oleg,

It seems your collection is a smash. We were so amused by the story in the Herald Tribune, which was charming, and Diana Vreeland called to say how good she heard it was.

The 2 little pictures in the Tribune looked divine. It's true Bohan did every-thing you said I should do way before the Inauguration.

I sent you the pictures today just for fun—not for any other reason—as I adore all the things John brought down. What a saint you are. You never told any-one it was the day of your opening you were sending John and Marie. You must never do that again as any day is all right with me and I hate to think of the difficulties you had without them.

Jack ADORES his ties—they are so perfect. I thought I would never be able to get him pretty ties again—now that I can't go to my old haunts—but these are better than any I ever saw.

You were so sweet about your horse. I was very touched. It is so difficult now because the place we have rented has so few stalls and they are all filled with pigs—it is a pig farm which I never knew—but the farmer will be cleaning things out soon. Someday it just might be lovely—but right now I can't even shelter a pony for Caroline—much less my own horse. Maybe next Fall and you could come and hunt.

Congratulations. I am so proud of you.

Jackie

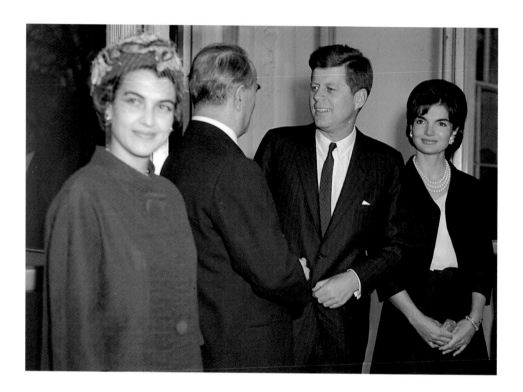

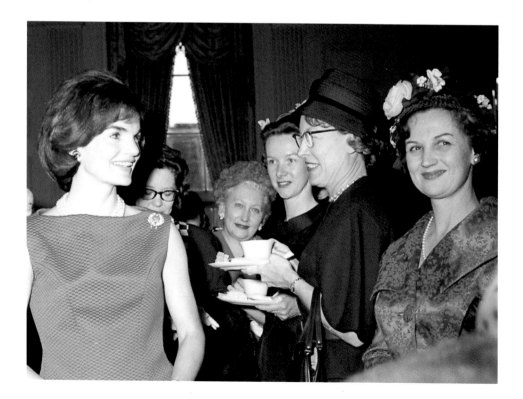

Sometimes, she would look at color slides of my collection and order several styles in unique colors or fabrics. We also made many special outfits, particularly when she would travel abroad or for important events. In anticipation of State visits, we would go over her itinerary and discuss the upcoming trip— whom she would be meeting, the local customs, climate, etc. We used the itinerary as we would a shooting script for a movie, planning each appearance and how she should look. I would think of her in vignettes, and imagine how she would stand out as the star. I was always thinking like a film director when I worked with Jackie—envisioning how she would look in close-ups or from a distance. I could see the pictures in my mind.

Our collaboration worked because I knew and understood Jackie's taste and had created a look for her. It was totally exclusive to her—in fact she insisted on it. She was comfortable with my approach and I was careful not to do things outside the framework we had established. The architectural lines were so perfect for her figure and everything had been so thoroughly thought out that success followed success.

For the first few months of 1961, the Kennedys stayed mostly in Washington. They occasionally traveled to Palm Beach for a weekend to rest and relax, and in March, Jackie spent a few days in New York shopping, visiting friends, and attending the theater.

LEFT:
For an afternoon
reception for the
prime minister of
Greece on April 17,
Jackie wore a simple
black suit with a
white blouse and
a triple-strand pearl
necklace.

RIGHT:
A fitted daytime
ensemble. The jacket
features notched
detailing with welt
seaming, self-button
closure, and three-
quarter sleeves. The
fitted sleeveless dress
has an eased skirt
softly gathered at the
waist with inseam
pockets.

LEFT:
A radiant Jackie
enjoyed her role as
hostess. Here, at a
White House tea,
she stood in stunning
contrast to the older
Washington political
wives.

ABOVE:
A typical "Jackie
look": a sleeveless
dress with a geometric
neckline in a sumptu-
ous fabric, shaped to
the body in an elegant
sheath. A matching
coat in the same fab-
ric completed the
ensemble.

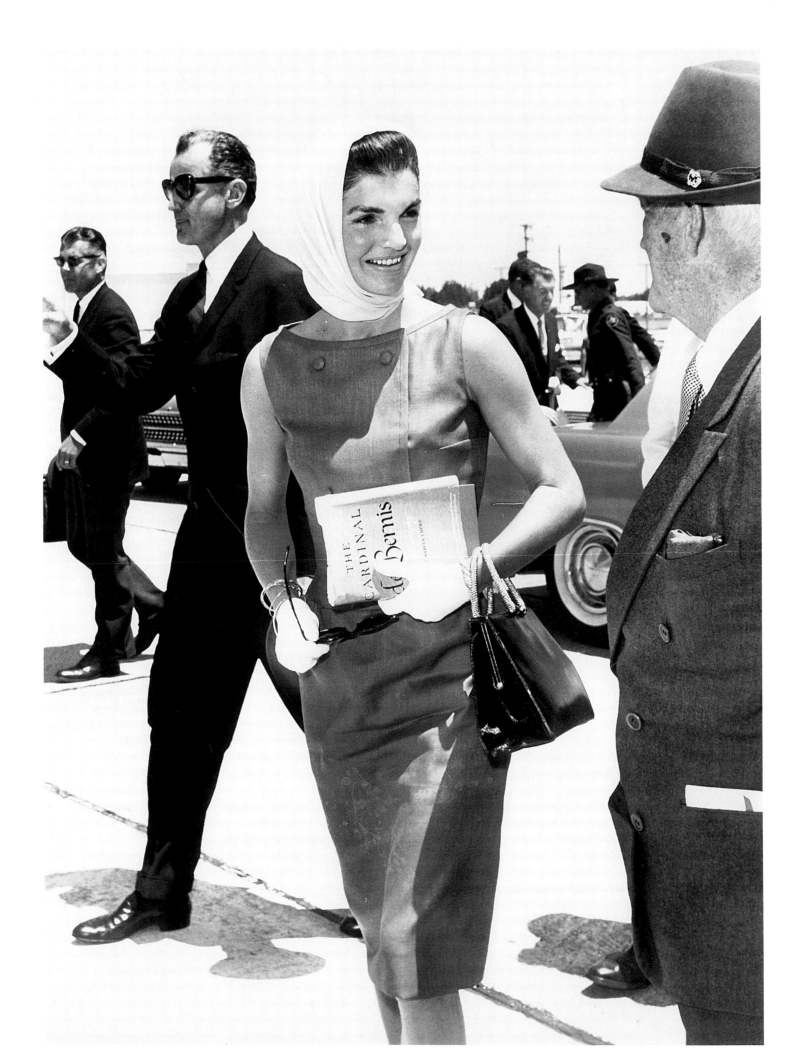

LEFT:
Jackie left Palm
Beach on May 15,
right before the
Kennedys went on
their first state
visit.

In April, British Prime Minister Macmillan and his wife were in Washington. The President entertained the prime minister at lunch and the First Lady hosted a separate tea for Lady Macmillan. The prime minister was impressed with the new First Family and was quoted, "They certainly have acquired something we have lost, a casual sort of grandeur about their evenings, pretty women, music, and beautiful clothes, and champagne, and all that."

Princess Grace and Prince Rainier of Monaco visited in May. Early in her career, Grace had a reputation for "dressing down," hiding her beauty and glamour. She usually dressed conservatively, wearing glasses, no makeup, and pulling her hair tightly back. She often wore cotton button-down shirts, pleated skirts and flat shoes. I had created a wardrobe for Grace, selecting from my collections and making special things for her putting her in simple, elegant looks that set off her patrician beauty. I told Jackie that I had suggested to Grace that to be taken seriously as an actress, she didn't have to appear unglamorous. This appealed to Jackie because in the past she too had given very little importance to fashion.

In the early months of the administration, reporting on Jackie's wardrobe was at an all-time high. In order to stop the flow of misinformation and fashion gossip about Jackie's clothing, her social secretary, Letitia Baldrige, wrote a letter to John Fairchild, publisher of *Womens Wear Daily*. Jackie was annoyed that the newspaper was reporting that she was buying clothes from all over and spending a fortune. Tish's letter read, in part:

Dear Sir,
I write to you at the suggestion of Mrs. John F. Kennedy, regarding several erroneous articles about her clothes, which have appeared in your publication during the past few months . . . Mrs. Kennedy realizes that the clothes she wears are of interest to the public, but she is distressed by the implications of extravagance, of overemphasis of fashion in relation to her life, and the misuse of her name by firms from which she has not bought clothes. For the next four years Mrs. Kennedy's clothes will be made by Oleg Cassini. They will be designed and made in America. She will buy what is necessary without extravagance . . . Should you receive a report that Mrs. Kennedy has ordered clothes not made by Mr. Cassini, I would appreciate it if you would call me and I will give you a prompt and accurate answer.

Mr. Fairchild replied, in part:

Dear Mrs. Kennedy,
We have been in touch with Mr. Oleg Cassini, who has been most cooperative and most kind. We are also most pleased and delighted with the beautiful clothes he is making. The whole fashion world and especially the American fashion world owes you a big debt.

Mr. Fairchild had approached me and asked if I would show him advance sketches of what Jackie would be wearing to various important events. I could not grant him his wish, since the final decision could be changed at the last moment, and I could not guarantee the order in which she would wear the clothing. Even more important was Jackie's desire that I not leak sketches. I had promised her complete discretion and I kept my word.

Jackie had a certain quality of mystery about her, an aura she succeeded in maintaining. People did not usually know what she was thinking or what she was doing behind the scenes— and she wanted to keep it that way.

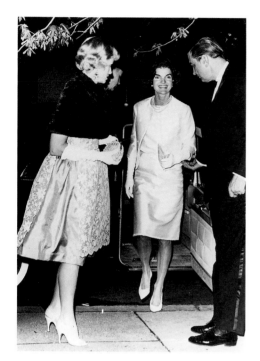

LEFT:
Wearing a white silk theater ensemble, Jackie arrives at the ballet in Washington on April 28, escorted by Franklin Roosevelt, Jr., and his wife.

RIGHT:
The President fixes his wife's wind-blown hair as they leave Blair House for the White House on May 3. They had just met President and Mrs. Bourguiba of Tunisia at the air-port and had taken part in an open-car motorcade through the streets of Washington.

RIGHT:
The white silk dress ensemble—another take on the T-shirt as evening wear—was collarless with cap sleeves and heavily embroidered with crystal brilliants at the hem. The matching cardigan was embroi-dered at the neckline, on the cuffs, and down the front of the opening.

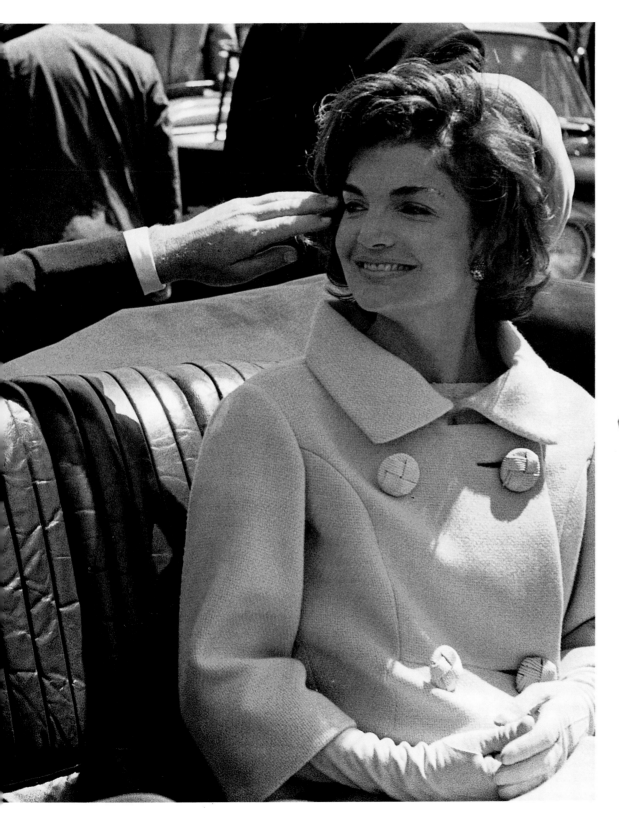

ABOVE:
Jackie wore a military-style coat—double-breasted in soft Watteau pink—with oversized silk corded buttons, rounded seams shaping the body, and softened shoulders in a modified A-line with three-quarter-length sleeves.

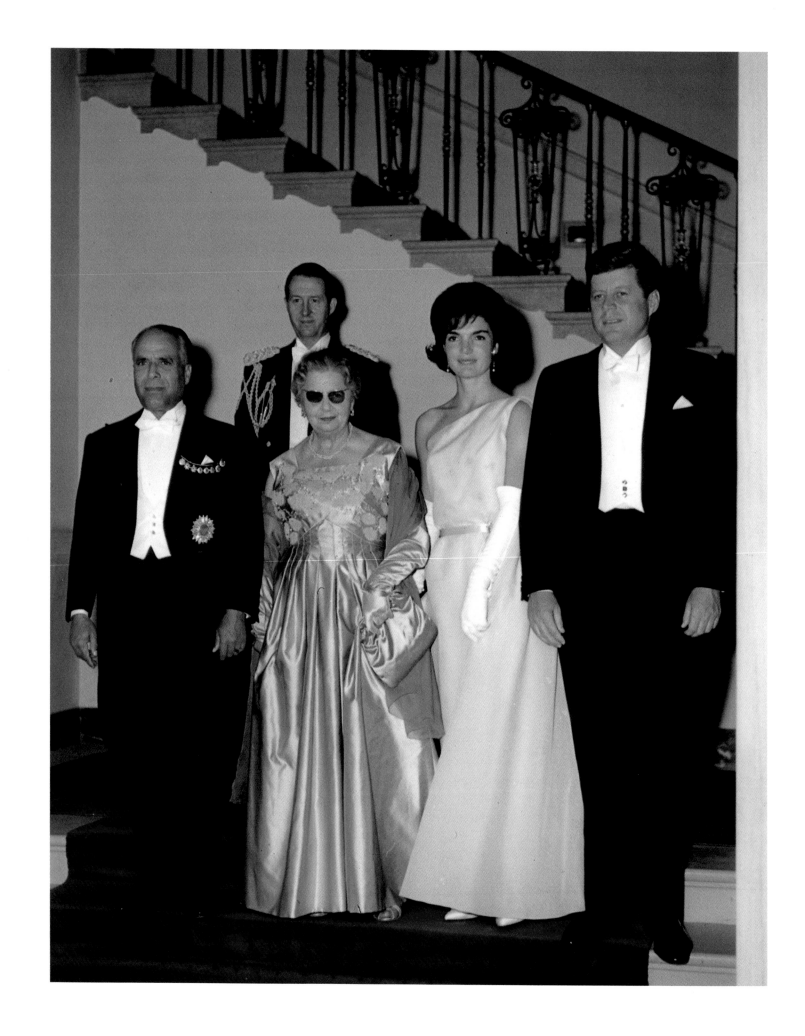

LEFT AND RIGHT:

At an evening reception for the President of Tunisia and Mrs. Bourguiba, Jackie wore a yellow one-shouldered "Nefertiti" gown. The full-length dress was gathered at one shoulder in the ancient Egyptian fashion. The fabric fell to a side drape, was trimmed with embroidery and brilliants, and was accented at the waistline with a signature bow. The black velvet gown Jackie wore for the reception honoring the President of the Sudan had the same feeling.

When I created a one-shouldered evening gown, Jackie loved it, but she was convinced her husband would not let her wear it.

So I went to see the President. "From the dawn of antiquity, the queen or high priestess has always set the style," I told him. "That is her role in society, to be a little advanced and thus admired by her people. You know how valuable Mrs. Kennedy has been to you in that regard. In this particular case, I am proposing nothing outrageous or undignified; indeed, the look is more than three thousand years old. The ancient Egyptians would have considered this dress rather conservative!" The President laughed and shook his head. "Okay, Oleg, you win," he said.

Later on, of course, Jackie and I were able to convince him to allow her to appear with both shoulders bare.

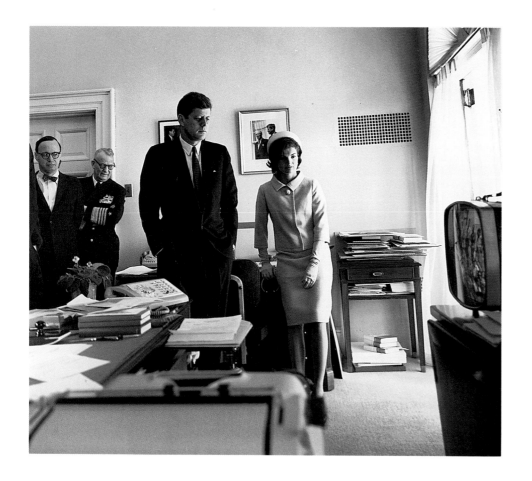

LEFT:
Jackie and the
President joined
Lyndon Johnson and
military staff to watch
the blast-off of the
first manned space
launch on May 5.

BELOW:
Astronaut Alan
Shephard and his wife
were honored at the
White House on May 8.

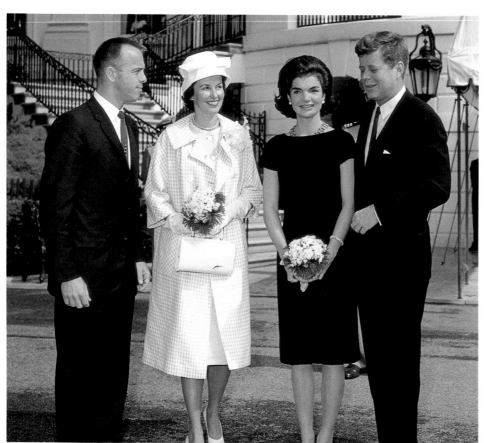

RIGHT:
A modified T-shirt look, in a black light-weight wool sheath with cap sleeves was self-belted at the waist.

FAR RIGHT:
Softly fitted two-piece wool suit, with rolled 'cowl collar', large single button accent at neck closure. The jacket front welt seamed with three-quarter length sleeves, with narrowed skirt.

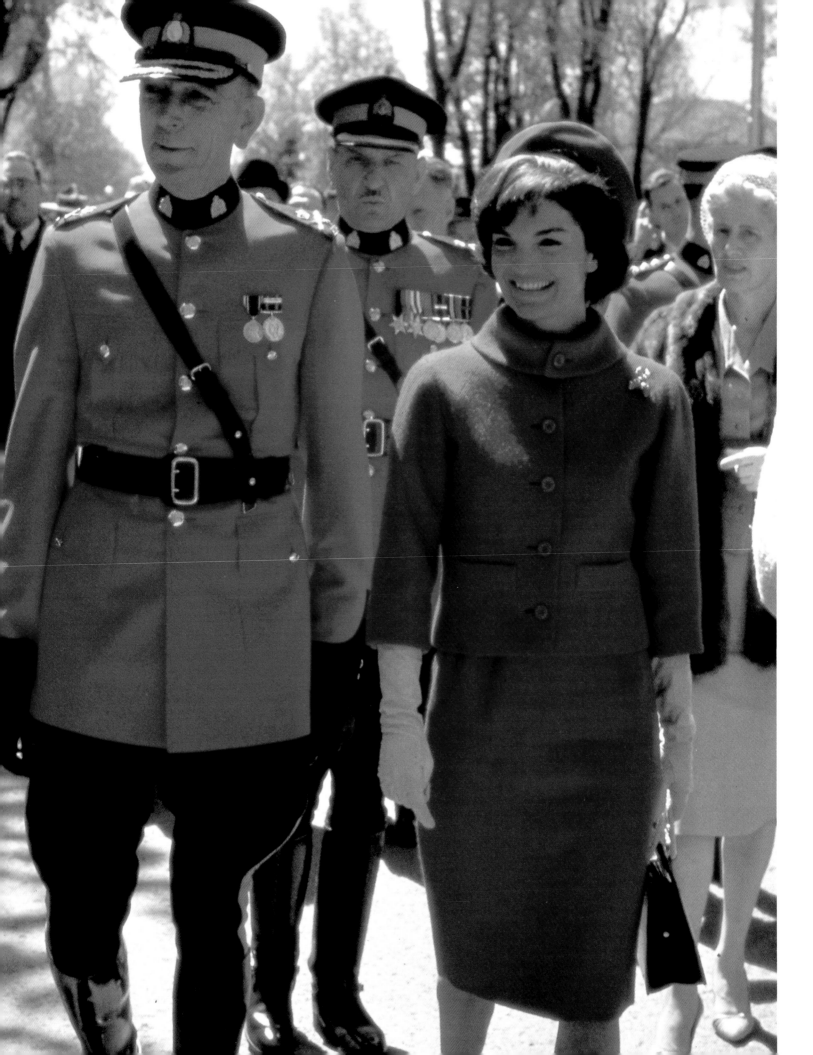

In May, the Kennedys went to Canada, the first of many foreign state visits. President Kennedy was on a mission to America's closest neighbor, confirming its friendship and urging greater cooperation in the Western Hemisphere.

For the Canadian trip, we issued a press release, sending it to Pam Turnure, Jackie's press secretary, for her approval. But the press kit only seemed to fuel a media frenzy and it was not done again. There was concern that interest in Jackie's clothes would overshadow the issues and accomplishments of the administration. The visit to Ottawa was quite successful, with Jackie planting trees alongside the President on the grounds of Government House. Unfortunately, ten shovel-loads were too much for his back, and the President suffered a great deal of pain because of it.

Jackie inspected the horses of the Royal Canadian Mounted Police, and posed with them. She was appropriately attired in a red wool suit, inspired by the uniforms of the Canadian "mounties."

The President was well received and Jackie was praised in Parliament by Senate speaker Mark Drouin, who said: "Before your election, Mr. President, many Canadians searched the civil register to see if she was a Canadian. They found she was not, but we all took heart from the fact that she is of French ancestry . . . Her charm, beauty, vivacity, and grace of mind have captured our hearts."

After Canada, the President was the first to recognize that Jackie had become a force to be reckoned with and a powerful

FAR LEFT: This red wool suit was inspired by the Royal Canadian Mounted Police uniforms and created quite a sensation in Canada. The suit had a buttoned cowl collar, rounded shoulders, pockets, and a straight skirt. A matching beret completed the look.

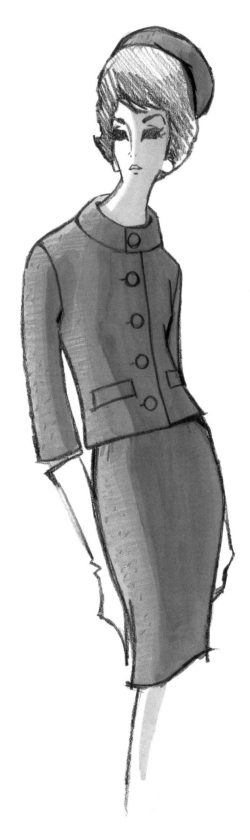

FAR RIGHT:
On May 16, guests
at the state dinner at
Government House in
Ottawa, Canada, were
greeted by Governor
General George Vanier,
President Kennedy, Mrs.
Vanier, and Jackie.

RIGHT:
A black and white
sketch of this dress
was included in the
official press release
for the trip. It includ-
ed this description:
"Heavy white silk long
evening gown with a
slim skirt and sleeve-
less belted overblouse.
The neck of the
overblouse and hem
of the skirt have
embroidered detail
of white beads and
brilliants."

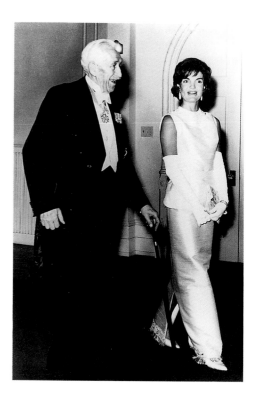

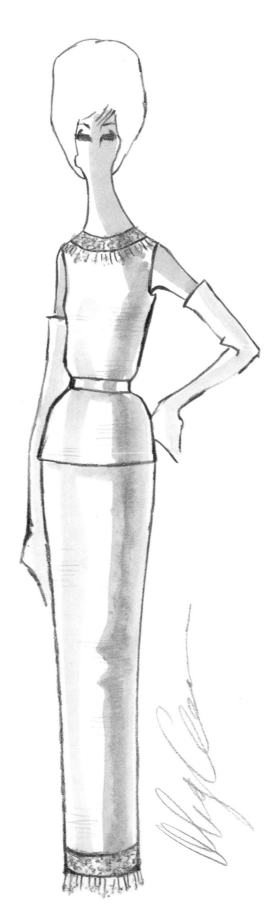

symbol for the United States. Her success in Canada began a metamorphosis of Jackie. As she began to realize her political value, she gained a lot of confidence. A new world was opening for her. It was the first step in the continuous evolution of her persona.

Shortly after returning from Canada, the Kennedys departed for France. France was important for political reasons, but it was important for me as well. I knew that France was where fashion criticism could start. My goal was to dress her like a queen. The French, who are experts, realized that this was truly couture. Prior to leaving for Paris, Jackie wrote me a lovely note:

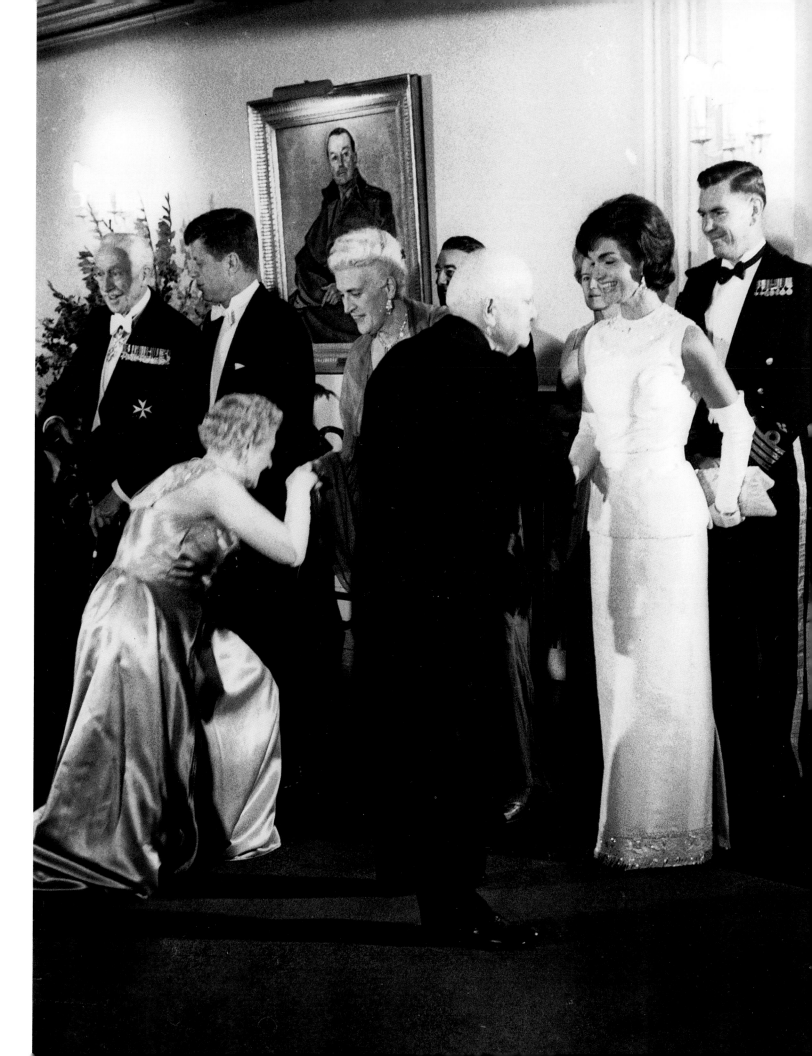

A B O V E :
A dinner was held
at the American
embassy on the second
day of the Kennedys'
visit to Canada. In
attendance were
(from left to right):
President Kennedy,
Governor General
George Vamier, Jackie,
Mrs. Vanier, Ambassador
Livingston Merchant,
and Prime Minister John
Diefenbacher.

MAY 25, 1961

Dear Oleg,
Just a note in the midst of packing all your clothes for Paris!

They have really been prettier than I ever dreamed clothes could be and never a tiny alteration needed. So I want to tell you in the midst of all this furor lately—that I think you have been just great.

You saw what everyone said about my clothes in Canada and I hope it made you happy. In a way, Mr. Fairchild has been a blessing in disguise—because everyone is on your side now. So do keep calm the way you have been.

It took a while for us to coordinate, for me to know what clothes I needed and for you to get them ready. Now we have our little system working perfectly and people know much more than they would have without Mr. Fairchild—how really lovely your clothes are.

There really isn't any point to this letter except I flelt so out of touch these hectic days and I wanted you to know a) I am delighted with everything you've made for me b) The way you answer the press is so good—so don't ever panic again as you now are in too dignified and respected a position to ever have to.

You may end up the darling at 7th Avenue, a kindly mellow gentleman who Galanos will say is his best friend!!

I don't need anything more now. So when you go to see the Fall Collections, just plan ahead so I'll have a couple of suits, coats, dresses. 2 theatre or reception things and a couple of evening dresses and I'll be set for next winter always in advance of my deadline.

And I don't mind if Charlene or anyone has the same dresses—but just don't let them wear them before I do!

Thank Kay for me—she is a marvel and all the best to you dear friendly couturier

Jackie

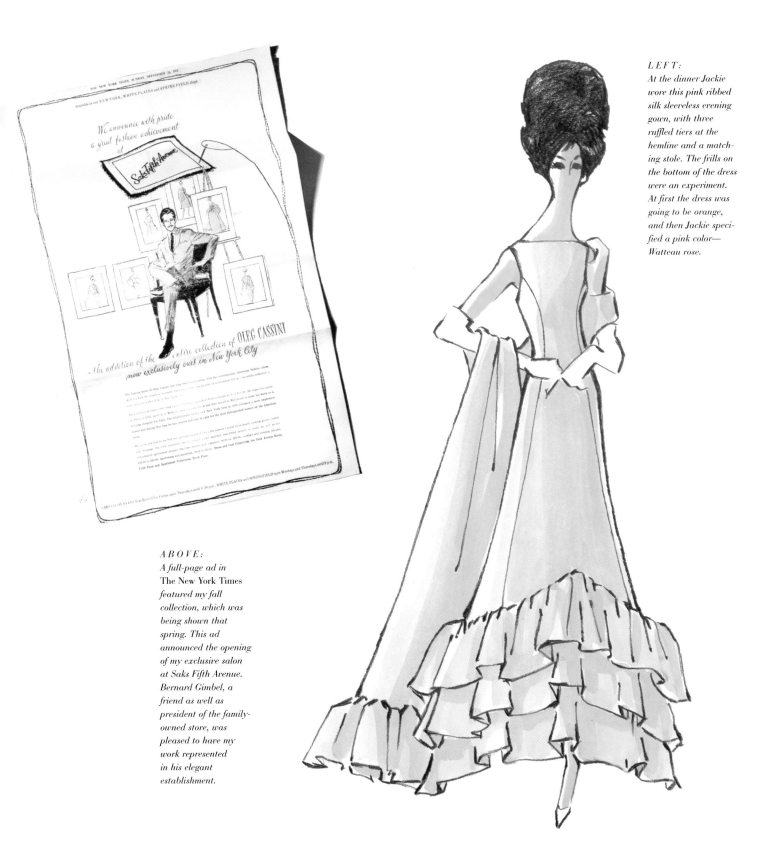

LEFT:
At the dinner Jackie wore this pink ribbed silk sleeveless evening gown, with three ruffled tiers at the hemline and a matching stole. The frills on the bottom of the dress were an experiment. At first the dress was going to be orange, and then Jackie specified a pink color—Watteau rose.

ABOVE:
A full-page ad in The New York Times *featured my fall collection, which was being shown that spring. This ad announced the opening of my exclusive salon at Saks Fifth Avenue. Bernard Gimbel, a friend as well as president of the family-owned store, was pleased to have my work represented in his elegant establishment.*

According to Tobe's most recent coast-to-coast survey, the best known name in American fashion is now Oleg Cassini.

—*Eugenia Sheppard in the*
New York Herald Tribune
October 25, 1961.

LEFT:
The media interest
in Jackie was strong,
and once in a while,
the press made a few
jokes. This humorous
photo appeared
nationally.

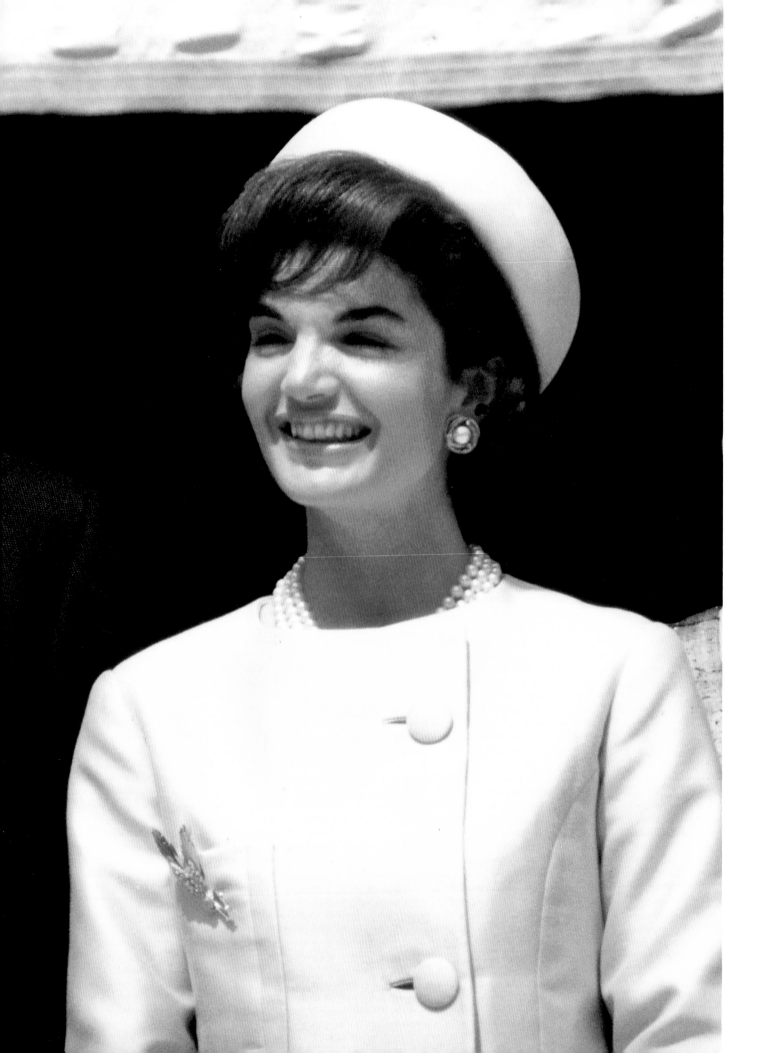

For France, I created a special group of gowns and day wear. We selected from that group for the most important occasions. For the grand gala reception, we selected a pink-and-white straw-lace dress with a matching stole, which Jackie wore at the Elysée Palace.

For the official state luncheon with President Charles de Gaulle and his wife at the Elysée Palace on May 31, we selected a jonquil-yellow silk suit. The sun was brilliant that day. The choice of color was right and Jackie virtually shone in the bright daylight. The suit was a classic example of what would become the "Jackie Kennedy" look—tailored with elegant simplicity, using sumptuous fabric, unusual color, and some distinctive details. President de Gaulle was effusive in his comments about "the gracious and *charmante* Madame Kennedy."

The Kennedys were greeted by a 101-gun salute and large crowds lined the streets of Paris, screaming "Jacqui!" The press coverage was incredible. *Time* magazine reported, "From the moment of her smiling arrival at Orly Airport, the radiant young First Lady was the Kennedy who really mattered."

Jackie visited Malmaison, the home of Empress Josephine, with Andre Malraux, the minister of culture. She admired the beautiful First Empire furniture and decor, which were in keeping, in period and elegance, with the plans for the restoration of the White House, which was built in 1803.

For the visit, she wore a soft putty-gray wool ensemble accented by fringe detailing. I have always loved fringe, and have used it as a recurrent theme ever since I designed Gene Tierney's black evening gown for the film *The Razor's Edge.* It was a theme I used frequently with Jackie—from the faux tie on the white wool dress for the *Life* magazine cover to the fringed ends of stoles for several gowns. It was one of the details that was part of the "Jackie" look.

Jackie did a great service for French-American public relations. She gave interviews, including a televised one in French, and visited Nôtre Dame cathedral wearing a lovely pink wool coat over a navy silk dress.

The President and Jackie also brought a thoughtful gift to the president of France from America, an autograph letter from President George Washington to the vicomte de Noailles, the brother-in-law of Lafayette. The letter had cost $90,000 and was donated by Charles and Jayne Wrightsman.

As a special gesture to French couture, which was and is important to the French economy, Jackie wore a Givenchy gown to the state dinner at Versailles, held in the Hall of Mirrors. Jackie was terribly thoughtful and sweet to call me and explain why she felt, for political reasons, that she had to wear a French dress.

Later, it was reported in the press that Givenchy leaked the spurious story that Lee Radziwill was covertly buying his dresses for her sister and I was tak-

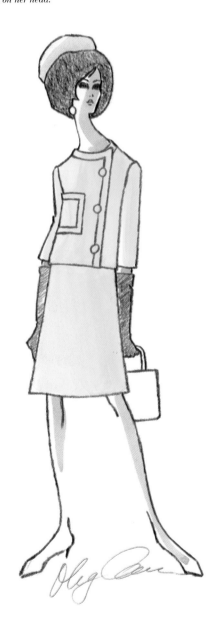

FAR LEFT AND BELOW:
For the state luncheon, Jackie looked elegant in a jonquil-yellow suit. The jacket featured an asymmetrical side-button closing with a wide welt seam, fabric-covered buttons, and bold topstitching. The skirt was in an easy cut, widening at the hem in an A-line. The hat, in matching fabric, was worn set back on her head.

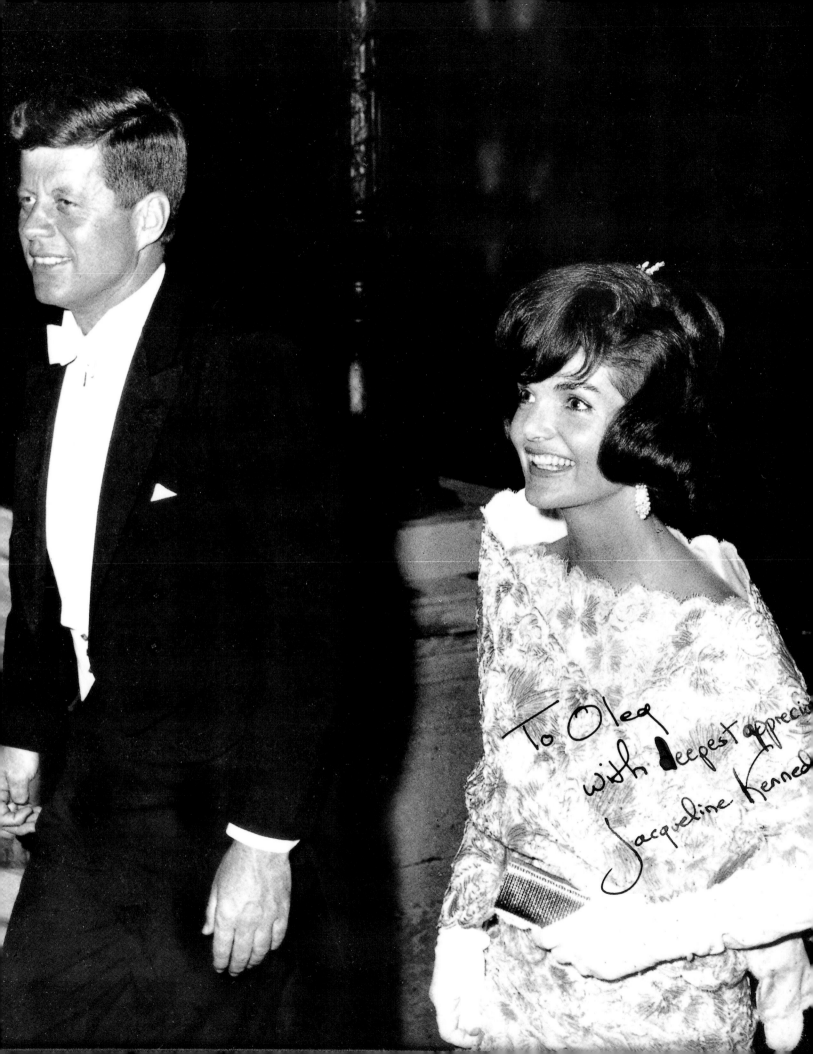

To Oleg
with deepest appreci...
Jacqueline Kenned...

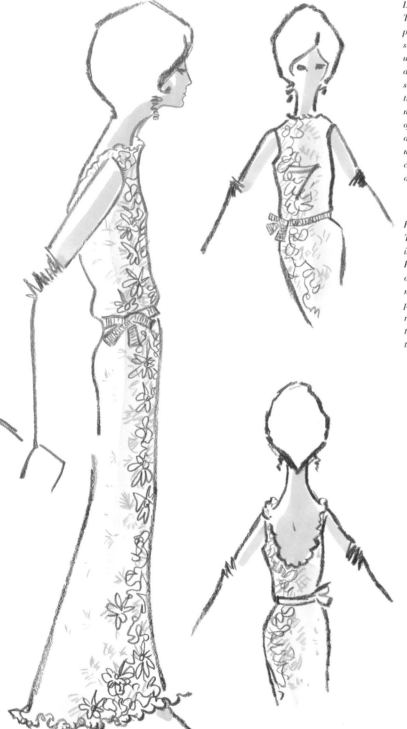

LEFT:
The back of the pink-and-white straw-lace dress was quite dramatic, while the scalloped effect of the simple bateau neckline in front set off Jackie's neck and profile. A matching stole completed the outfit.

FAR LEFT:
The Kennedys arriving at the Elysée Palace for the state dinner. Jackie sent me this autographed photograph on her return from this triumphal European trip.

ing the credit. When Jackie learned of this, she sent me a note, which read in part:

Before you explode with a cry that can be heard echoing all down 7th Avenue . . . (I should explode—isn't it breaking the law what Givenchy said I supposedly did!) . . . Just realize . . . it makes him look so absurd to be feeding out these petty stories about Lee & me. I thought he was too grand to show annoyance—so this is rather pleasant. I have not gotten anything from him since last June—Versailles. If anyone asks you about the story just smile rather patronizingly and say, "Mr. Givenchy must be feeling the heat wave in Paris," or something very light & unconcerned—Also you could say, "A look at Mrs. K's clothes for India & Mexico, for example, will show you that they were not Givenchy inspired."

This writing paper was especially designed for writing heads of state—do you think it is good enough?

It was lovely to see you if only for a minute—

> *Until September*
> *Love,*

> *Jackie*

From France, President Kennedy and his exceptionally popular First Lady flew to Austria, to meet Prime Minister Khrushchev of the Soviet Union. The Boston *Times* quoted President Kennedy as stating that he was going to Vienna as "a leader of the greatest revolutionary country on Earth."

Austria was chosen for the meeting between Kennedy and Khrushchev because, although it was a neutral country, it abutted Soviet bloc nations. This visit was important, since relations with the Soviet Union at that time were very delicate. There had been the problem with Cuba in April 1961—the Bay of Pigs. In early 1961, the Soviets had also made demands for a United Nations veto over nuclear inspection, which would delay nuclear disarmament. In Vienna, President Kennedy and Premier Khrushchev had private talks and exchanged views. A model of the USS Constitution was given to the premier as a gift. It was a good beginning, and Khrushchev was friendly.

At the state banquet in Schoenbrunn Palace, Premier Khrushchev was most intrigued by Jackie, and before greeting President Kennedy, asked to meet her. Jackie's subtly seductive mermaid dress was a bold move in this East-meets-West encounter, and it greatly disarmed the Soviet premier. After dinner, Khrushchev insisted on sitting next to her while sipping coffee.

I thought how my life had been changed so greatly by the advent of the Communist regime, and how ironic it

RIGHT:
For her visit to Nôtre Dame Cathedral, Jackie wore a double-breasted lightweight wool coat in Watteau pink. The coat was fitted to the upper body with a narrow cut, the hem gently flaring to an A-line.

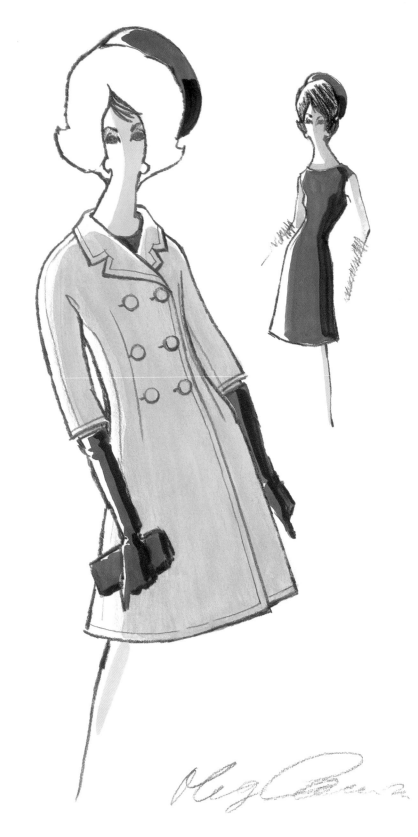

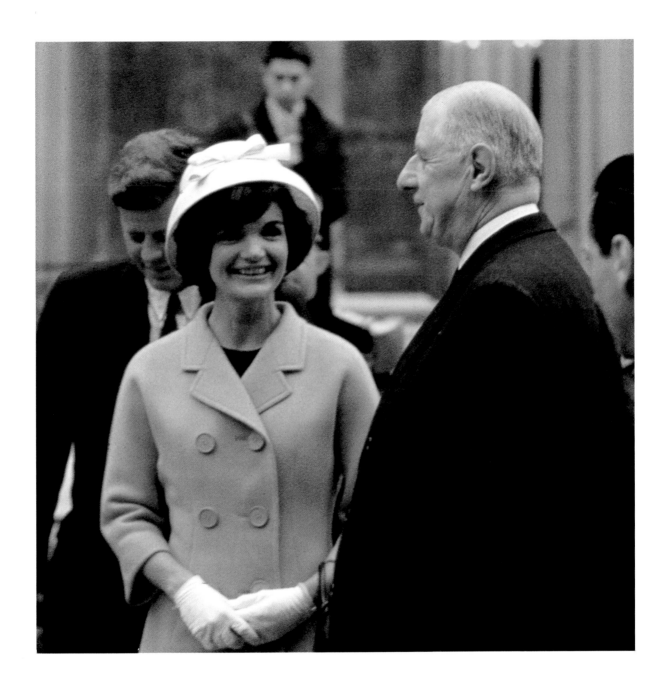

ABOVE:
Jackie was fluent in French, having gone to the Sorbonne. President de Gaulle was very taken by her beauty, her manners, and her knowledge of French history. When she told him, "My grandparents were French," the delighted French president replied, "Madame, so were mine!"

was that the reigning exponent of Soviet Communism was admiring the dress that I had created for Jackie Kennedy.

From Vienna, Air Force One lifted off for Great Britain, which was to be an unofficial visit for the christening of Princess Lee Radziwill's new baby, Anna Christina. The President would be the baby's godfather.

The trip to Great Britain was equally successful and the Kennedys were met by large and enthusiastic crowds. President Kennedy—a war hero and the son of the former ambassador to the Court of St. James—was exceptionally popular and had a lot of built-in good will with the British people. It was a much photographed visit, culminating with dinner at Buckingham Palace with Queen Elizabeth II and Prince Philip.

From England, the President returned to the States. Jackie and the Radziwills went on to Greece, where the headlines read: "After the peerless Helen—Athens prepares for a Jacqueline conquest."

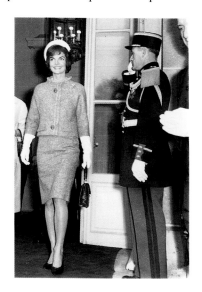

LEFT AND RIGHT:
For her visit to Malmaison, Jackie wore a soft putty-gray wool ensemble with a slim skirt. The jacket had modified dolman sleeves accented by fringe detailing on the rounded neckline and down the front panel closure. The suit also featured large signature buttons and inset pockets.

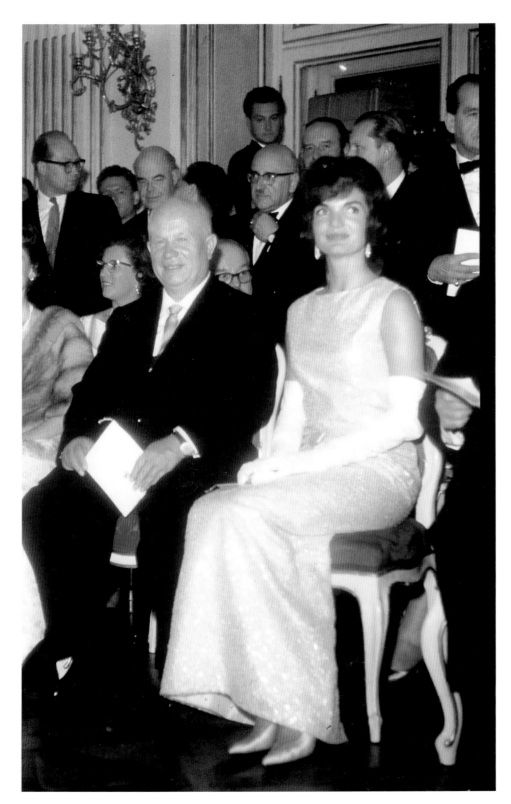

LEFT:
In Vienna, at a state banquet at Schoenbrunn Palace, Jackie looked like a mermaid in shimmering pink-silver. Her full-length sheath gown featured very simple lines, a rounded bateau neckline, an easy waist with a double side-tied bow, and a narrowed skirt that flared slightly at the hem. The fabric told the story, sparkling in the light and highlighting every curve and movement.

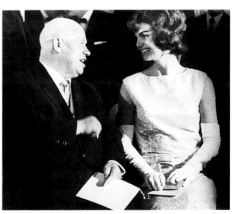

ABOVE:
The First Lady created quite an impression on Premier Khrushchev, who insisted on sitting next to her during the musical entertainment after dinner. Upon being introduced to Jackie, his first words were, "It's beautiful," referring to her gown.

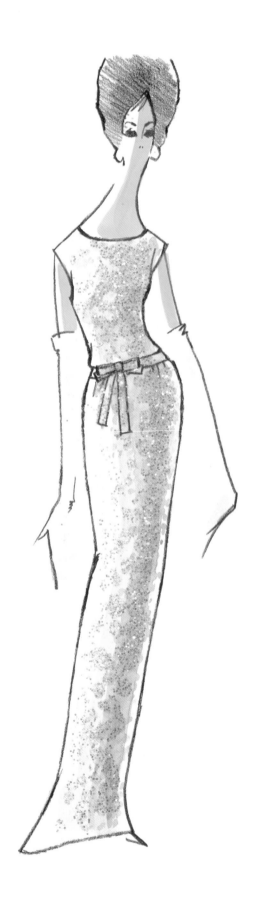

FAR RIGHT:
The Kennedys pose
with the Queen of
England and Prince
Phillip. Both cou-
ples looked equally
handsome and
appropriately regal.

LEFT:
At the dinner at
Buckingham Palace,
Jackie wore a very
simple silk satin
dress, with two
small bows on the
neckline. It was a
neckline that I often
used for her, as it
showed off her
shoulders. This
dress was in our
original press
release for the
inauguration.
The geometric cut
was a strong part of
the "Jackie Kennedy
look."

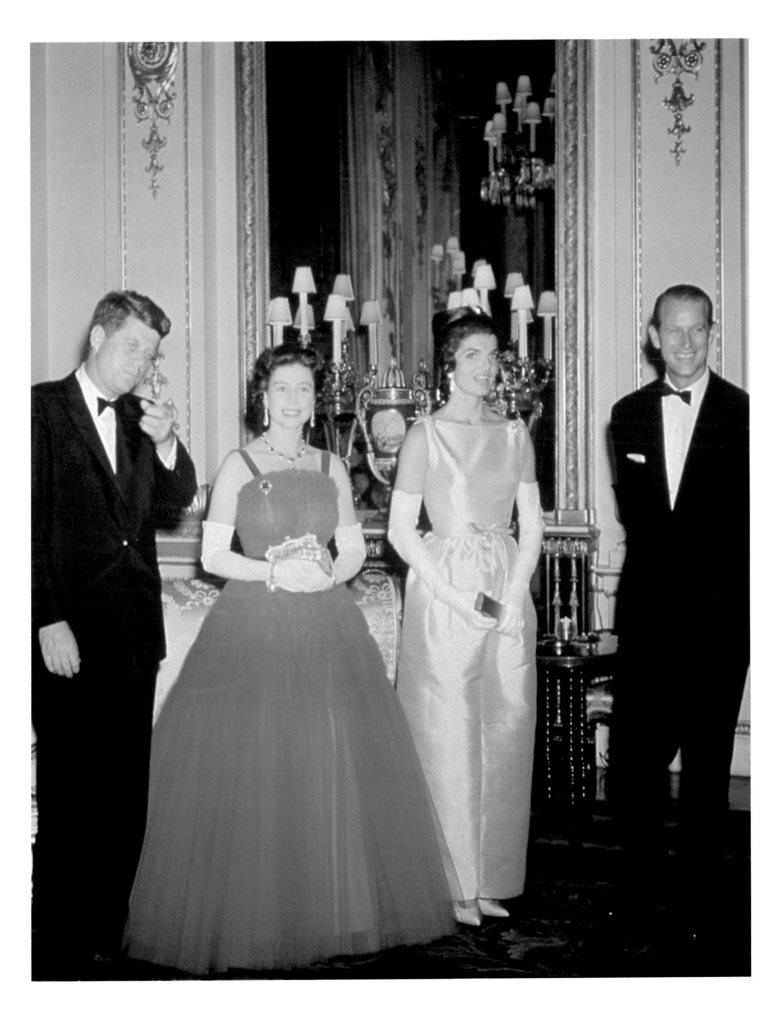

Later that summer, perhaps inspired by her visit to France and the state dinner at Versailles, Jackie held a dinner and reception at Mount Vernon, the ancestral home of George Washington, in honor of Mohammed Ayub Khan, the president of Pakistan. This would be the history-making event of the year and the first state dinner given outside the White House.

On July 11, the guests were transported down the Potomac to Mount Vernon by four boats. The food was brought in by special trucks, and electric generators supplied the light and power needed to prepare the food. All the dining equipment was transported from Washington and set up on the lawn. The National Symphony Orchestra and Lester Lanin supplied the music. Jackie had made another coup by soliciting private donations to cover much of the expense.

In the great tent on the lawn, tables for ten were set up with bright yellow cloths. Vermeil bowls filled with flowers were used as centerpieces. Mint juleps in silver cups were served on the terrace overlooking the river. The Colonial Color Guard, along with a fife and drum corps, executed an intricate drill in their colonial uniforms. Jackie looked authentic in a full-length white gown with rows and rows of narrow white lace on white organza.

The guest of honor, Pakistan's President Ayub Khan, was enchanted by the unique evening.

President Kennedy made a memorable toast, saying: "George Washington once said, 'I would rather be at Mount Vernon with a friend or two about me than be attended at the seat of government by the officers of state and the representatives of every power in Europe.'"

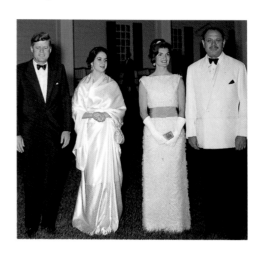

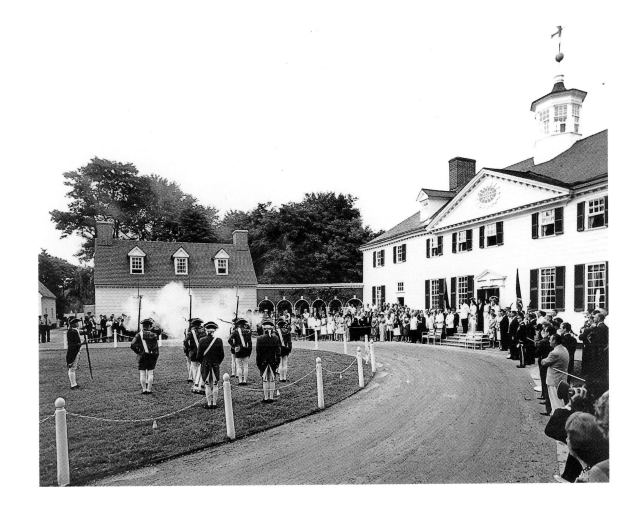

From the moment she moved into the White House, Jackie was determined to bring a sense of history and beauty to the president's house. She wanted to bring back the furnishings and art that related to the families that had lived the mansion, from the Adamses, in the 1800s, to the present.

"Everything in the White House must have a reason for being there. It would be a sacrilege merely to redecorate it. It must be restored," she said. Within one month of becoming First Lady, Jackie formed a special committee—headed by Henry Francis DuPont, one of the foremost experts on American antiques and the creator of Winterthur, the great museum of American decorative arts—to advise her and search out either original White House pieces or other appropriate American antiques for the interior.

In addition to a curator, whom Jackie hired, there were fourteen committee members, all experts in the fine arts, with sufficient wealth and contacts to get the very best and most authentic period pieces for the White House. Stephane Boudin, from the French design firm of Jansen, coordinated the restoration.

Jackie was much more than the honorary chairman of the White House Restoration Committee; she was the heart and soul of the restoration.

LEFT:
This sleeveless shantung dress with a rounded neckline had military accents— double-breasted buttoning on the plastron-fronted bodice and a leather belt at the waist.

RIGHT:
At the gala reception for the president of Peru on September 19, Jackie wore a gown in one of my favorite color combinations— jet black contrasted with a vivid Tintoretto mustard-gold. The sleeveless tank top in jet silk was tied at the waist with the mustard-gold satin of the bell-shaped skirt with a signature bow fringed at the ends.

I used to go to Paris twice a year to visit friends and to ski. Jackie said, "Why don't you go and see some of the collections and fabrics while you're there?" So I did.

In Paris, I was well received by everyone. In fact, nobody charged me the usual entrance fees to view the collections. Some of the French designers even talked to me about collaborations for future Kennedy clothes. When I went to look at the Balenciaga collection, however, they said, "You have a choice: you can either pay the entrance fee or you can buy two dresses." And I said, "I'll buy two dresses." So after viewing the collection, I bought two very attractive dresses for Jackie.

After my trip, I traveled to Washington and arrived at the White House with this beautiful Balenciaga package. I gave it to her and said, *"Compliments de la maison."* So she went into the other room with the box and came out a few moments later. She was furious with me. She said, "How dare you do a thing like that? It's not like you." Confused, I asked her, "What did I do?" She said, "You purposely picked the worst things that you saw, in order to make yourself appear better." I said, "That is not true. I took two day dresses, because I thought it was more practical than one evening dress and I thought you might really enjoy the Balenciaga look."

I was "in the doghouse" with Jackie for two or three weeks, but she called me shortly thereafter and said that her sister, Lee, had bought a Balenciaga dress in Paris. In fact, it was one of the

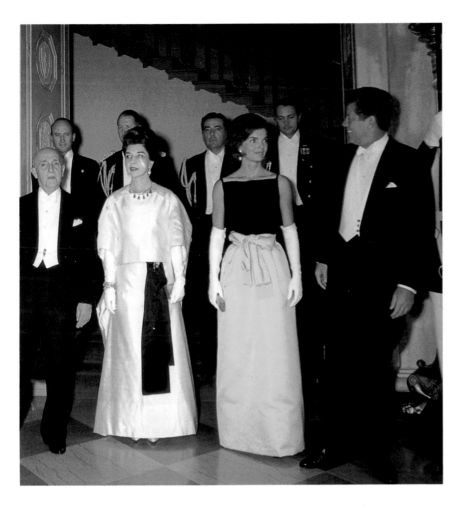

ABOVE:
Jackie looked radiant at the gala reception for the president of Peru and his wife.

BELOW:
This black - and - white ensemble was made of ribbed ottoman. The sleeveless dress was accented by a signature bow at the waist and a rounded neckline. The white matching double-breasted jacket had four large buttons and short sleeves. It fit neatly over the dress, giving two completely different looks.

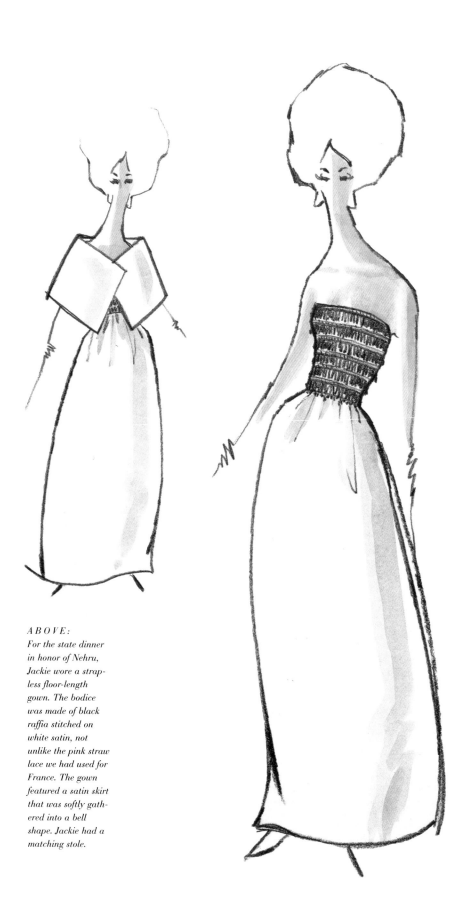

ABOVE:
For the state dinner in honor of Nehru, Jackie wore a strapless floor-length gown. The bodice was made of black raffia stitched on white satin, not unlike the pink straw lace we had used for France. The gown featured a satin skirt that was softly gathered into a bell shape. Jackie had a matching stole.

two dresses I had selected for Jackie.

She said, "I realized after working with you that the trouble is that you're so good that it's difficult now to understand other people's work.

My mother died suddenly on a September weekend. On the Friday preceding her death, she had insisted from her hospital bed, "Go to the beach and I will see you on Monday." We had been assured by her doctors that there was no immediate danger, but the prognosis proved to be wrong.

I was shattered and inconsolable, and I cried for the first time in many years. Jackie sent me a thoughtful note, by hand, and called immediately upon hearing of Mother's death.

SEPTEMBER 25, 1961
Dear Oleg,
We were so very sorry to hear about your mother. I know how much you loved her.

She must have been a wonderful woman to have two sons who adored her so.

You have our deepest, deepest sympathy. I am so sad. I wish I knew of some better way to tell you that we are thinking of you with all affection in this unhappy time.

Love,
Jackie

She invited me to join her and her family in Newport. "Come and spend some time with us and bring a friend," she said. I will never forget Jackie's thoughtfulness.

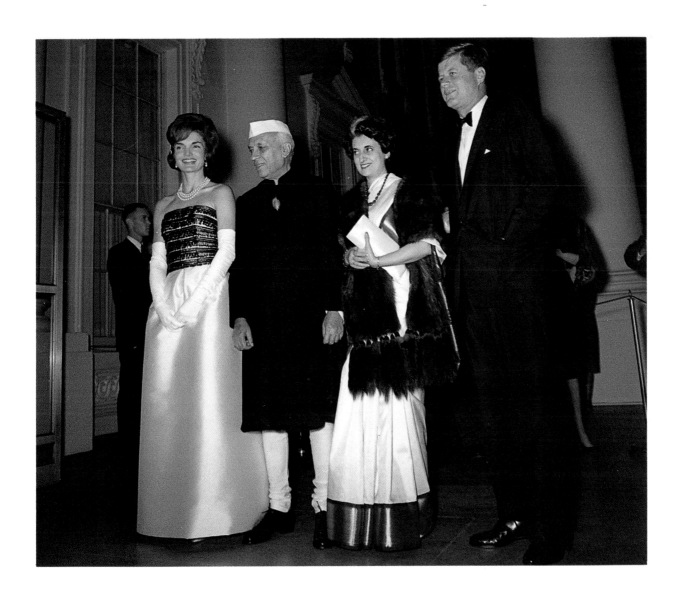

ABOVE:
I was there when the prime minister of India, Jawaharlal Nehru, visited Washington with his daughter,
Indira Gandhi, in November. Mrs. Gandhi invited me to consult with the textile
and fashion industries of India and advise them on development.
Jackie and Nehru got along quite well together. The President told me that he drove the prime minister
past the grand mansions of Newport—"millionaires row." As a joke, he told him,
"I wanted you to see how the average American lives."

RIGHT:
The Kennedys gave a
state dinner in honor of
President Ibrahim
Abboud of the Sudan. At
the White House prior to
the dinner were (from
left to right in the front
row): President Abboud;
Mrs. Osman El Hadari,
wife of the Sudanese
ambassador; Jackie; and
the President. In the
back row were: General
Godfrey McHugh, air
force aide to President
Kennedy; Captain
Tazewell Shepard, naval
aide to the President;
and ambassador Osman
El Hadari, the Sudanese
ambassador. Jackie liked
the one-shouldered
Nefertiti dress so much
that she had it made in
several colors.

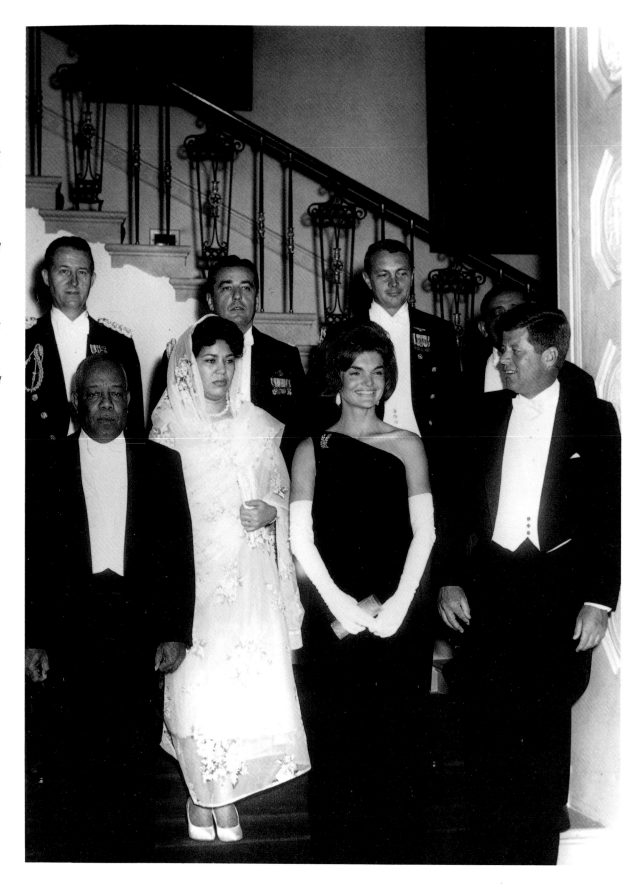

Once I did bring a friend with me. She was a beautiful model from Texas, who froze when confronted by social conversation with the President and his wife. The four of us had dinner alone in the dining room, and my lovely friend was awestruck. Later, Jackie said, "She is very pretty, but certainly you can find someone more interesting."

I visited the Kennedys in Newport several times, but I always slept badly there because the Secret Service men pacing the gravel drive always kept me awake.

I was often at the White House or Palm Beach. I was on the list for all the top parties, and on the list for weekends.

I spent a lot of time with them. The President encouraged it, because he enjoyed my attitude, which was similar to his.

He liked to discuss history, a mutual interest, and was quite knowledgeable. In many respects, although we were not from the same background, we were contemporaries.

The President and I sometimes spoke of ambassadorial posts, and how it would be far better if our ambassadors spoke the native language of the countries they served in, if they knew the

ABOVE LEFT:
Jackie received a season ticket to the National Symphony on October 5.

LEFT:
This graphically simple coat dress was made in heavy white silk shantung and belted at the waistline in black leather.

local customs, and if large campaign contributions were less of a factor in someone's becoming an ambassador. "Yes," he said, "but if there wasn't the promise of some reward, no one would ever contribute to a political campaign." Because of my linguistic abilities, and because of my educational background—a degree in political science—I felt that I could have been an ambassador in a French-speaking or Italian-speaking country. The President asked me if I wanted to consider it. At that time, I was still in the process of creating some wealth for myself in the design business, and I was having a good time doing it.

Once, on the president's yacht off Newport, reviewing what seemed like a flotilla of navy vessels, he said to me, "You know, this job might even be fun if the world weren't in such a mess." And then he said, "Just months ago I was begging people to shake my hand and vote for me, and now they're lining up to see me!"

Throughout the fall, Jackie was a hostess with many international guests: Andre Gromyko of the U.S.S.R., President Urbo Kekkonen of Finland, the president of Liberia, President Senghor of Senegal, and the president of the Sudan, Ibrahim Abboud.

November saw former President Truman and his family visiting the White House, and a lovely dinner was given, after which the former president played a minuet on the piano.

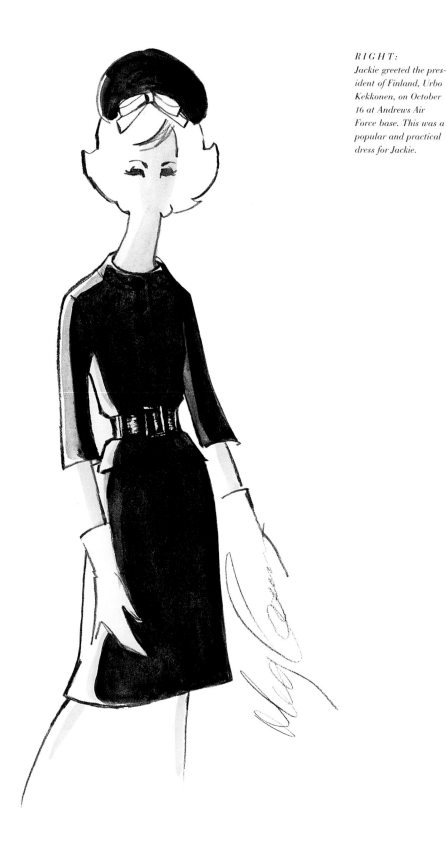

RIGHT:
Jackie greeted the president of Finland, Urbo Kekkonen, on October 16 at Andrews Air Force base. This was a popular and practical dress for Jackie.

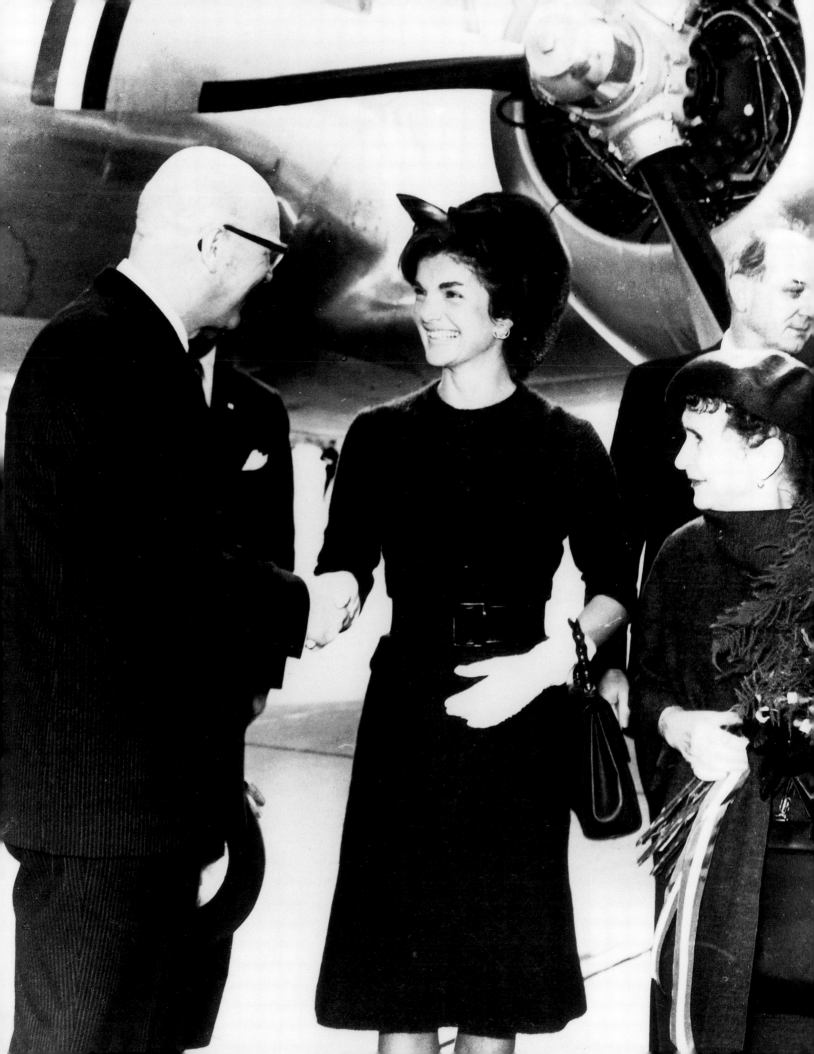

LEFT AND FAR RIGHT:
For former President Truman's visit to the White House, Jackie wore a dramatic full-length white satin sheath with a straight geometrical neckline that swept from shoulder to shoulder. The dress had a cut-out back adorned with two small bows. A matching satin cardigan completed the ensemble.

The Kennedy family was very involved in charitable organizations, and many times I would provide "entertainment," in the form of fashion shows, for the various benefit luncheons and dinners they hosted. In October, after a benefit for Caritas, the President sent me a telegram: "Caritas should be congratulated for having chosen you to put on the fashion show this year. It assures the success of the occasion . . . Mrs. Kennedy and I hope the supply of dresses is not exhausted so that one can be sent to her at the White House."

Perhaps the most famous event at the White House that year was the concert given by Pablo Casals in the East Room after the reception for Luis Muñoz Martin, the governor of Puerto Rico, and his wife. Alice Roosevelt Longworth attended, as she had attended Casals's last concert in the White House in 1904.

For the Casals reception, Jackie looked spectacular in what I called the "sheath look." It was a lean, angular cut, narrowed to the body, similar to the sheath of a sword. I always felt that a dress is merely an envelope for the body. In Jackie's case, I modified this look, yet many of the outfits followed the angular lines of her body. They accented her height, slimness, and youth, and the simple lines let the rich fabrics shine.

Thanksgiving found the family together in Hyannisport. In mid-December, visits were made to Puerto Rico, Venezuela, and Colombia. In Venezuela, Jackie looked beautiful in a strapless gown of pearlescent creamy white

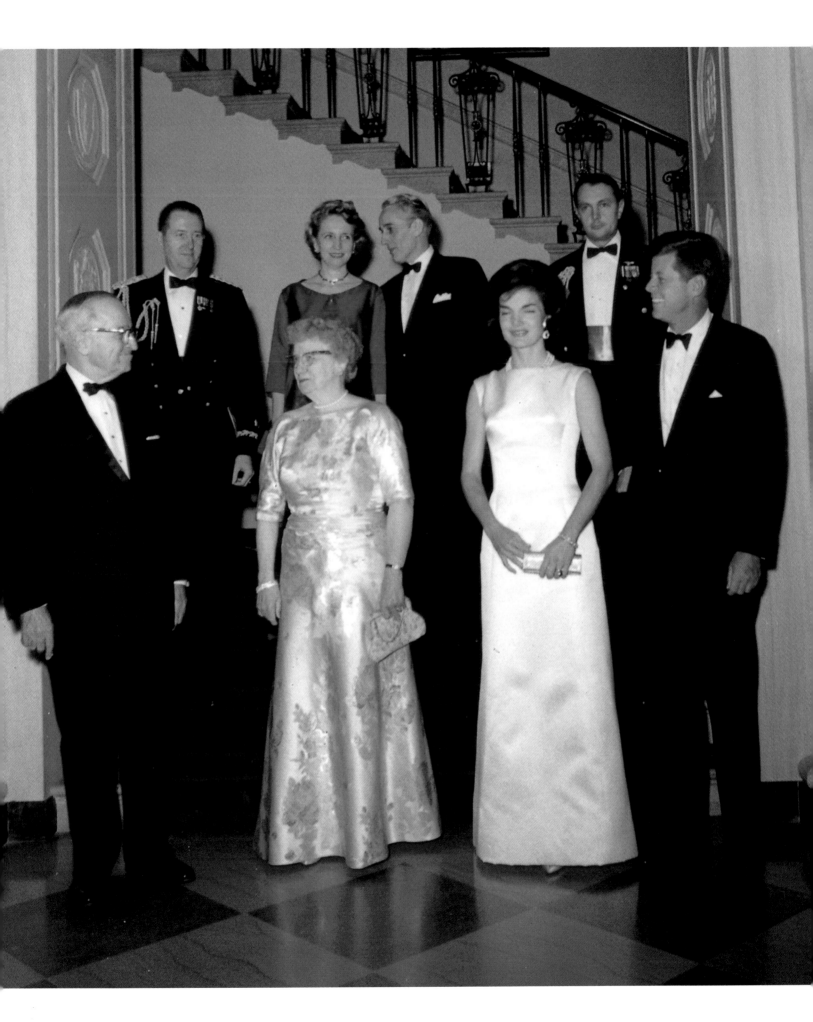

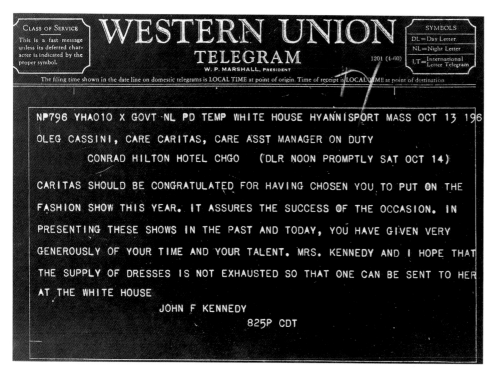

NP796 YHA010 X GOVT·NL PD TEMP WHITE HOUSE HYANNISPORT MASS OCT 13 196

OLEG CASSINI, CARE CARITAS, CARE ASST MANAGER ON DUTY
 CONRAD HILTON HOTEL CHGO ('DLR NOON PROMPTLY SAT OCT 14)

CARITAS SHOULD BE CONGRATULATED FOR HAVING CHOSEN YOU TO PUT ON THE
FASHION SHOW THIS YEAR. IT ASSURES THE SUCCESS OF THE OCCASION. IN
PRESENTING THESE SHOWS IN THE PAST AND TODAY, YOU HAVE GIVEN VERY
GENEROUSLY OF YOUR TIME AND YOUR TALENT. MRS. KENNEDY AND I HOPE THAT
THE SUPPLY OF DRESSES IS NOT EXHAUSTED SO THAT ONE CAN BE SENT TO HER
AT THE WHITE HOUSE
 JOHN F KENNEDY
 825P CDT

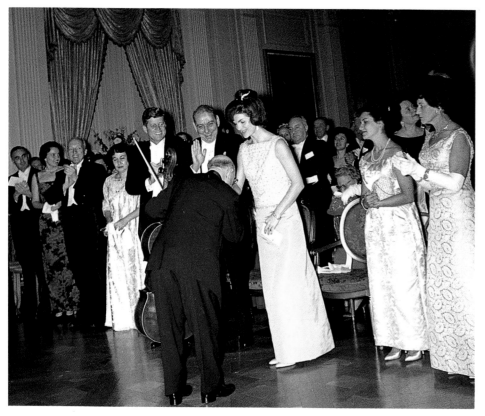

sheer silk gazar, trimmed in satin. The gown was inspired by a sari, and it was created for Jackie's forthcoming trip to India and Pakistan, which had been postponed from fall of 1961 to March of 1962.

For her first Christmas in the White House, Jackie had dreamed up a very unusual Christmas tree that was inspired by the Nutcracker Suite ballet.

Traditionally, the Kennedys spent part of the Christmas holidays in Palm Beach, and 1961 was no exception. When the President was in Palm Beach, I would play golf with him. His father and my brother made up the foursome, but in December 1961 Ambassador Kennedy suffered a stroke from which he never fully recovered.

The President and Jackie often stayed at the home of Colonel C. Michael Paul. The Wrightsmans would also turn over their classic Palm Beach mansion to the Kennedys so the President could restore his strength. C.B. had always been a solid Republican, more to the right in his politics than Louis XIV, but after Kennedy became president, C.B. and Jayne adapted to the "New Frontier" and they became good friends.

There were many festivities that year. The Wrightsmans' New Year's Eve party was always the high point of the holiday season. It was not uncommon to see the Duke and Duchess of Windsor, the British ambassador, plus the French ambassador, Hervé Alphand, and his wife, Nicole, at the Wrightsmans'. The champagne was

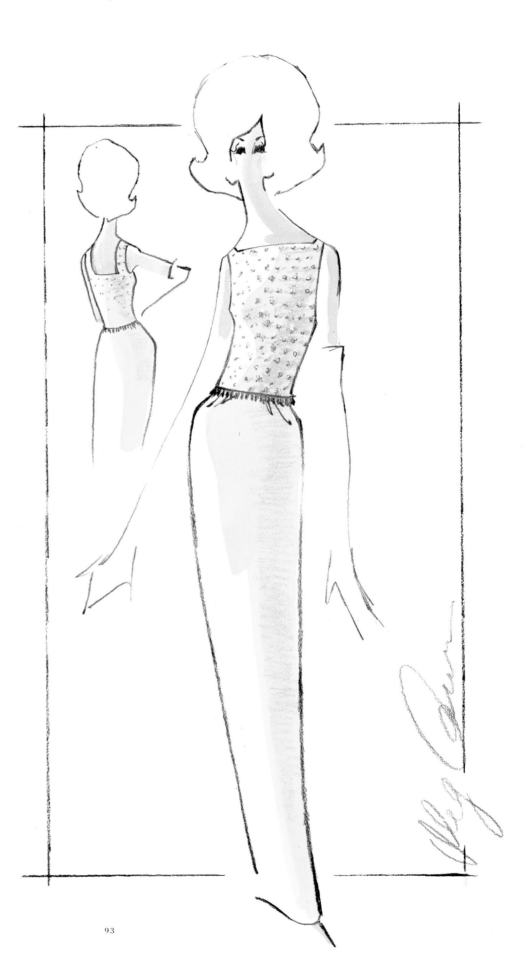

ABOVE:
A few of the
invitations and
passes to the White
House.

LEFT:
The governor of
Puerto Rico and his
wife were the guests
of honor at a state
dinner. Pablo Casals
provided the evening's
entertainment.

RIGHT:
The gown Jackie
wore at the dinner
was a pale Venetian
yellow with a bodice
of gold embroidery
on silk crepe de
chine. Sleeveless, it
had a rectangular
neck and a deeply
cut back. The bodice
fell almost to hip
length and was
trimmed with golden
fringe. The skirt,
softly gathered at the
waist, fell to the floor
in a narrowed
sheath, widening
slightly at the hem.

FAR LEFT:
Joe Kennedy escorted
his daughter-in-law to
the funeral of Anthony
Drexel Biddle, a for-
mer ambassador to
Spain, at Arlington
cemetery on November
16.

LEFT:
This two-piece black
wool suit featured a
rounded open cowl
neckline and natural
shoulders. It was
accented by two large
fringed buttons. The
suit was seamed and
shaped to the body and
had a straight skirt.

Krug '29, the food was impeccable, the music was by the renowned Lester Lanin, and the house was absolutely beautiful, with seventeenth-century parquet floors, marble fireplaces, and exquisite period furniture. The contents of the Wrightsmans' living room later became the core of the Metropolitan Museum's collection of French decorative arts.

However, the Wrightsmans canceled their annual fete after the party in 1961, which was particularly boisterous. A touch football game in the living room involving Bobby and Teddy Kennedy, Steve Smith, and Peter Lawford wreaked havoc with the Savonnerie. Glasses were overturned and broken in the scrimmage, and a rare signed pair of antique chairs was demolished.

The football players were not the only ones who had a good time. The polo-playing millionaire Stephen "Laddie" Sanford almost drowned in the reflecting pool, only 35 inches deep, which faced the living room. He was res-cued, along with a goldfish that was stuck in his pocket.

As First Lady, Jackie felt she was doing something worthwhile. In the beginning, she had seen her role as making the President comfortable, tak-ing his mind off issues of the day, and allowing him to relax. She made their home a haven and a refuge so that he could see his family as much as possible. She said, "I want to take such good care of my husband that whatever he is doing, he can do it better, because he has me."

But in her own way, even though

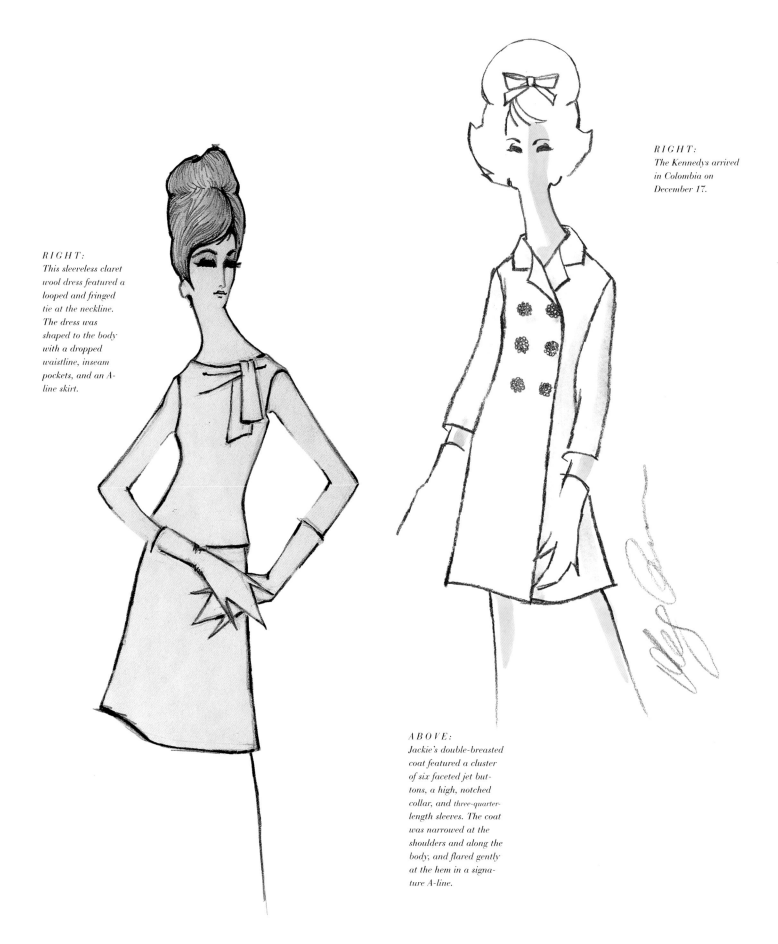

RIGHT:
This sleeveless claret wool dress featured a looped and fringed tie at the neckline. The dress was shaped to the body with a dropped waistline, inseam pockets, and an A-line skirt.

RIGHT:
The Kennedys arrived in Colombia on December 17.

ABOVE:
Jackie's double-breasted coat featured a cluster of six faceted jet buttons, a high, notched collar, and three-quarter-length sleeves. The coat was narrowed at the shoulders and along the body, and flared gently at the hem in a signature A-line.

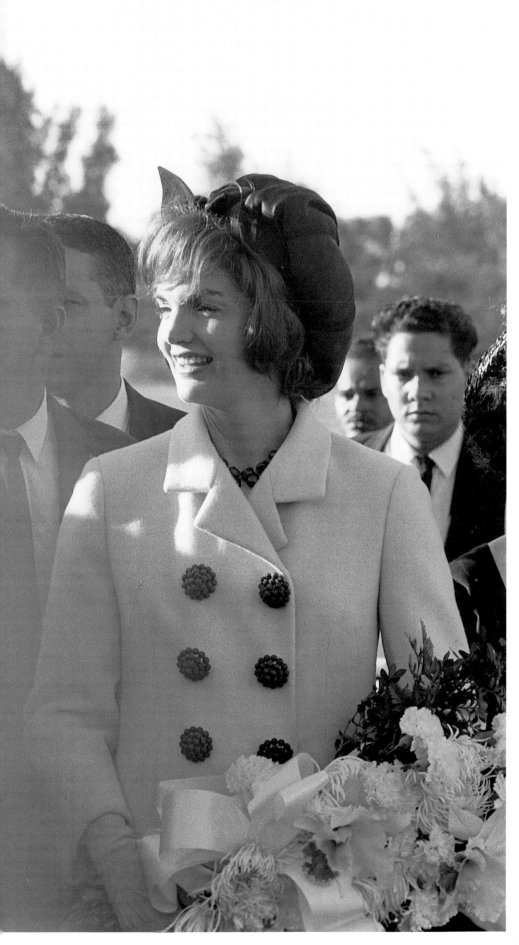

Jackie disliked politics, she found her
own world within the world of politics.
She had a chance to demonstrate her
gifts and abilities, and when the
President saw this new side to his wife it
affected him too, and he fell in love with
her all over again.

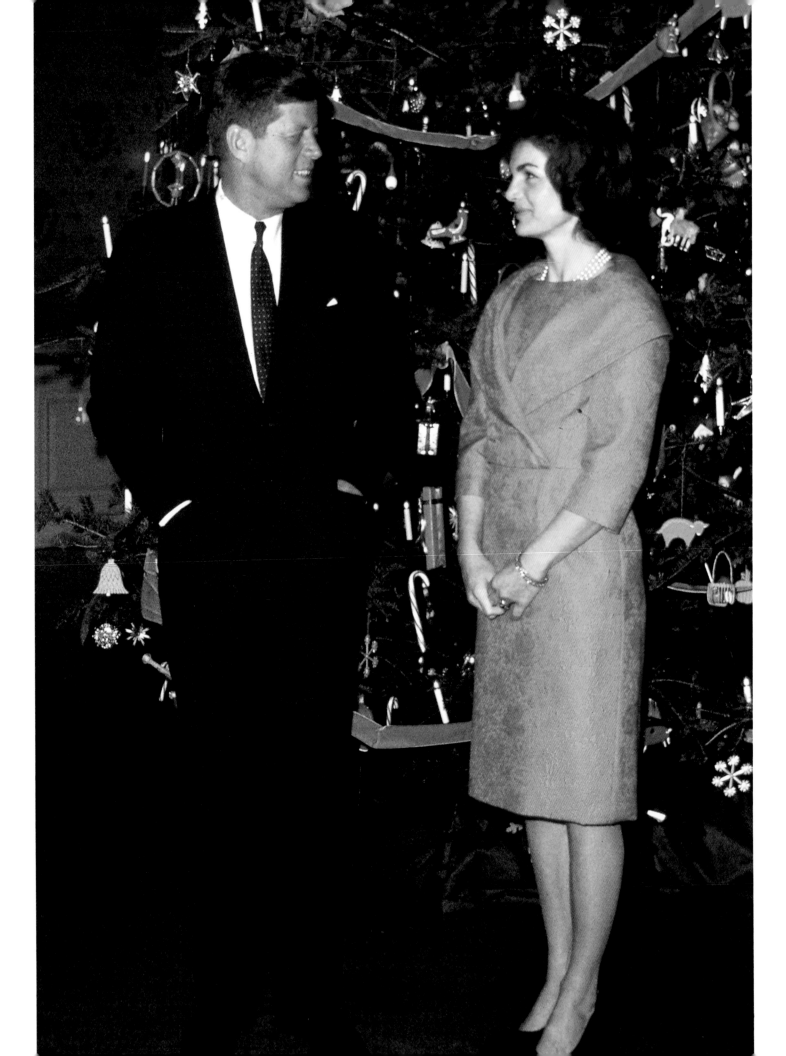

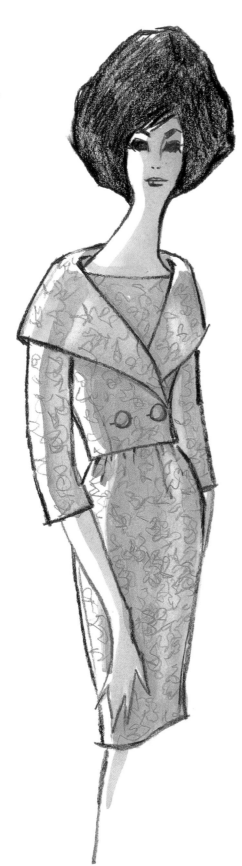

FAR LEFT:
Jackie and the President in front of the White House Christmas tree. Its decorations, inspired by The Nutcracker, *included toy soldiers, candy canes, bells, and snowflakes.*

Jackie's Christmas outfit was a claret ensemble of silk brocade. The jacket featured a large shawl collar crossing in front in a V/and narrowing at the waistline. The fabric-covered button closure revealed the dress beneath, which had a straight geometric neckline. The back of the dress was deeply cut.

1962

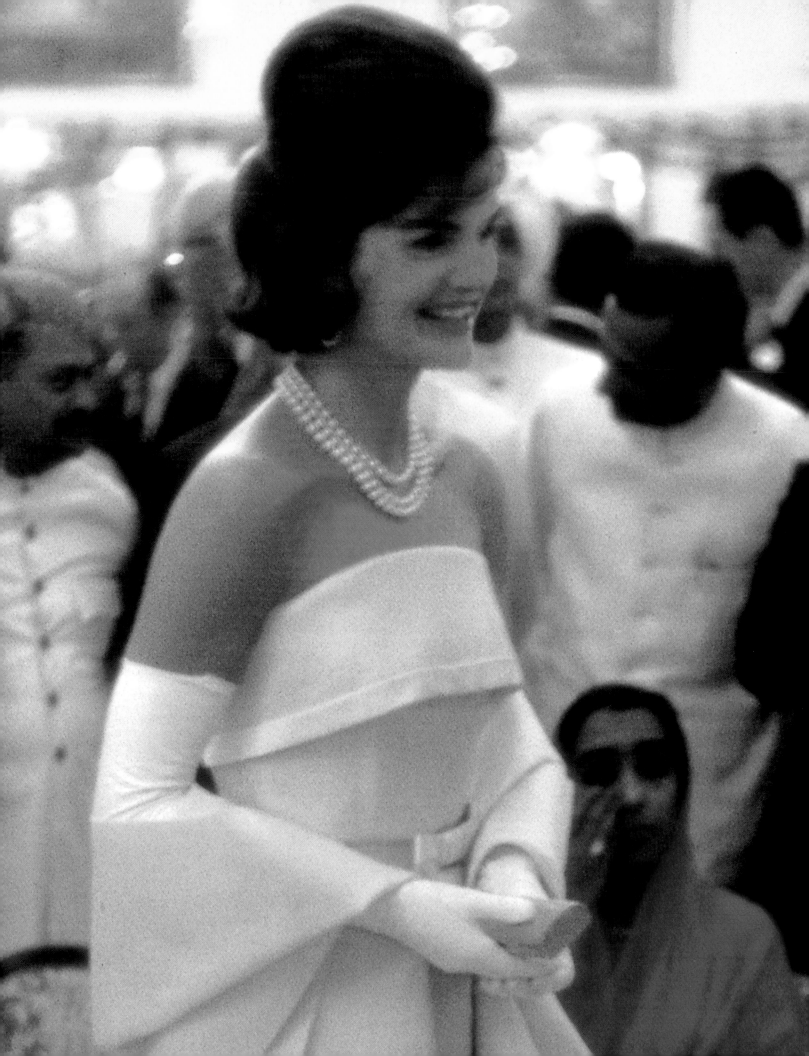

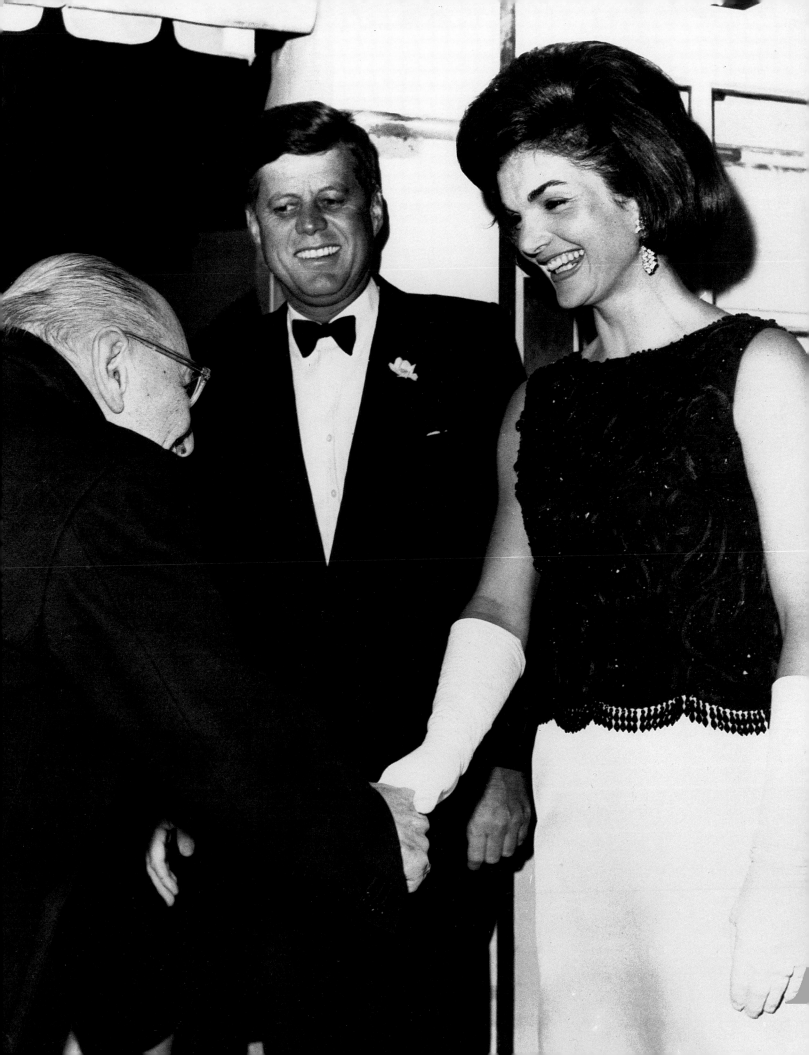

*PRECEDING
PAGE:*
*During her trip to
India and Pakistan,
Jackie was honored at
a state banquet.*

LEFT:
*For the dinner honoring
the conductor Igor
Stravinsky, Jackie wore
a full-length evening
suit of white* peau
d'ange *with a smooth
cardigan jacket and
floor length skirt. Under
the jacket, for accent, she
wore a sheer black silk
chiffon camisole embroi-
dered with jet beading,
which also trimmed the
scalloped hem.*

BELOW RIGHT:
*Arriving for dinner, the
Kennedys are greeted
by the US Navy Band.*

The frenzied reporting on Jackie's clothes in the national media continued through the beginning of the new year. Jackie was rapidly becoming a worldwide obsession. *Newsweek* had a cover story about Jackie its first issue of 1962. It said that "Jacqueline Kennedy has made more changes in the White House than any woman in its 143 years. This alone entitles her to at least a footnote in history. Her style and influence could easily give her some highly readable paragraphs in the main text of history."

During the first two years of the Kennedy administration, the President met with 74 foreign leaders. Almost every one of them was entertained at the White House. The official receptions became more relaxed under the Kennedy administration, with the President and First Lady mingling freely with the guests. In the great tradition of good manners, subtlety, and good taste, Jackie was always friendly and interested in the

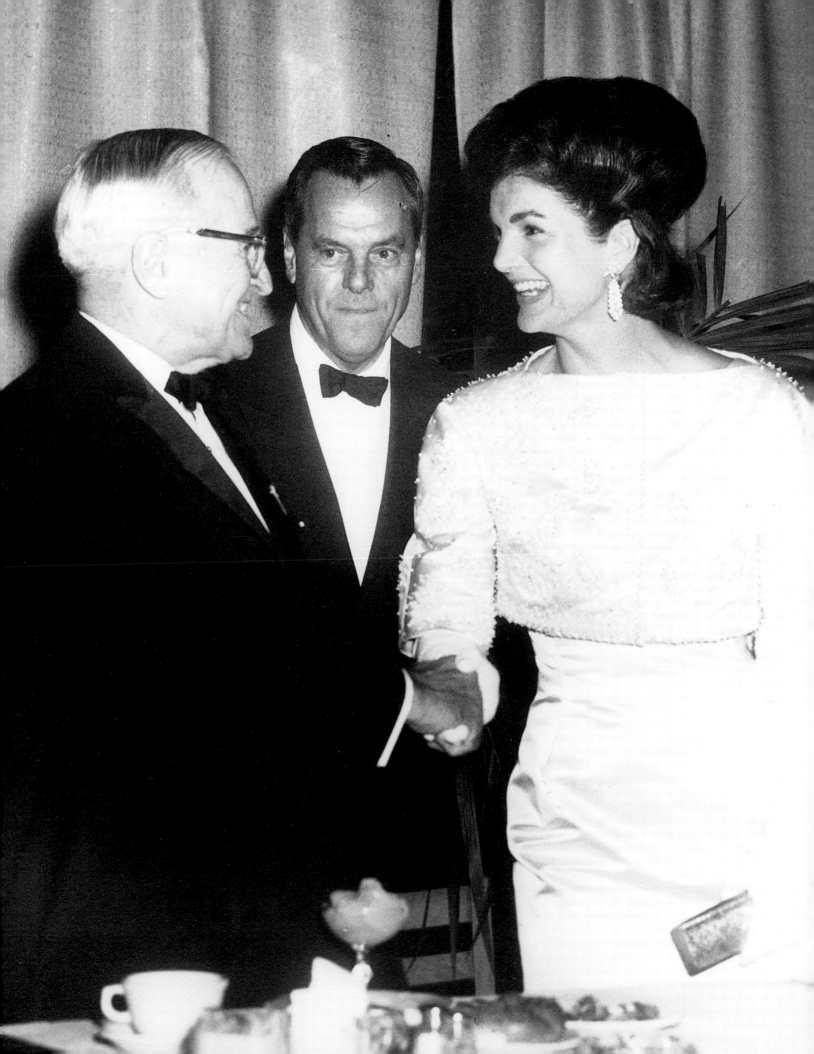

people she was to meet. She took pains to know the likes and dislikes of her guests, and great thought was given to the cuisine, seating, state gifts, and entertainment.

The Kennedy dinner parties at the White House were always fun, with sparkling conversation, wonderful food in the best French tradition of haute cuisine, and excellent wines and champagne. Jackie particularly liked to serve Dom Perignon, but there was always at least one American wine served.

Jackie preferred to seat her guests at round tables of 10 to promote a more relaxed atmosphere and encourage conversation. The tables were often covered with pale yellow fabric and embroidered white organdy overcloths. Vermeil centerpieces were filled with casual flowers such as anemones, freesia, bachelor's buttons, tulips, lily of the valley, or whatever was in season. The flatware was old vermeil and the crystal came from Morgantown, West Virginia. Jackie had a special place in her heart for West Virginia because of its support during the 1960 campaign.

For state dinners, a long table seating 22, at which the President presided, might be set up along with the round tables of 10. Each guest was made to feel special and welcome and a relaxed atmosphere always prevailed.

FAR LEFT:
Jackie greets former President Harry Truman at the first anniversary of JFK's inauguration.

LEFT:
The floor-length sleeveless white satin gown was a look that showed off Jackie's figure. A short beaded bolero of embroidered white satin was worn over the narrowed sheath.

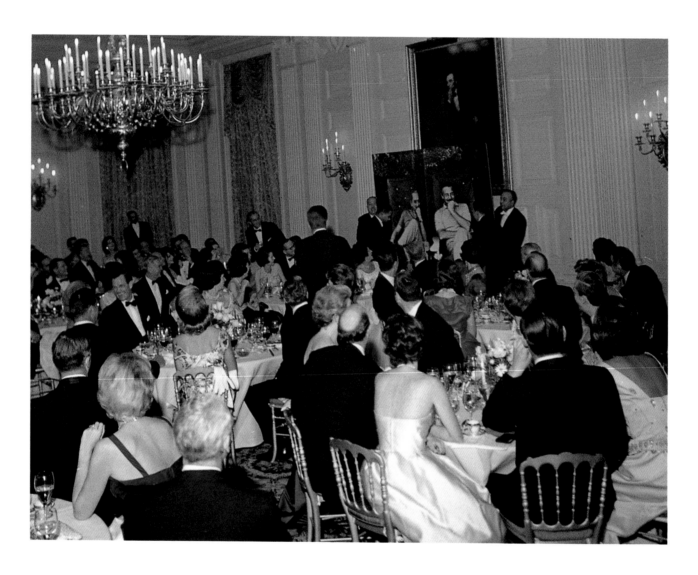

ABOVE:
The President,
standing (center),
laughed when
Franklin Roosevelt,
Jr., thought I was
Prince Radziwill at
a dinner given in
honor of the prince
and his wife, in
spite of having
known me since
1936.

In addition to the many official state dinners, there were also quite a few private dinner parties. At these dinners, I usually sat at the President's table, near him. One that stands out in my mind is the party that was given in honor of Prince and Princess Radziwill. A photo of me and the prince was enlarged and made the centerpiece for the room. The concept was that we were lookalikes.

When Jackie was going to give a party, she often called me and said, "Who would be interesting to invite?" I suggested people from California that she didn't know—writers and actors—and Europeans, like Gianni Agnelli and his wife, Marella; Profirio Rubirosa and his wife, Odile; Count Volpi; Jacqueline de Ribes; and others.

The private parties were very relaxed and fun. You would arrive around 8:00 p.m. and go to the Oval Room, which had been exquisitely restored and refurnished in eighteenth-century Louis XVI style by the noted decorator Mrs. Henry Parrish. It was a large, beautifully proportioned room, painted a pale yellow color with crisp white moldings and luscious yellow silk draperies. The furniture was covered in silks of yellow, brown, and raspberry moiré, and important art graced the walls. It was the best drawing room, and Jackie's favorite.

The President would be relaxing by the fireplace or greeting people. Often he would have a daiquiri. After a drink and some stimulating conversation, dinner would be served in the President's dining room, which had been a sitting room but had been remodeled into a beautiful American Federal-style room. After dinner, there would be coffee and cigars in the Treaty Room. And frequently, a film would be shown in the White House screening room.

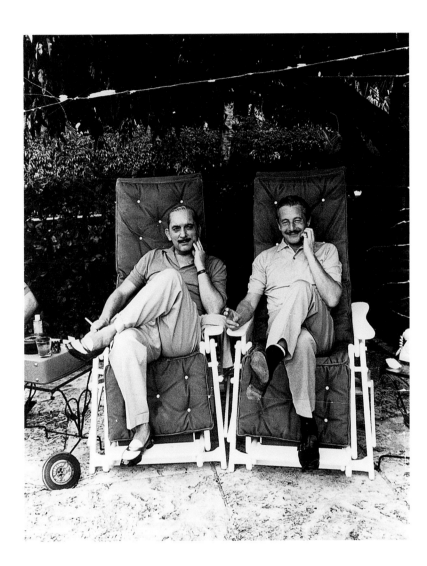

This photo of me (right) with Prince Radziwill (left) was blown up to life size for a private party at the White House. The dinner was held in honor of the prince, who never made it to the party because his transatlantic flight was delayed by bad weather.

One of the many interests that Jackie and I shared was a passion for horses. Jackie liked to hear about my Army days in the U.S. Cavalry at Fort Riley, Kansas, where I trained horses.

Jackie had one great look of her own that I didn't try to interfere with—the "equestrian" look. There was no need to because she had the best of everything—good boots, good pink coats—not tailored by me, but by a British tailor specializing in hunting clothes. She looked great in those clothes, and she always looked good on a horse—she had both the silhouette and the carriage.

Early that year, my favorite horse, Galway Ghost, died of a heart attack. In January, Jackie wrote me this note from the White House:

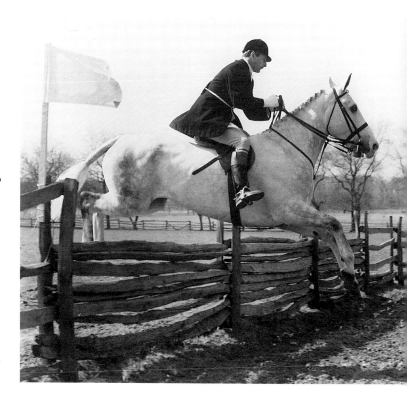

ABOVE:
I am riding my horse Galway Ghost, who subsequently died of a heart attack while jumping a fence.

JANUARY 25, 1962
Dear Oleg,
Your clothes are all lovely—really perfect—all those pretty coats and dresses and the best of all was the white satin evening dress with panel I wore last Sat.

Also, I have a lovely idea for an evening dress sometime. You must see Les Dernière Années à Marienbad—all chanelish chiffons. I saw a picture of Bardot in one—in Match or Elle—in black, but mine could be red—covered up long sleeves—transparent.

That and a drapey dress like jersey would be fun for a change. I'm sorry about Galway Ghost and glad that you weren't riding him then!

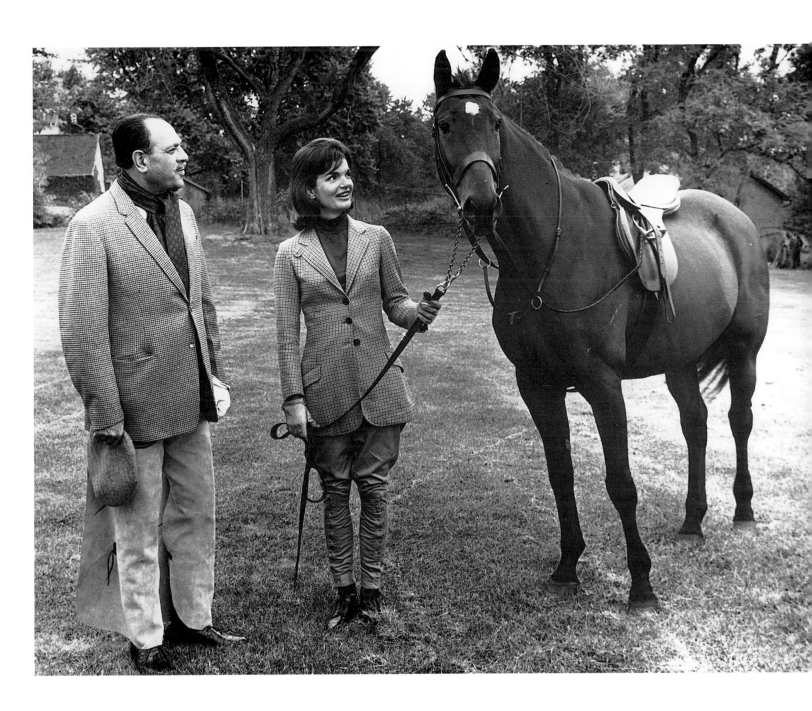

ABOVE:
Jackie with Pakistani President Khan and his horse,
Sardar. Impressed by her riding skills, he was to give her
the horse during her visit to Pakistan in March.

For her guided tour of the White House, Jackie wore a claret wool dress in a trompe l'oeil design that gave the effect of a two-piece dress. The rounded cowl neckline was one I frequently used for her and was a signature, along with the rounded shoulders and A-line skirt. Three large buttons, another signature, added accent.

LEFT:

Jackie's guided tour of the newly renovated White House charmed millions of television viewers. Her ongoing commitment to making the White House a showplace for American decorative arts was an inspiration to the nation. Jackie wanted only the best for the home of America's president, and with the help of many generous contributions she was able to realize her dream.

On Valentine's Day, Jackie's nationally televised tour of the White House aired on CBS. It was one of the most watched TV programs of the 1960s. More than fifty million Americans tuned in to see how Jackie had restored the White House into a mansion of great beauty, with historically correct period furniture, important paintings, and artifacts, many of which had been donated by wealthy patrons. The tour idea had grown out of the exclusive interview Jackie had given to *Life* the previous September. In her distinctive voice, Jackie expounded on the building's history, its inhabitants, and the furniture that had belonged to former presidents and first families. She had written the script, and spoke from memory directly to the viewers. Jackie said that she felt the most affinity for Jefferson, but Lincoln was the president she most loved.

The Red Room, the Blue Room, the Green Room, all came alive to the audience as Jackie took them on a tour of her home. She was so young and pretty, and so dedicated to the cause that she completely captured the hearts of the American people. The program was a great success, and the public loved the aura of grandeur, elegance, and wealth that surrounded the First Family. The Kennedys had become American royalty.

ABOVE:
For her special audience
with Pope John XXIII on
March 11, Jackie wore a
black dress that was in
keeping with Church
protocol, which meant it
had to be full length
with full-length sleeves.
She also wore a lace
mantilla and hair comb
that had been borrowed
from her sister-in-law
Ethel Kennedy.

FAR RIGHT:
Jackie is greeted by
President Giovanni
Gronchi of Italy at the
Quirinale Palace as one
of the Corazziere guards
salutes. At the reception
held in her honor on
March 13, Jackie wore
a black two-piece dress
with a modified cowl
neckline, front button
closure, and a leather
belt at the waistline.
The pillbox hat sat back
on her head.

Jackie's first international trip without the President was scheduled for early March.

We always had fun planning these trips together. She would say, "What do you think, Oleg? There will be a lot of sun, a lot of light—what colors do you think I should wear?" For the trip to India, I said, "A lot of white and brilliant color—pink, blue, green—not subdued."

We also discussed her trip to Rome. "I'm going to visit the Pope," she said. "It has to be a significant appearance and convey the importance of the event." I created a full-length black silk dress especially for the occasion, in keeping with the required protocol.

On Thursday, March 8, Jackie and her sister, Lee, began their voyage. For this trip I designed not only Jackie's wardrobe but Lee's as well. They would travel 16,000 miles in 21 days, taking 64 pieces of luggage and 24 security guards. They stopped in Rome first for a meeting with President Gronchi of Italy and a private audience with Pope John XXIII.

Jackie brought a special gift to the Pope—a velvet-lined vermeil letter case —and was graciously received by him. They spoke for 32 minutes, mostly in French—the longest private audience he had ever granted. Later Jackie said that the pope had "centuries of kindness in his eyes." Meanwhile, in St. Peter's Square, 15,000 Italians jammed together, hoping to catch a glimpse of her.

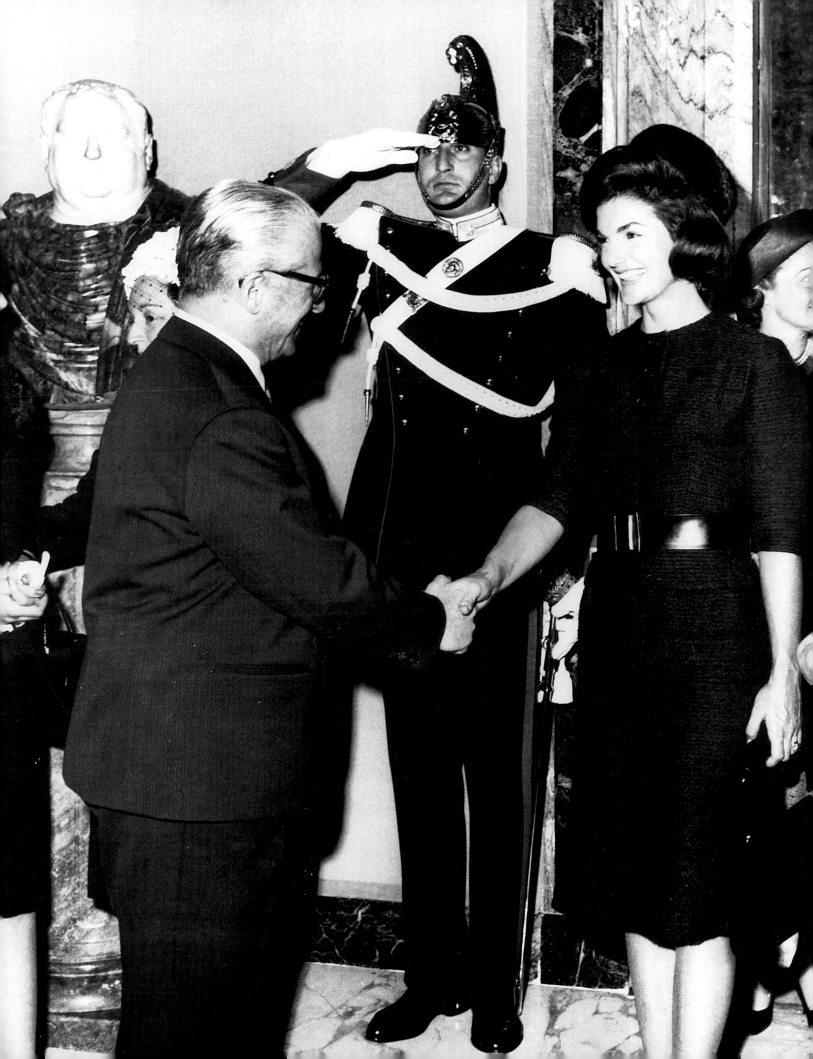

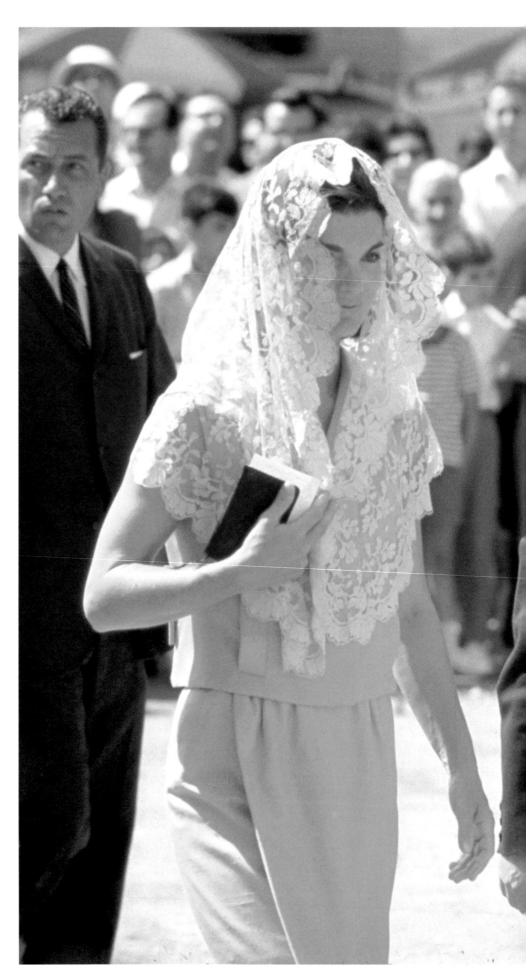

LEFT:
Jackie briefly toured
Rome before departing
for India and Pakistan.

RIGHT:
When she returned
from her trip to Italy,
she sent me this photo-
graph of herself with
Monsignor Martin
O'Connor, the rector of
the North American
College in Rome.

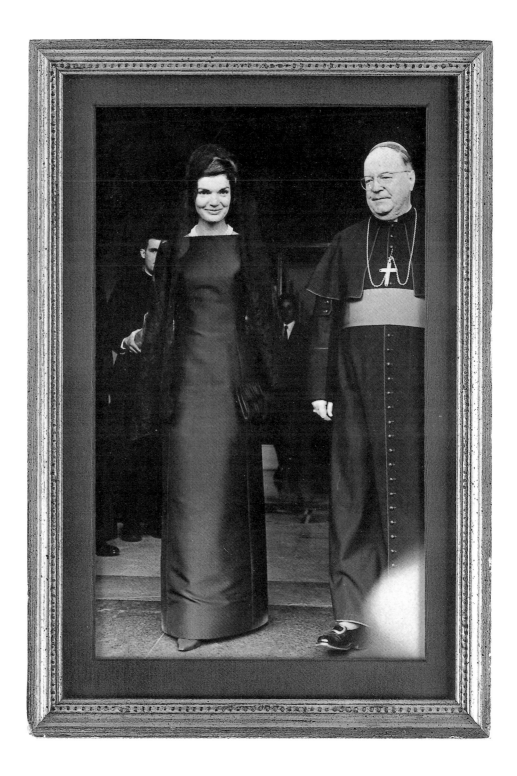

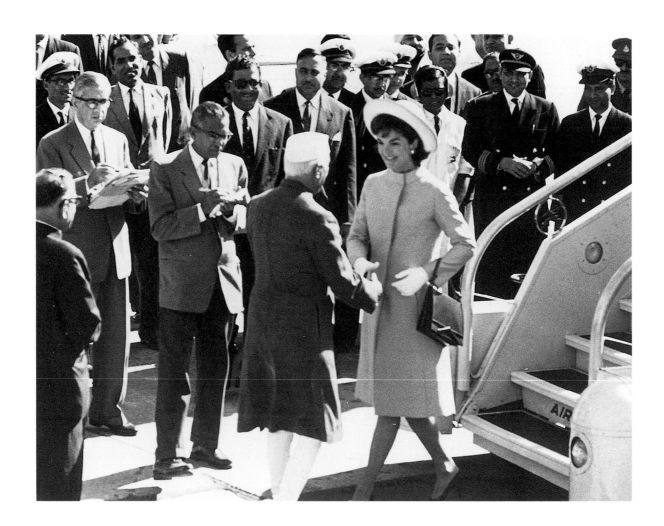

ABOVE:
Jackie is greeted by
Prime Minister Nehru
upon her arrival in
New Delhi.

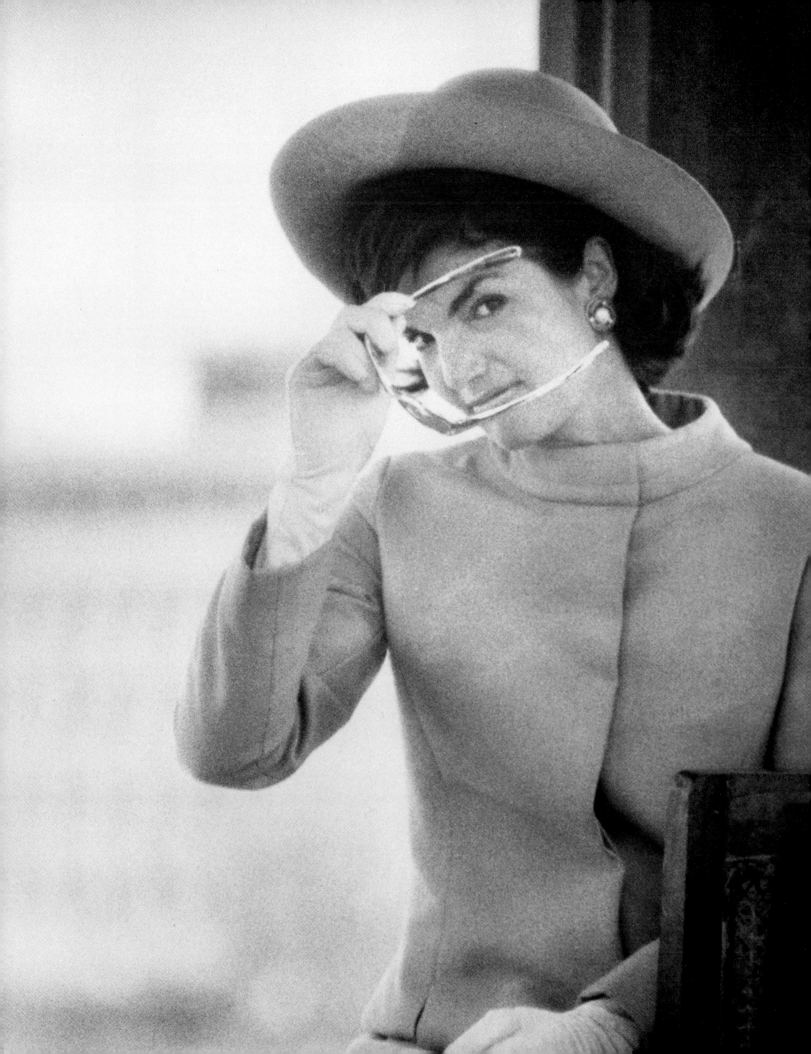

And then it was on to India. The trip to India and Pakistan had been suggested by John Kenneth Galbraith, the U. S. ambassador to India, as a semi-private cultural goodwill visit.

Prime Minister Nehru of India had been in Newport and Washington the previous November, and President Ayub Khan of Pakistan had visited Mount Vernon the previous July, so Jackie had been invited in reciprocation for her hospitality.

For the trip to India, I wanted Jackie to stand out, and we both felt that the visual impact of color was important. She and I had discussed the colors of Moghul miniatures—marvelous pinks, apricot, green, and, importantly, white. These colors would make an impact, and they were also in keeping with the climate and the wonderful vivid beauty of the country. I also took inspiration from traditional Indian dress, in particular the Raja coat, a look I would later introduce to menswear as the "Nehru Suit." I made "princess coats" based on this look, which were much admired. Jackie liked to wear them with Breton-style roller hats.

Ambassador Galbraith was her guide, and gave press briefings twice daily. A three-man film crew documented the trip for the U.S. Information Agency. The footage became a documentary entitled "Jacqueline Kennedy's Asian Tour." Narrated by Jackie, it was released for television audiences worldwide. In addition to the USIA film crew, there were more than 60 journalists and cameramen who covered the expedition for newspapers,

LEFT:
The modified Raja coat I created for Jackie's trip to India was made of dupioni silk and featured a rounded modified military collar.

FAR RIGHT:
Jackie visited Gandhi's memorial with Ambassador Galbraith.

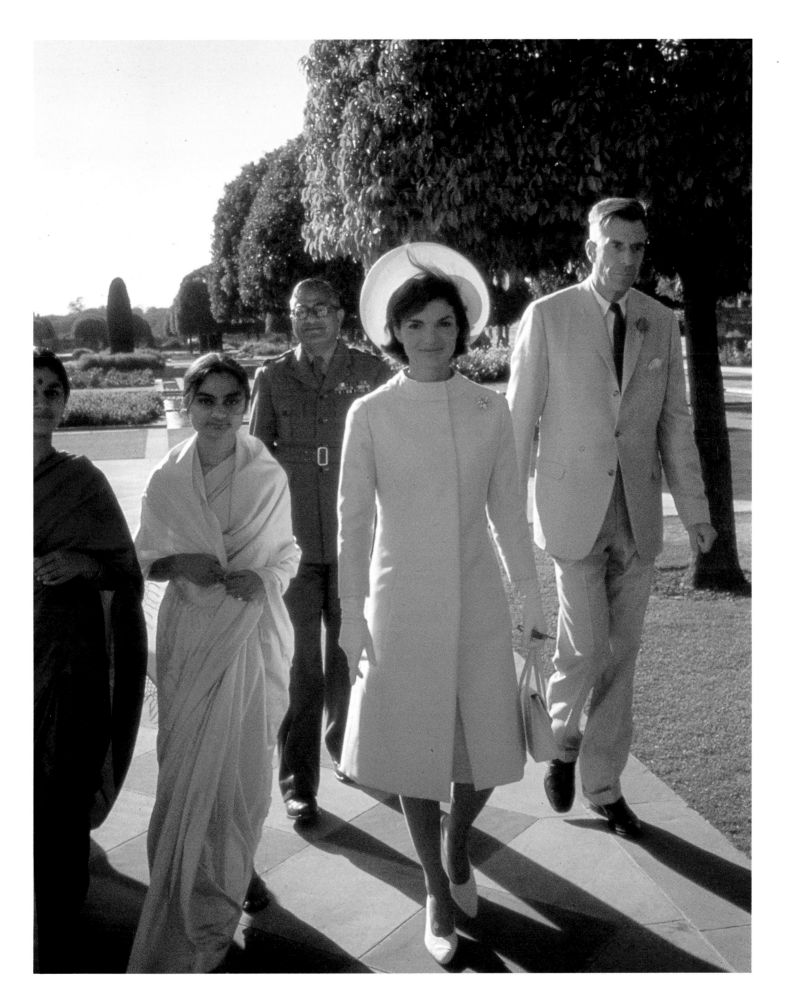

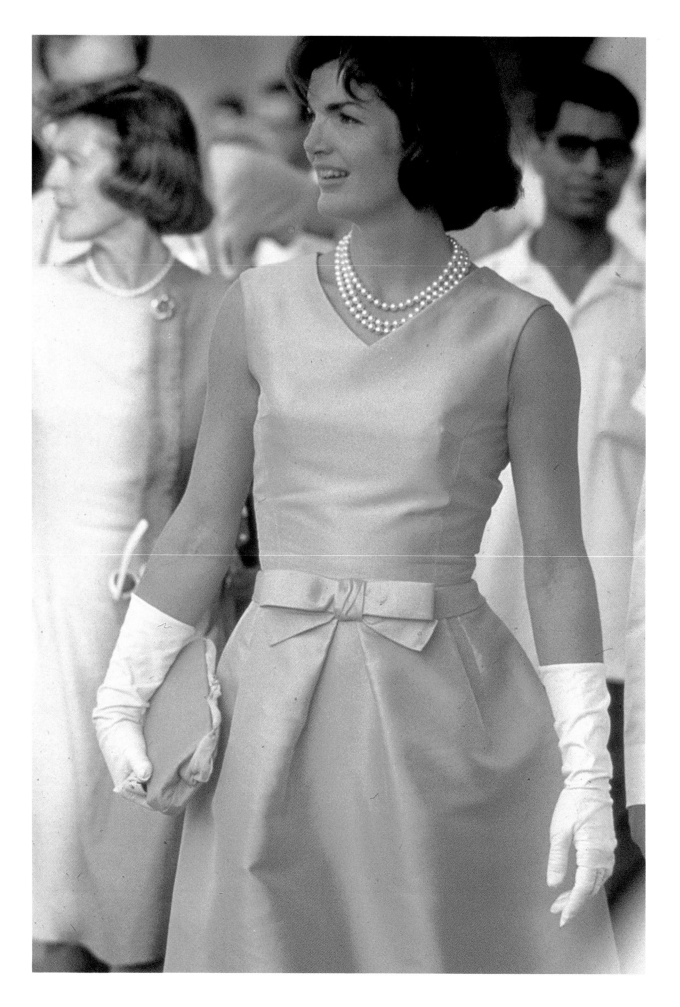

magazines, and television around the world.

Arriving in New Delhi, Jackie was met at the airport by Prime Minister Nehru. Jackie's Raja coat and hat were very effective, and she was greeted warmly by the crowds. She learned the traditional palms-together Hindu greeting, the *namaste*, and when she used it in Udaipur, the crowds started screaming *"Jackie Ki Jai! Ameriki Rani!"* ("Hail Jackie! Queen of America!").

A New Delhi newspaper referred to her as "Durga, Goddess of Power" and the *Times of India* wrote: "Nothing else happened in India while Mrs. Kennedy was here. Her presence completely dominated the Indian scene."

A formal state luncheon was given in Jackie's honor at the Presidential Palace. Jackie was seated to the right of Prime Minister Nehru, and Lee was at his left. Lee and Jackie wore green sheath dresses for the occasion.

Escorted by Ambassador Galbraith, Jackie and Lee visited the Taj Mahal first in the morning, and again that evening by moonlight.

They sailed down the holy Ganges River in a flower-garlanded boat, past pilgrims and water buffaloes. They saw snake charmers, witnessed a fight between a cobra and a mongoose in Nehru's garden, jumped horses with New Delhi mounted guards, visited hospitals, were entertained by tribal sword dancers, and were the guests of honor at numerous state dinners, luncheons, and tented lawn parties. They took a boat trip on beautiful Lake Pichola, and were welcomed at the maharajah of Mewar's palace by crowds shouting *"Zindabad!"* ("long life").

FAR LEFT AND RIGHT: This vivid peach silk sleeveless day dress with a V-neck was shaped to the body with a fabric bow accenting the waistline. The softly pleated skirt ended in a modified A-line. It was accessorized with white gloves and pearls.

Jackie also visited the site where Mahatma Gandhi had been cremated, and she left behind a beautiful bouquet of white roses.

At the airport in Jaipur, Jackie, wearing a pink silk brocade ensemble, was greeted by the governor of Rajasthan. She was given a coconut encased in silver to mark the occasion, and had the Rajasthani mark of luck and respect, the *tika*, placed ceremoniously on her forehead.

In Jaipur, where they were the guests of the Maharajah and Maharani of Jaipur, two days of "vacation" were scheduled at the Pink Palace. Jackie and Lee were photographed riding in an elaborate howdah on the back of a painted and spangled elephant.

After a final banquet in New Delhi, Jackie and Lee flew to Pakistan for another round of festivities and events. In Pakistan, President Ayub Khan hosted a sunset reception at the Shalimar Gardens, built by the same Moghul Emperor who had built the Taj Mahal, Shah Jahan. Ayub Khan was so impressed with Jackie's horsemanship that he gave her a beautiful bay gelding named Sardar.

The voyage to India and Pakistan had been a brilliant success and public relations coup. Jackie was an exceptional goodwill ambassador.

From Pakistan, Jackie and Lee flew to London for a few days of rest and relaxation, which included lunch with the Queen, before Jackie returned to Washington.

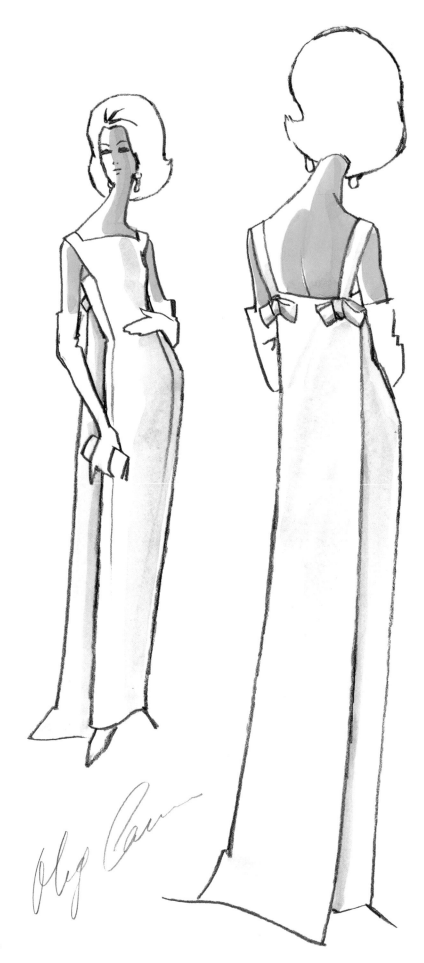

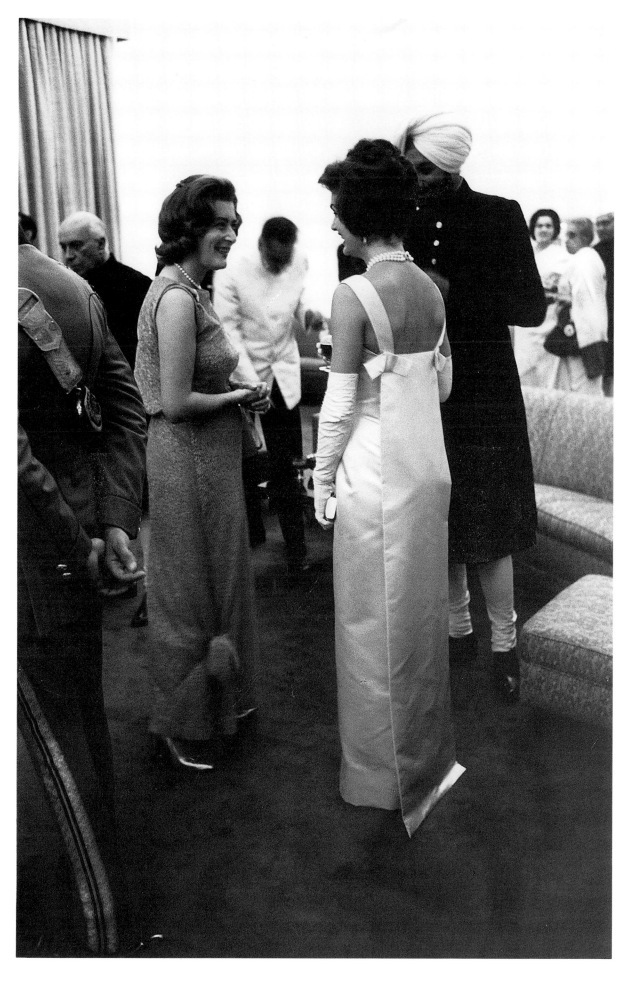

FAR LEFT AND LEFT: *At a formal banquet given by Prime Minister Nehru, where she spoke with Edwina Mountbatten, wife of Lord Mountbatten, Jackie was resplendent in a classic cut sheath done in a pearlescent white silk peau d'ange. The form-fitting floor-length column narrowed to the body and featured a squared neckline. The pinafore back was dramatic, with a sweeping panel forming a train. The wide shoulder straps were accented with bows. Jackie accessorized the gown by wearing her signature long white kid gloves. Jackie loved this dress because it had both function and form. The panel could be moved aside as she was seated. And when she was standing or moving, the panel swept behind her, regal and uncreased.*

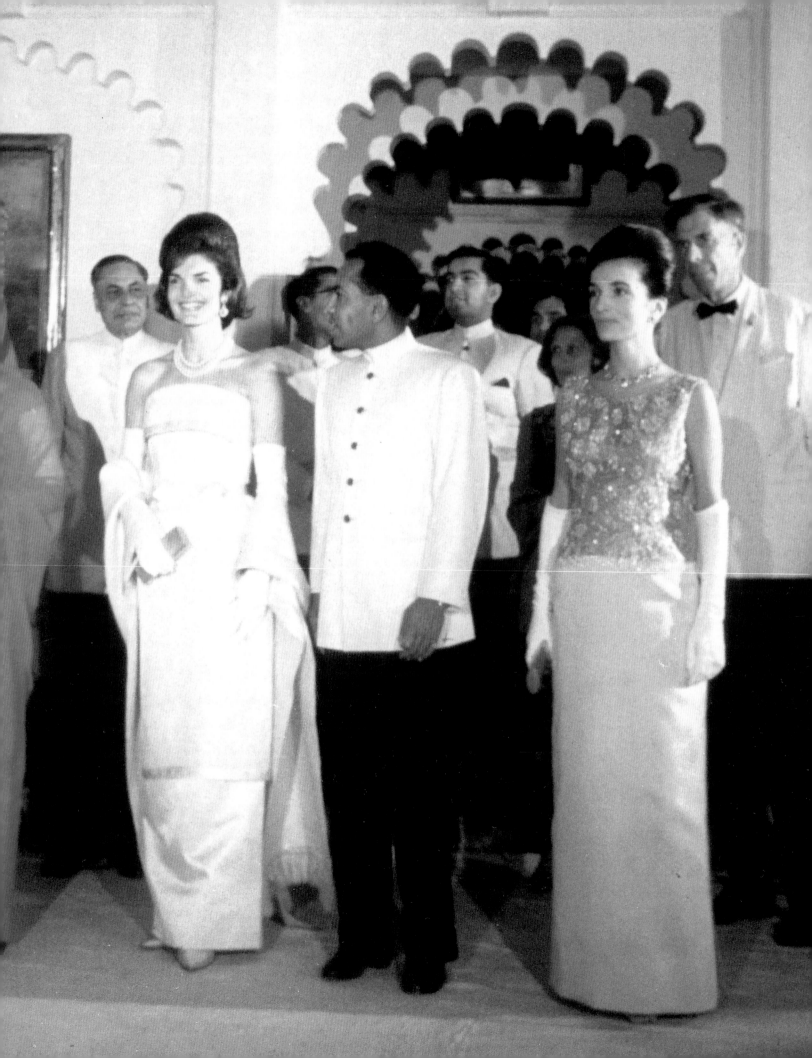

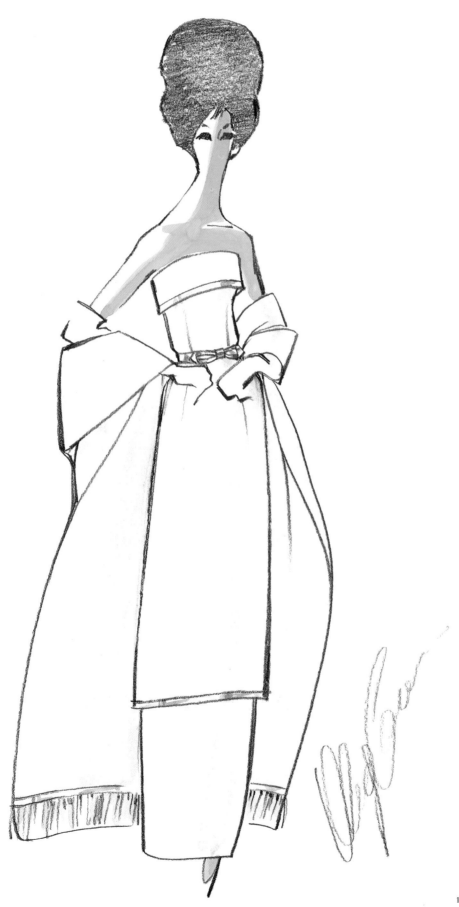

FAR LEFT:
Lee, standing at right, looked delicately beautiful in a full-length gown. Sleeveless, with a bateau neckline, it was heavily beaded and embroidered with brilliants. The gown was fitted at the waist and ended with a skirt of pink peau de soie, *and formed a beautiful contrast with Jackie's dress.*

LEFT:
Jackie looked magical in a strapless gown of creamy pearlescent white silk gazar trimmed in satin. The ultimate in tailored simplicity, the strapless bodice was cuffed and the hem of the cuff was trimmed in a top-stitched ribbon of satin, which was used again at the narrow waistline. A satin belt and ribbon bow at the center added to the look. The narrow underskirt fell to the floor, and the mock-tunic overskirt was hemmed with satin ribbon. Matching the dress was a ten-foot-long double-faced stole with a fringed satin hem.

*Jackie posed in front of
the Taj Mahal in a
sleeveless green printed
sheath with a jewel
neckline. The dress
was accessorized by
white kid gloves and
three strands of pearls.*

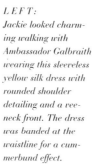

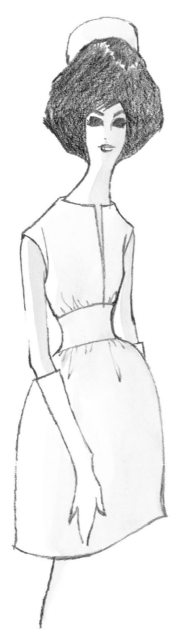

*LEFT:
Jackie looked charm-
ing walking with
Ambassador Galbraith
wearing this sleeveless
yellow silk dress with
rounded shoulder
detailing and a vee-
neck front. The dress
was banded at the
waistline for a cum-
merbund effect.*

*LEFT:
Jackie was photo-
graphed with Nehru
wearing this Veronese
green sleeveless dress
in heavy silk shan-
tung. It had a round-
ed neckline with self-
piping at the waist-
line and shoulders.
The skirt fell to a soft
bell shape.*

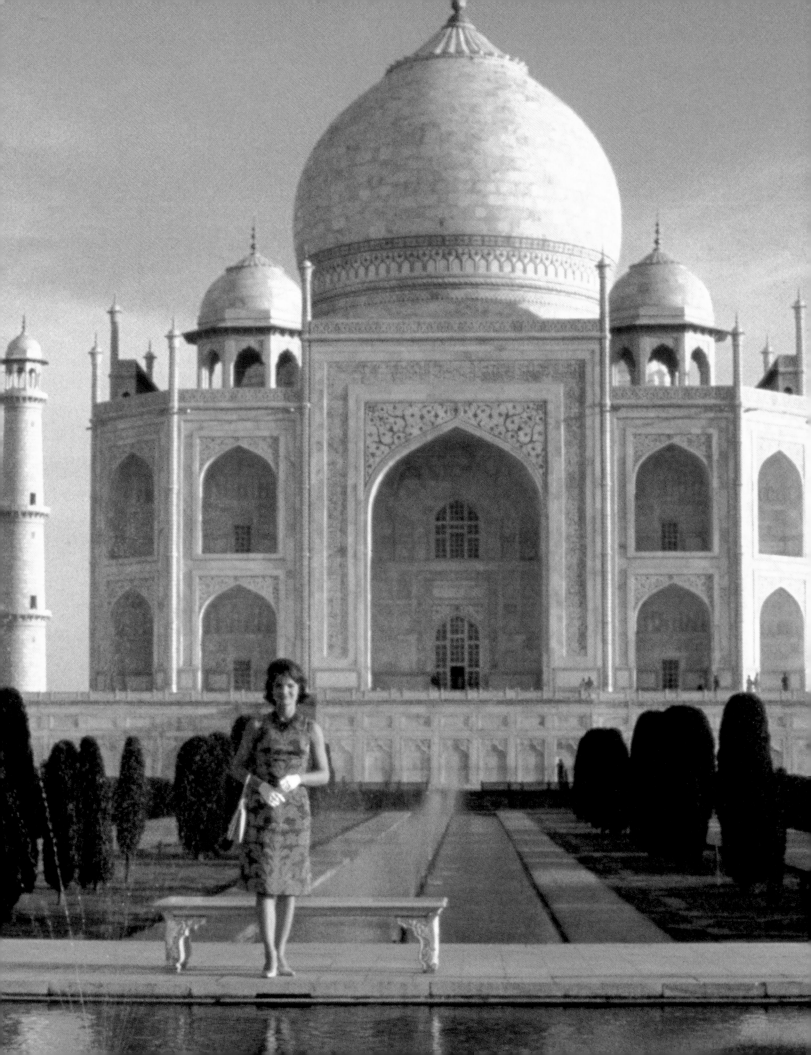

ABOVE AND RIGHT:
Jackie spent an afternoon with President Nehru's daughter, Indira Gandhi.

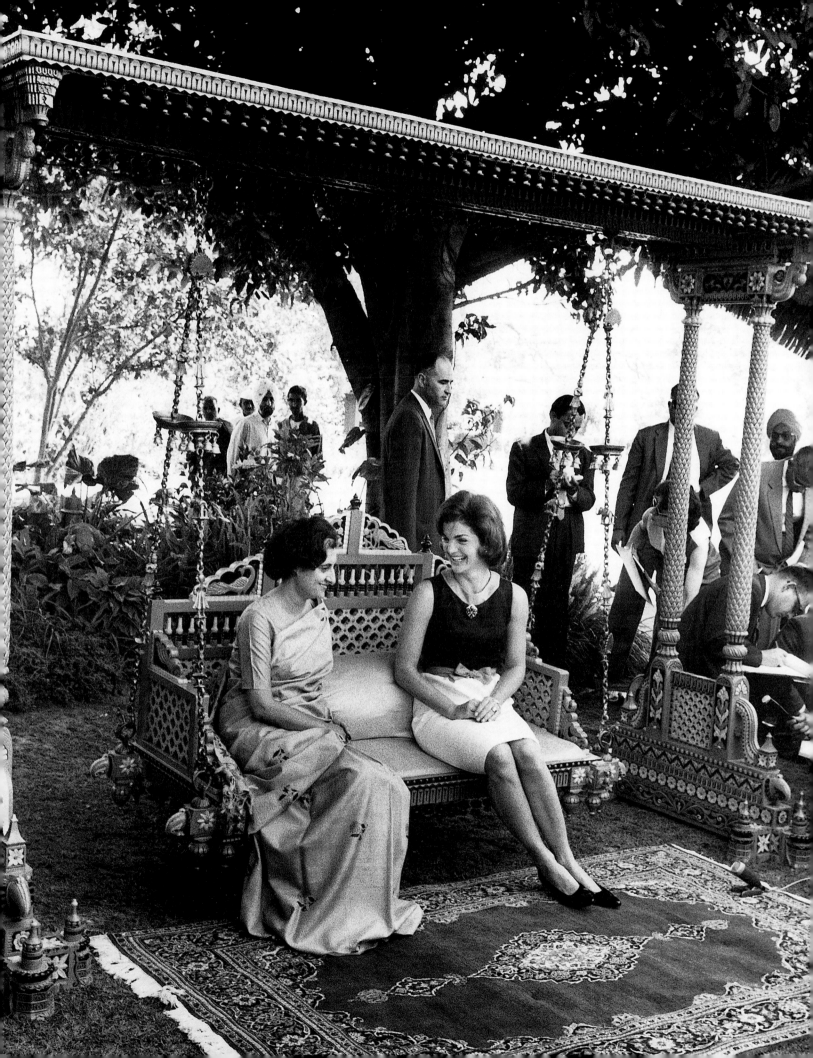

BELOW:
A typical look for Jackie, this dress was created in navy, green, and white. The sleeveless sheath had a navy-blue bodice and white skirt, and was circled at the neck in Veronese green. The same green accented the waistline in a signature bow. The combination of colors created a crisp, fresh look for the hot climate.

RIGHT:
The sleeveless sheath in bright pink brocade silk was worn with Jackie's signature gloves and pearls. The dress had a matching single-breasted coat.

Oleg Cassini

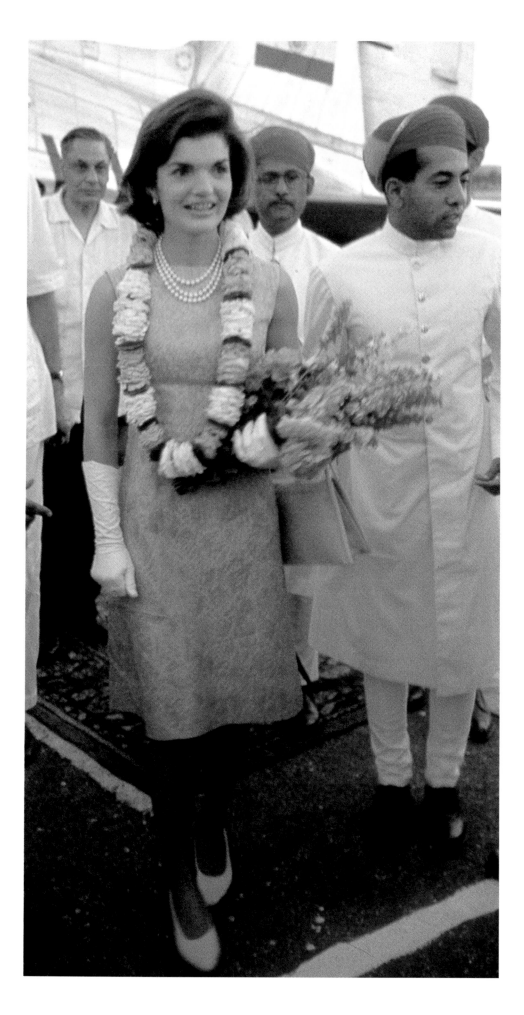

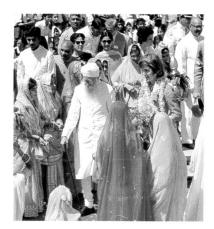

ABOVE:
Surrounded by saris
at the airport in
Rajasthan, Jackie stood
out in a silk brocade
ensemble. The Indian
people called her
"Queen of America."

LEFT:
Jackie was met by
the maharajah of
Mewar when she
arrived at his
palace.

*TOP TO
BOTTOM:
Jackie and Lee attended
the Lahore livestock show,
took a boat ride on the
river Ganges, and spent an
afternoon shopping,
Crowds gathered
everywhere Jackie went.*

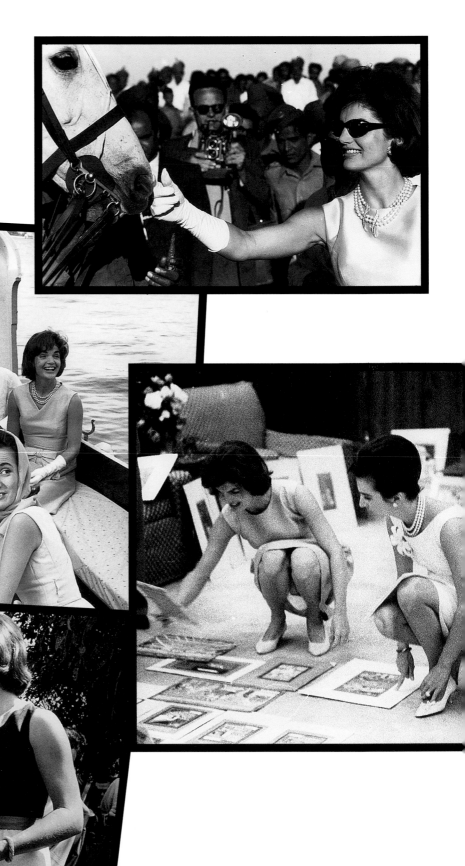

ABOVE:
En route, Jackie took
a moment to fix her
hair.

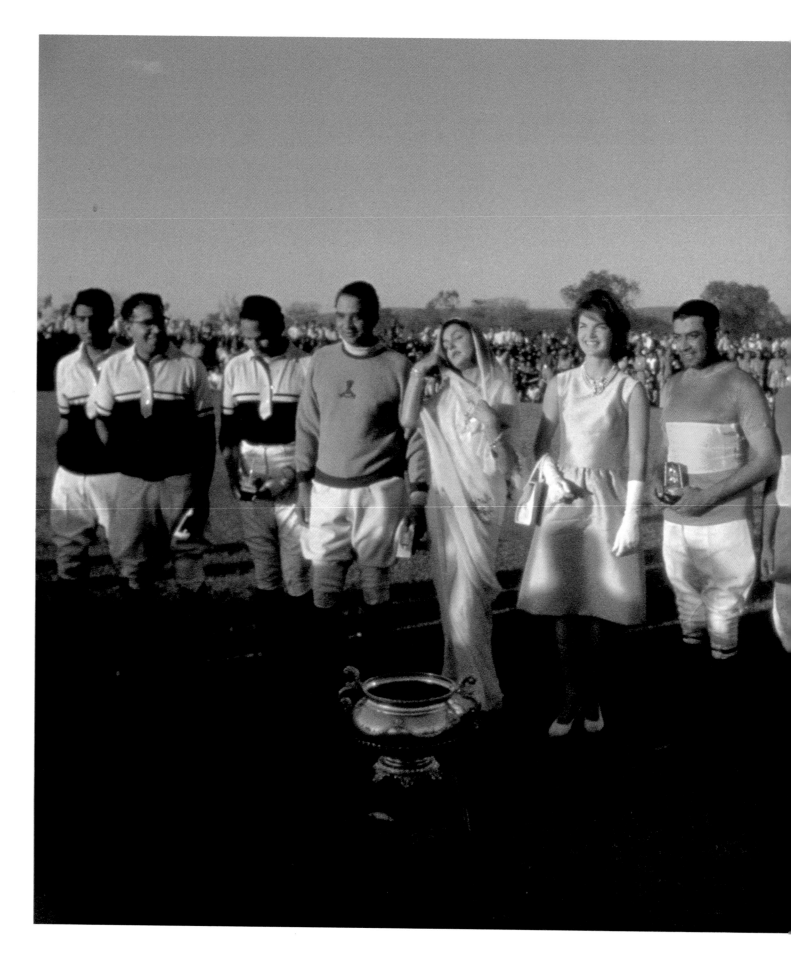

LEFT:
Brightly colored polo
jerseys complement
Jackie's dress of vivid
blue dupioni silk.

ABOVE:
Jackie visited the Pink
Palace in Jaipur with
Lee and Ambassador
Galbraith and later
rode on an elephant.

LEFT:
A quiet moment with
the Majharanee of
Jaipur-Ayasha.

RIGHT:
Riding in India.

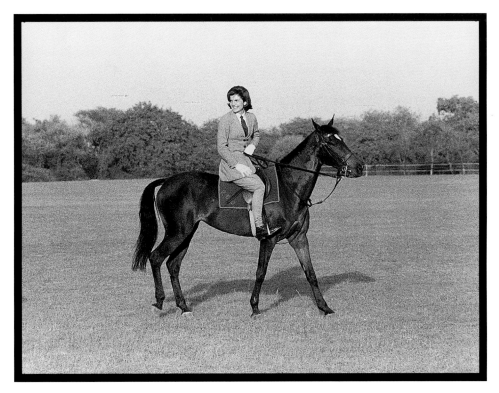

LEFT:
Upon her arrival in
Pakistan, Jackie trav-
eled in an open car
with President Ayub
Khan through the
streets of Karachi
to the cheers of the
thousands who had
lined the streets to
greet her.

ABOVE:
President Khan
escorted Jackie to the
National Horse and
Cattle Show in
Lahore in an open
landau drawn by six
horses.

March 26th 62

PRESIDENT'S HOUSE
KARACHI.

Dear Oly —

We're finally enroute
home in a complete
state of exhaustion, but
theres no doubt the trip
was a TREMENDOUS success
so it was all worthwhile

This is just to tell you
that all your clothes were
an absolute dream and
I was delighted with
them. the white coat is
ESPECIALLY lovely & really

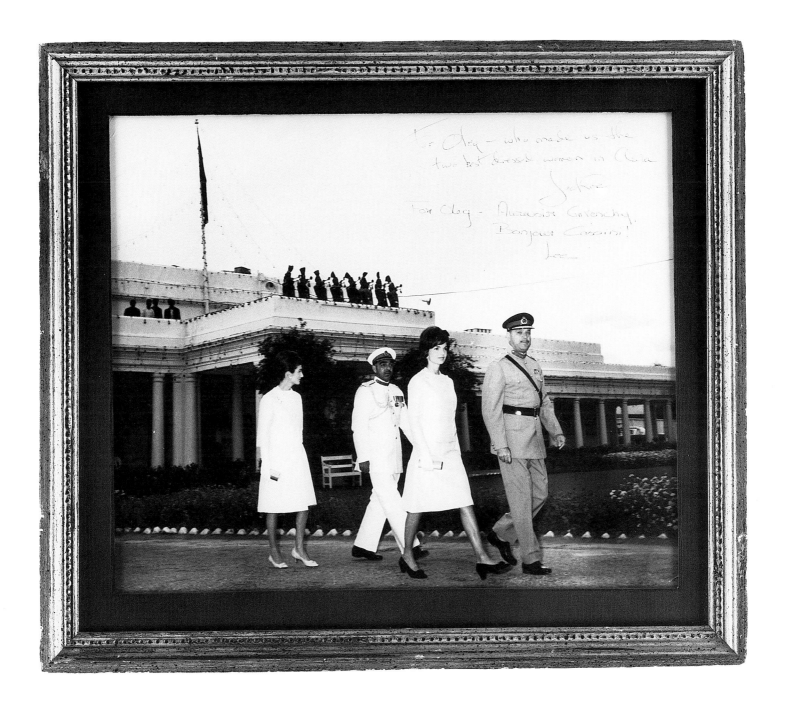

ABOVE: I was delighted when Jackie and Lee sent me this photo, taken in Pakistan, when they returned from their trip. The inscription from Jackie said, "For Oleg—who made us the two best-dressed women in Asia." And Lee's comment was: "Au revoir Givenchy, Bonjour Cassini!" They both wrote lovely letters to me from the President's house in Karachi.

I was in Europe skiing in Sistriere, the ski resort outside of Turin owned by the Agnelli family, when Jackie and Lee invited me to London for an intimate dinner after their return from Pakistan. This was the kind of gathering Jackie preferred—a few close friends in an informal family setting.

The party was at Lee and Stash Radziwill's elegant London *hotel particular*. Moira Shearer, the lovely ballerina and actress who starred in the film *The Red Shoes*, was there. Also attending were Cecil Beaton, Benno Graziani—the photographer of *le tout mondé*, and his wife, Nicole.

Lee was radiantly happy. She looked quite divine and had a particular softness that made her irresistible. When she thanked me again for the clothes I had created for their trip, it really made my evening.

Prince Radziwill, a gentleman of the old school, was full of charm and *joie de vivre*, always fun. He had a lot of style and physically resembled Lee and Jackie's father—the dashing "Black Jack" Bouvier.

After a sumptuous dinner featuring lots of caviar and vodka in the classical Russian/Polish manner, we danced the twist. Benno and I taught "Le Hully Gully," the hot new dance from Paris, to the group.

Jackie loved to dance. She said that when she was an adolescent, she was a tomboy, but she became feminine when she learned to dance. She liked to learn all the latest steps.

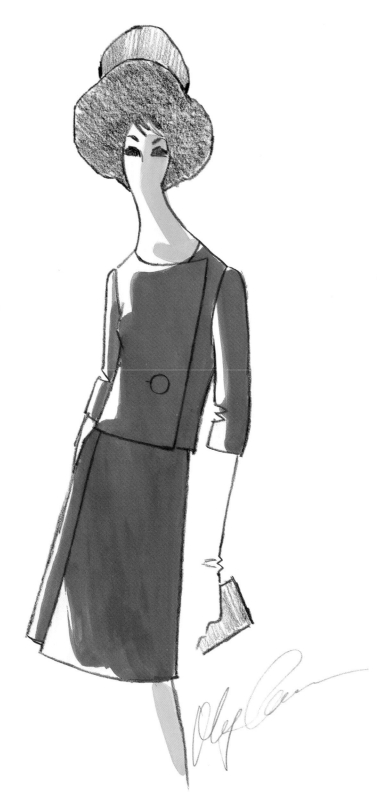

RIGHT:
During her stopover in London, Jackie was invited to lunch by Queen Elizabeth II. On her way there, the crowds of newsmen were held back by British bobbies.

LEFT:
A slim-lined claret wool dress featured a rounded neckline, three-quarter-length sleeves, and a single fabric-covered button. The matching jacket featured an asymmetrical closure.

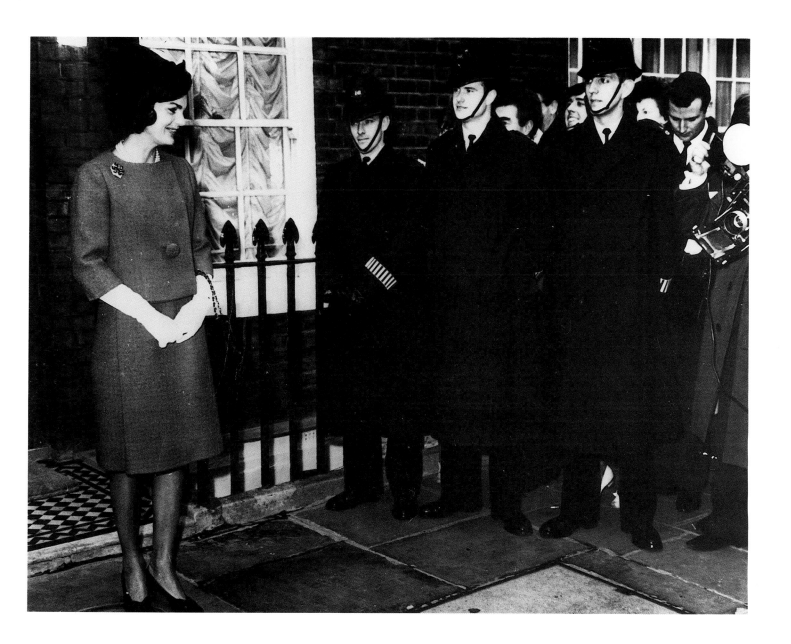

Jackie told us about their magical trip and all their adventures on the subcontinent. She was particularly happy with her new horse Sardar, the gift of Ayub Khan. She confessed to being a little uncomfortable on top of the camel in Pakistan and said she preferred the elephant ride in India.

To recapture the mood of the trip to Pakistan and India (Benno had been on photo assignment for *Paris Match*), we put traditional Indian necklaces around our necks and I wore a makeshift turban and Jackie's jacket. Benno wore a pot on his head while we practiced our dance steps. It was an amusing, elegant party, typical of how Jackie and Lee liked to entertain.

We recreated the evening for President Kennedy in Washington a few weeks later. One night, after a White House dinner for the Indian Ambassador, a small group of us gathered. After arranging myself in a costume consisting of an impromptu turban (a towel), a robe, and a fireplace implement, I did an impression of a quiet evening at home with the great Mughal Emperor Akbar.

Jackie, her sister and Stash, Nicole and Herve Alphand (the French Ambassador), their two lovely nieces, and Benno Graziani were there. Once again, he and I demonstrated the Hully Gully.

These private parties among friends and family were quite different from the formal evenings at the White House. It was a relief for Jackie, after the more formal events, to discuss the evening. She would often ask, "Do you think it

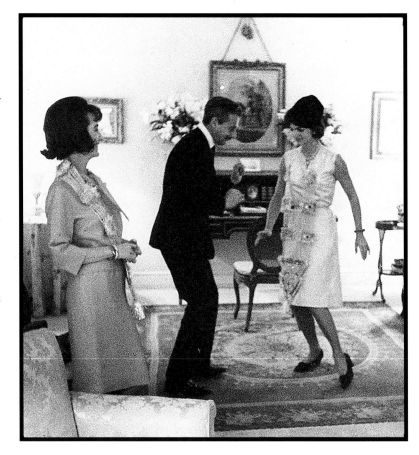

went all right? Was it a success?" She was always the perfectionist. She wanted to know that everything had gone well and she considered me a good judge of the situation. We also had long conversations discussing the various people, how they were dressed—who looked great, who looked silly—and who tried to impress the President.

I would be there with the two of them, just JFK and Jackie, and they could completely relax. They knew that I would not disseminate information. The Kennedys had an inner circle of people, their own "clan," and I was privileged to be adopted into it.

ABOVE:
Jackie and I danced at the party at the Radizwills' London house.

FAR RIGHT:
Later we re-created that evening at the White House. Jackie was wearing a black sheath, cut out at the back and banded with a little bow across the middle of the back— a line that, if it were a little less deep, would have also worked beautifully in front.

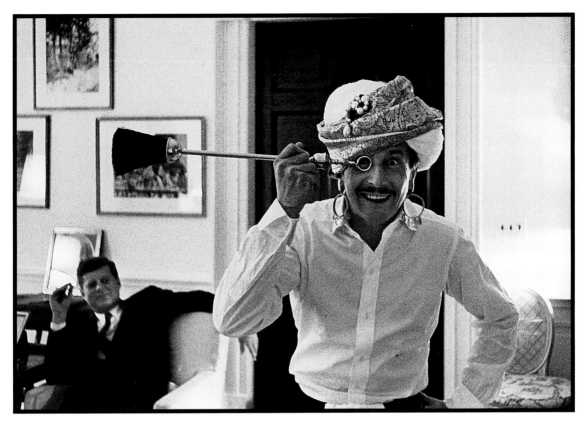

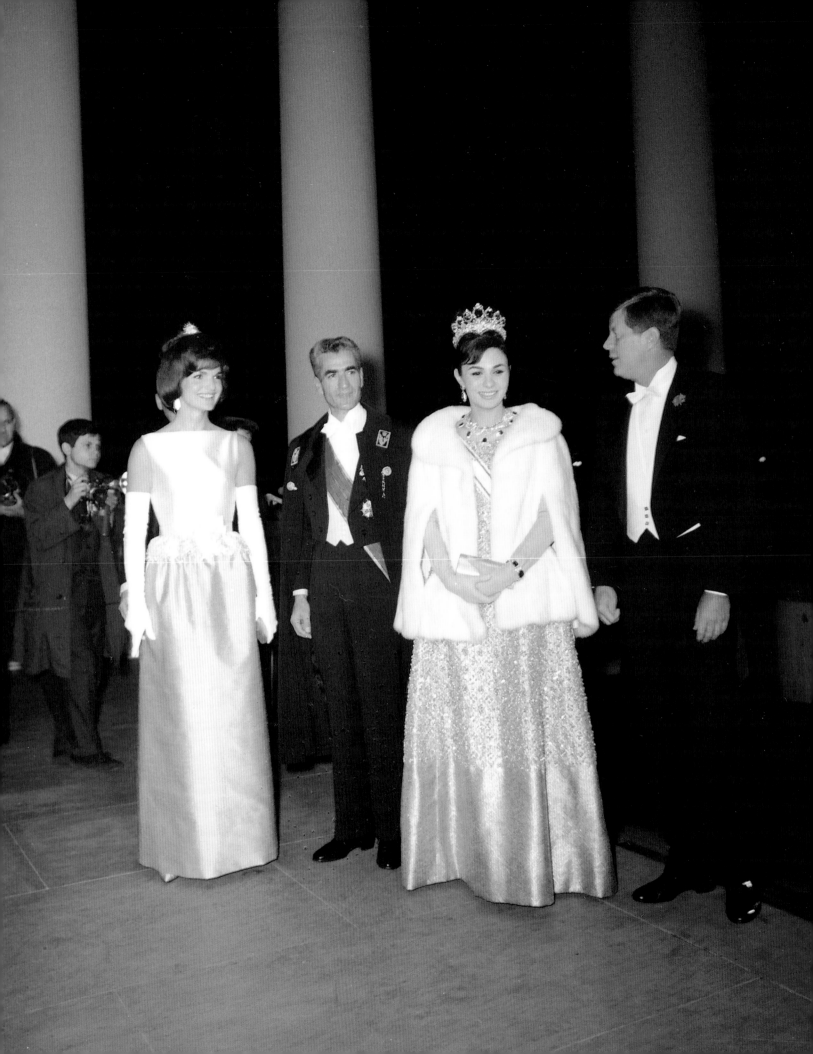

Astate dinner was held at the White House in honor of Mohammad Reza Pahlavi, the Shah of Iran, and his wife, Shabanou Farah Diba, on April 11, which, coincidentally, was my birthday. One hundred soldiers in dress uniform lined the driveway leading to the North Portico, where the Shah and Shabanou were greeted by President and Mrs. Kennedy.

President Kennedy toasted the royal couple, saying, "The Shah and I have one thing in common: we both went to Paris with our wives and ended up wondering why we had bothered. We thought we might as well have stayed home."

There was a reciprocal engagement at the Iranian embassy, where Jackie looked regal in a simple strapless pink dupioni silk gown. It was fitted at the top and softened to a modified A-line. The back was detailed with asymmetrical bow closures. Jackie wore her signature gloves, along with an eighteenth-century sunburst diamond clip in her hair that she had bought in London.

The day after the dinner, Shabanou Farah paid a private visit to see the White House nursery school and met Jackie's children. Jackie told me she was quite charmed by the lovely young empress.

Nobel Prize laureates and others were feted with a spectacular dinner on April 29. The idea for the dinner had been Jackie's and

FAR LEFT:
The young and beautiful Shabanou was attired in a golden dress and wore several million dollars' worth of jewelry, including the famous peacock crown, which was part of the state treasury. The Shah's evening jacket was covered in glittering medals. The royal couple literally glowed in the dark.

LEFT, ABOVE:
Jackie's hairdo, called a "brioche," was first seen at the dinner for the shah and the empress.

LEFT:
Jackie wore a pink and white dupioni silk gown with a bateau neckline. The white bodice, fitted to the waistline, featured a bow and lace effect studded with brilliants. The softly gathered skirt fell to the floor. Long white gloves completed the ensemble.

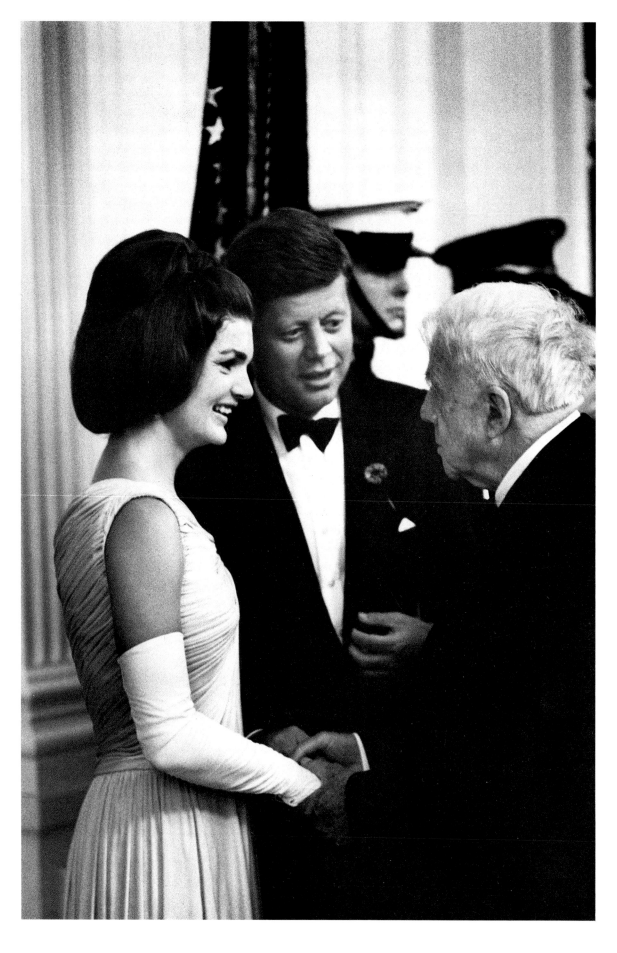

LEFT:
*The President and
Jackie greet the poet
Robert Frost at a White
House dinner honoring
Nobel Peace Prize win-
ners on April 29. In its
January 1, 1962, issue,*
Newsweek *quoted
Robert Frost as saying,
"There have been some
great wives in the White
House—like Abigail
Adams and Dolly
Madison—so great you
can't think of their
husbands, presidents,
without thinking of
them. It looks like
we're having another
one now."*

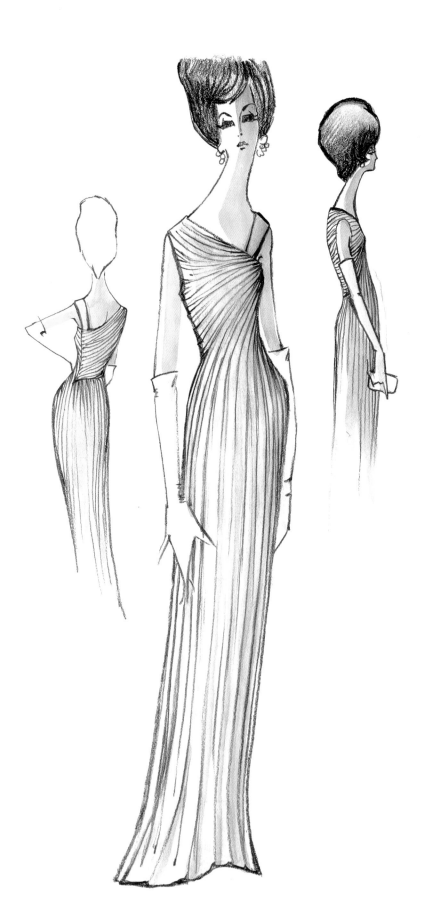

ABOVE:
Jackie and the
President talk with
the novelist Pearl
Buck in the East
Room, where Fredric
March gave a dra-
matic reading after
dinner.

LEFT:
This Grecian-style
gown in a greenish-
gray mossy color
was an updated
historical style. The
soft jersey was gath-
ered on the side in
an asymmetrical
design. Jackie's coif-
fure complemented
the soft draping of
the gown.

RIGHT:
At a White House lun-
cheon, Jackie was
joined by Vice President
Johnson's wife, Lady-
Bird (seated to the
right).

RIGHT
Jackie christens the
Lafayette, a Polaris
submarine, with a
bottle of champagne in
Groton, Connecticut.
She wore a wool coat in
a subdued green, which
was accented with
large buttons. It fea-
tured a cutaway wing
collar, seamed pockets,
and was modified to an
A-line at the hem.
Jackie loved the style of
this coat and we made
it in other colors and
fabrics for her.

included 175 guests in addition to the 49
Nobel laureates.

Jackie looked striking in a Grecian-style
gown in a green-gray jersey. We had dis-
cussed this look prior to her trip to India.

The President made a memorable
toast to the group: "I think this is the
most extraordinary collection of talent,
of human knowledge, ever gathered at
the White House, with the possible
exception of when Thomas Jefferson
dined alone."

On May 2, for a late afternoon
diplomatic reception, Jackie was
attired in a vivid Van Gogh yellow
silk dress.

On May 3, Jackie wore a silk wool
ensemble in a muted check from my
ready-to-wear collection when she attend-
ed a luncheon at the Congressional Club.

May 8 would find Jackie in Groton,
Connecticut, where she christened the
nation's largest Polaris submarine, the
Lafayette, with a magnum of champagne.

On May 9, a luncheon was given in
honor of Norway's prime minister. For
this event, Jackie wore a sleeveless dress
in framboise-colored wool that featured
a signature paneled skirt.

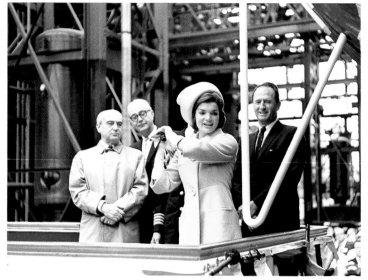

RIGHT:
Jackie joined the
President for an arrival
ceremony for Prime
Minister Macmillan
of Great Britain,
David Ormsby Gore
(later Lord Harlech),
and his wife.

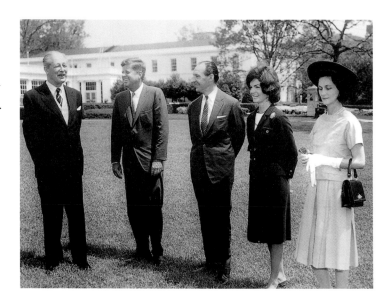

BELOW:
This navy blue wool suit was another take on the military look. The suit featured a four-button closure with four front flap pockets and buttoned cuffs. The skirt fell to a slightly flared A-line shape.

ABOVE:
This silk-and-wool ensemble in a muted check was from my ready-to-wear collection.

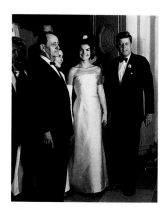

When Jackie was in New York, she usually stayed at the Kennedy apartment in the Carlyle Hotel. A luxurious apartment, it always reminded me of the oval sitting room at the White House. The apartment had a large two-story living room with magnificent views of the city. It was done in crystal yellow trimmed in crisp white.

The Carlyle had impeccable facilities and very tight security. Located right in the heart of Manhattan's art-gallery district, across the street from the Parke Bernet auction house, it was also close to the Fifth Avenue apartment of Stephen and Jean Kennedy Smith and Jackie's own sister, Lee.

We would do the fittings and review the sketches at the Carlyle and often we would have lunch. Jackie loved her visits to New York. One day, we got into a discussion about all of the misinformation being spread around about her and she surprised me with a philosophical quote in Latin: *Mors tua vita mea est*—"Your death is my life." She explained that, in a competitive situation, if your opponent can kill you, he lives.

Regarding the vagaries of fashion and its essential hypocrisy, Jackie had a big laugh when I told her about my lunch at

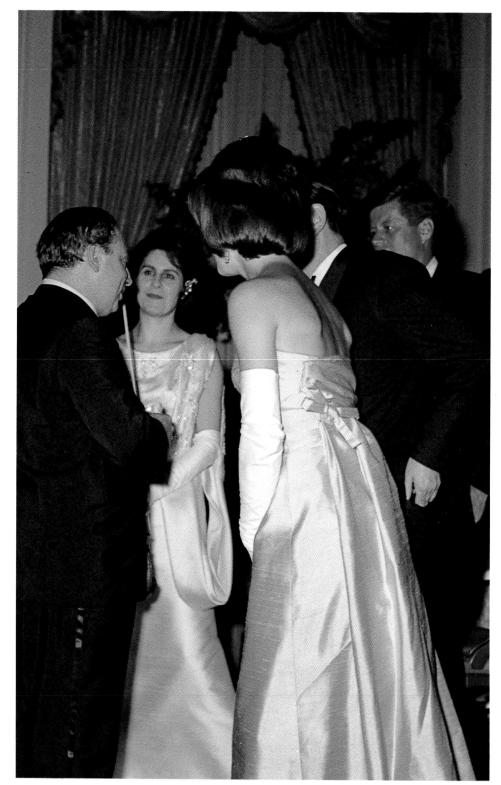

LEFT:
Jackie with Andre Malraux, the French minister of cultural affairs, and the President.

RIGHT:
The simple pink strapless dupioni silk dress was fitted at the top with a series of signature bows that narrowed the bodice, falling to the floor creating a mock train. Jackie had worn the same dress at the Iranian embassy dinner the month before. She did not really want to be photographed in the same dress twice, although this inevitably happened on occasion.

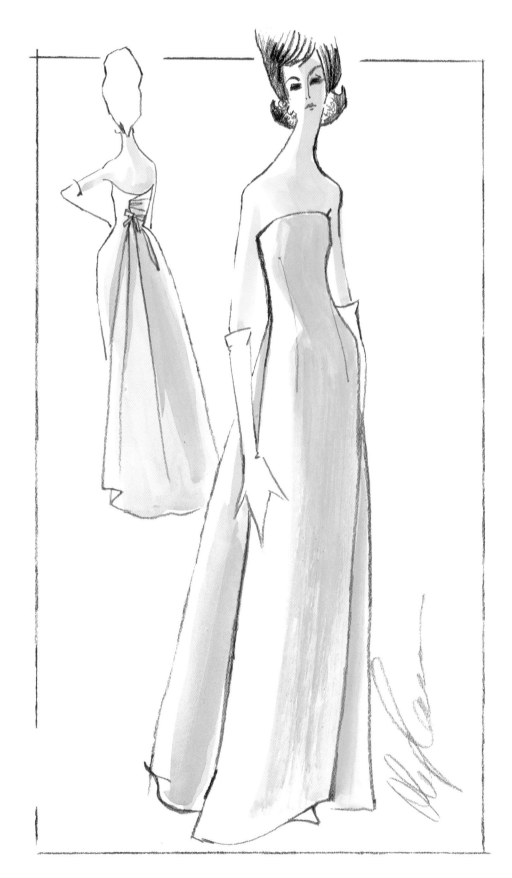

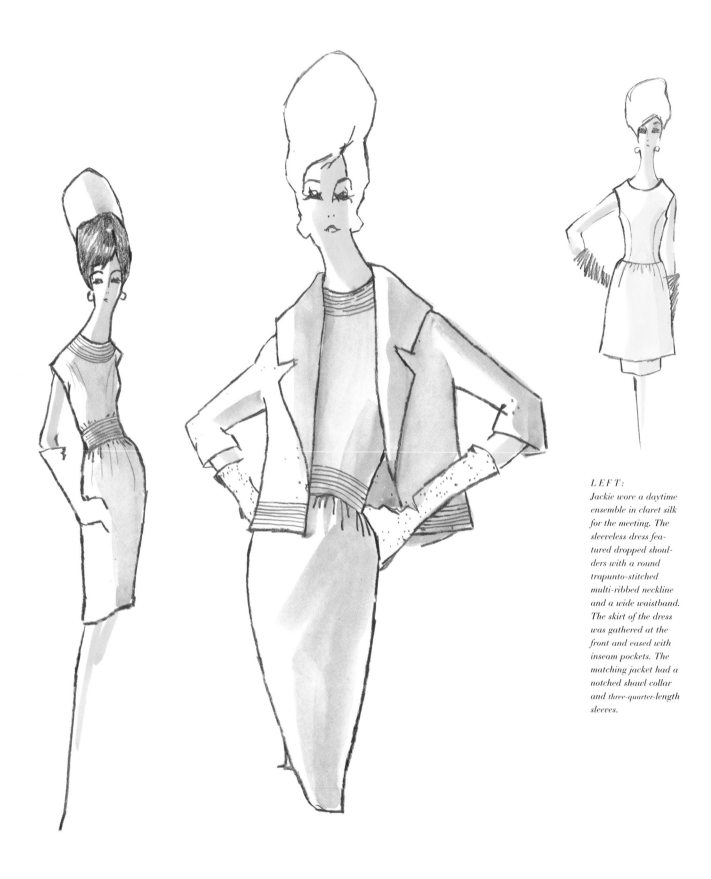

Jackie wore a daytime ensemble in claret silk for the meeting. The sleeveless dress featured dropped shoulders with a round trapunto-stitched multi-ribbed neckline and a wide waistband. The skirt of the dress was gathered at the front and eased with inseam pockets. The matching jacket had a notched shawl collar and three-quarter-length sleeves.

*LEFT AND
BELOW:*
*The Van Gogh
yellow dress was
seamed and
shaped to the
body in a modified
A-line. The three-
quarter-length over-
skirt of the same
dupioni silk had
high slits on either
side, adding to the
visual impact.*

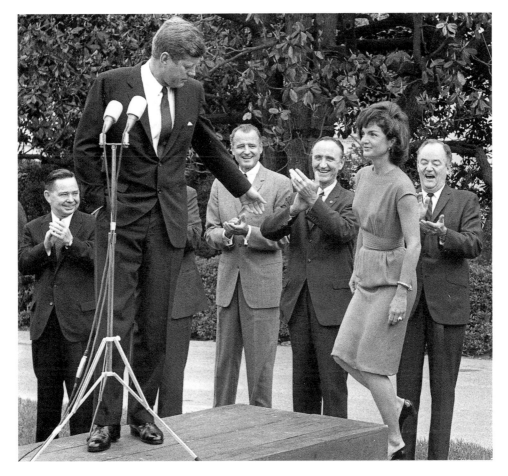

ABOVE:
*At a meeting of the
Conference for
Democratic Women,
the President helps
Jackie to the podium
while Hubert Humphrey
and others look on.*

RIGHT:
*Jackie stood with Mr.
and Mrs. Johnson at
a diplomatic recep-
tion on May 2.*

FAR RIGHT:
On May 22, at a dinner for the president of the Ivory Coast, Jackie and the President posed with the Marine Band

RIGHT:
This strapless white gown glistened with silver sparkles, crystal beading, and stones. The sheer crystal gauze extended from the rounded neckline to the bodice, and was encrusted with crystal beads. The form-fitting sheath dress was eased at the hem, creating a mock train.

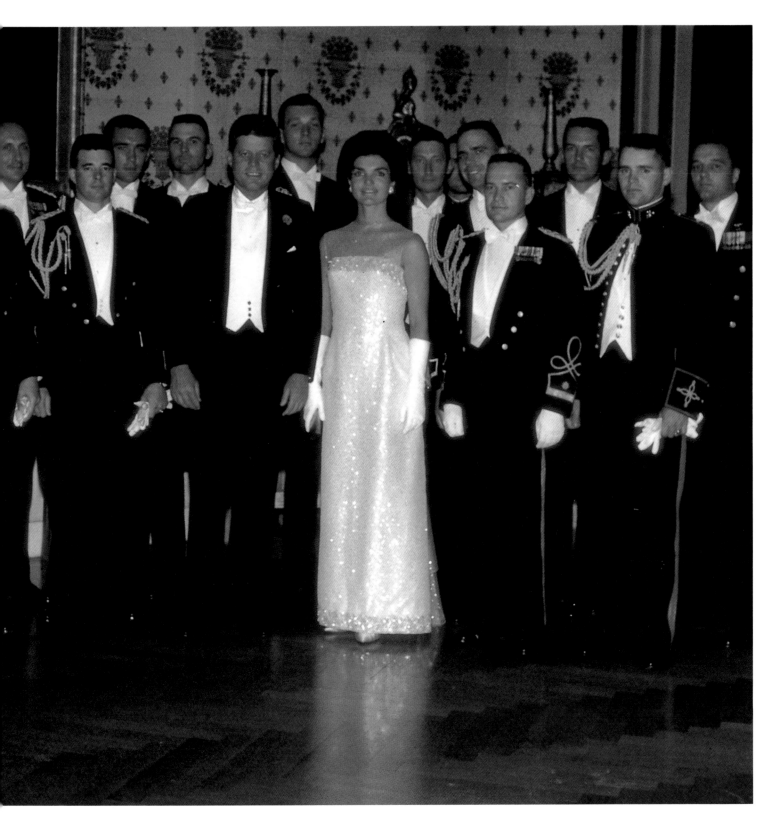

The Colony, a popular restaurant during the 1950s, with Nancy White, editor of *Harper's Bazaar.* "Nancy," I asked, "how can you rave over the new Norman Norell collection when he openly admits that every single dress is a copy of Chanel?"

"Yes," Miss White responded, "but he does it better."

On May 11, the French minister of cultural affairs, Andre Malraux, and his wife visited and Jackie planned a special cultural evening for them. Some of the guests were the Charles Lindberghs; the painter Andrew Wyeth; playwrights Arthur Miller, S. N. Behrman, and Tennessee Williams; poet Alexis Saint-Leger; film director Elia Kazan; the president of the Metropolitan Museum of Art in New York; actress Geraldine Page; choreographer George Balanchine; and Adam Clayton Powell, among many others.

Jackie wore the strapless pink dupioni silk gown that she had worn to the reception at the Iranian embassy, accessorized by the antique sunburst pin in her hair.

The evening was a success and negotiations began regarding a proposed visit to the United States by the world's most famous work of art and France's greatest art treasure, the *Mona Lisa.*

The painting would eventually be loaned, personally, to the President the following year.

Jackie mentioned *en passant* that Gene Tierney, Otto Preminger, and some cast members from the film *Advise and Consent*, a political thriller set in

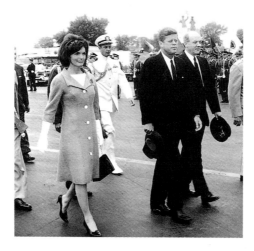

LEFT:
The President and Jackie participated in an arrival ceremony for the president of the Ivory Coast. Though he hardly ever wore one, the President often carried a hat to help stimulate the hat industry.

RIGHT:
Former First Lady Mamie Eisenhower joined Jackie at a tea for National Cultural Center campaign officials on June 22.

LEFT:
The President and Jackie receive the first copies of the White House guidebook. The President was very proud of Jackie's efforts on behalf of the White House.

BELOW:
This silvery dupioni
silk sleeveless dress
had a very military
look, with six bold
buttons and a
dramatic plastron
front.

BELOW:
Jackie's lightweight
single-breasted wool
coat was black and
white. It was rounded
to the body, had a
modified wing collar,
and three-quarter-
length dolman sleeves.

ABOVE:
At the presentation
of the guidebook to
the newly restored
and redecorated
White House, Jackie
wore a two-piece silk
suit with an A-line
skirt, large covered
buttons, a jewel
neckline, and three-
quarter-length
sleeves.

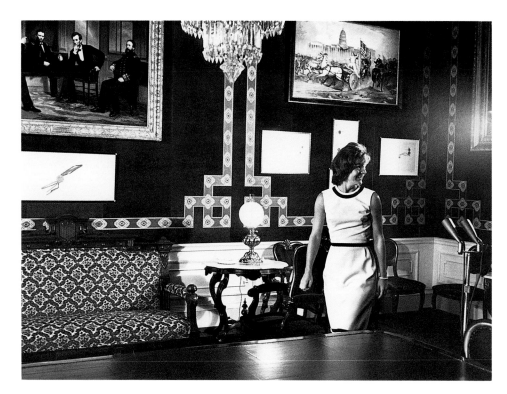

LEFT:
Jackie visited the newly
restored Treaty Room,
formerly known as the
Monroe Room, when it
reopened on June 28.
One of the most historic
rooms in the executive
mansion, it has been
the site of many treaty
signings from President
Lincoln's era to the
present.

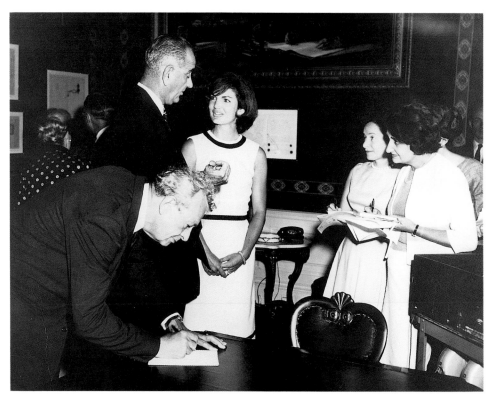

LEFT AND
FAR RIGHT:
Jackie wore a
sleeveless dress with
a nautical theme—
narrow black bands
the neckline, waist,
and hem.

Washington, would be having lunch with JFK. She was curious about Gene. She was aware, of course, that Gene and JFK had had a romance when Jack was a young naval officer and Gene and I were divorcing.

"She is beautiful," Jackie said. "I can see why any man would fall in love with her."

For the arrival of the President and Mrs. Huophet-boigney of the Ivory Coast on May 22, Jackie wore a black-and-white lightweight wool coat. In the evening, at the state dinner, Jackie glittered in a white floor-length trompe l'oeil strapless gown, covered with silver sparkles, crystal beading, and stones.

Jackie and Mrs. Huophet-boigney were photographed at the reception and featured on the cover of *Ebony* magazine. I was pleased that Mrs. Huophet-boigney asked Jackie if she could contact me about buying clothes from my collection, which she later did, visiting my showroom in New York.

In early June, Jackie began preparations for a visit to Mexico with the President at the end of the month. Also in June, former First Lady Mamie Eisenhower visited and was highly complimentary about the White House restoration.

On June 28, a press briefing was held as Jackie opened the refurbished Treaty Room with Vice President Lyndon Johnson. In addition to her renovation of the White House, Jackie had also developed a guidebook to the White House, *The White House: An Historic Guide*, sales of which raised considerable monies to maintain the President's house. Later

that same afternoon of June 28, there was a formal presentation of the guidebook to the Kennedys by David Finley, the chairman of the Commission of Fine Arts. At the presentation, Mr. Finley said, "Mrs. Kennedy has been the inspiration for its publication—her knowledge of history, her judgment, and her impeccable taste are evident on every page." After thanking everyone, President Kennedy turned to Jackie and said, "My warmest congratulations and appreciation to my wife."

Earlier in the year, an article in *The New York Times* said, "Not since Thomas Jefferson occupied what was then known as the President's Palace has culture had such good friends in the White House." Later on, the historian Lewis Mumford would say that Jack Kennedy was "the first president to give art, literature, and music a place of dignity and honor in our national life." But it was really the First Lady's influence on her husband, and her own well-developed interest in art and culture, that had such a terrific impact. Jackie was always the most exquisite blend of culture and glamour.

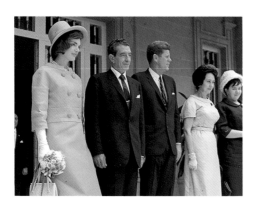

O n the morning of June 29, the Kennedys left for Mexico, where they had honeymooned almost ten years earlier. They were met with a huge shower of confetti and cheering crowds. Upon arrival, the presidential couple were photographed with Mexican president Mateo and his wife. Jackie wore a day ensemble of silk and linen in her favorite blue. The narrow, shaped sleeveless A-line dress with a front-paneled skirt was a "Jackie look" signature.

For the evening reception, Jackie wore one of her favorite dresses of all time—the Nattier blue strapless gown that she would continue to wear for the next several years.

Jackie, who was a skilled linguist, addressed a television audience in flaw-less Spanish, amazing her hosts and charming the millions who saw her.

Most of July was spent at the home of Morton Downey on Squaw Island. Morton was an entertainer and a strong Irish tenor who was a longstanding friend of the Kennedys from Palm Beach.

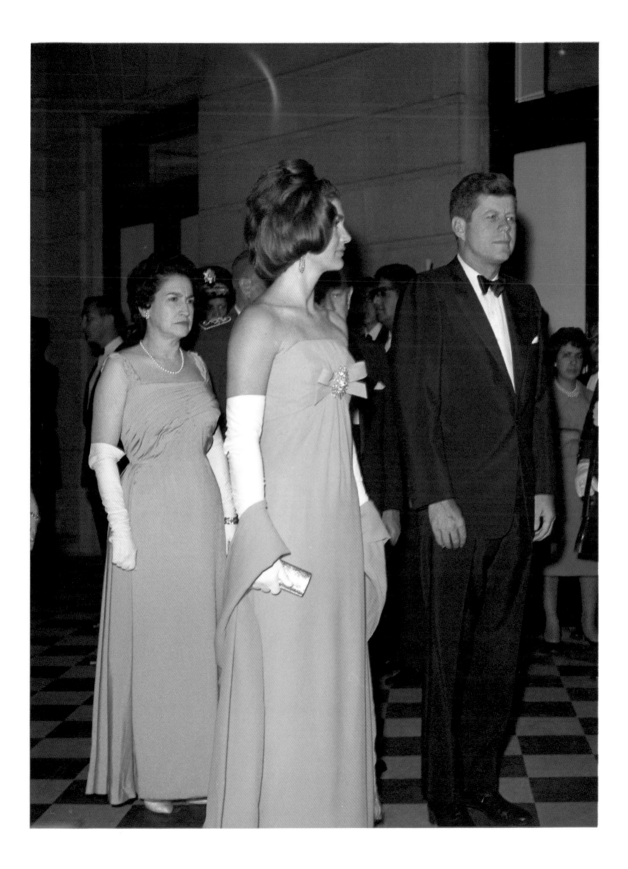

LEFT:
This jacket dress was made of Venetian yellow silk and linen and had a rounded neck that buttoned down the front. It featured a dropped waistline over an A-line skirt. The jacket had three-quarter-length sleeves and was banded in a contrasting fabric that tied with a center bow. A folded-back roller hat and leather gloves completed the ensemble.

RIGHT:
Inspired by the military, this dress featured a softly rounded neckline and extended shoulders. Decorated with four buttons on the front, the dress had a slightly raised waistline with a leather belt that tied in a signature bow in the center. The skirt had panels and inseam pockets.

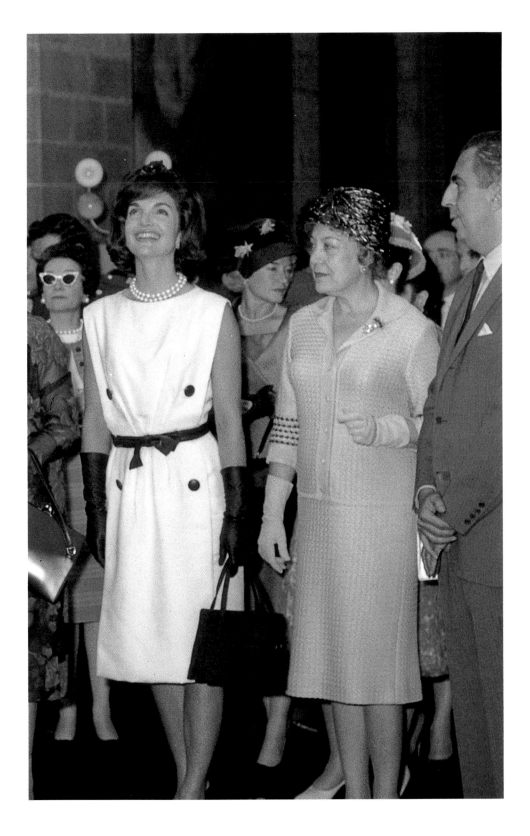

ABOVE:
Jackie was greeted
by children in
national costume
when she visited the
National Institute
for the Protection of
Children in Mexico
City on June 30.

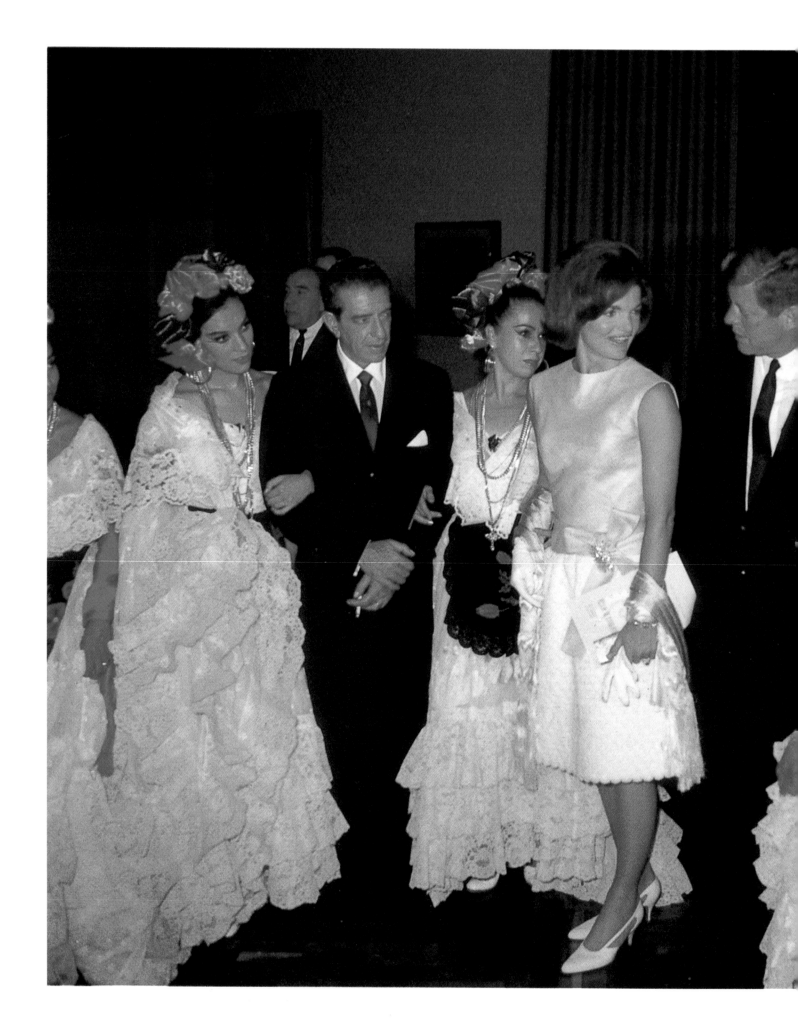

Jackie wore a short, festive dress that had been created for her visit to Mexico. The sleeveless bodice of Venetian blue had a dropped waistline accented with a bow at the top of the hip. The skirt was made of rows of white lace on silk organza. This was an adaptation of the Mount Vernon dress that Jackie loved so much.

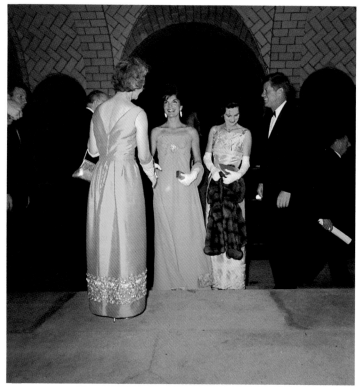

In August, Jackie and her children, along with Lee and Prince Radziwill and their children, would all spend an idyllic holiday at the Radziwills' rented villa in Ravello, above Amalfi on the southern coast of Italy. Other guests included Fiat magnate Gianni Agnelli and his wife, Marella, along with photographer Benno Graziani and his wife. Also along for the vacation were several Secret Service agents and a strong contingent of Italian security guards. Jackie was an instant hit with the paparazzi, who never stopped snapping pictures.

At the time, I had a very successful swimwear business. Most likely due to my association with the White House, sales were booming. I had sent Jackie a collection of swimwear in vivid prints and colors in anticipation of her vacation in Italy. After Jackie's trip to Italy, the one-piece swimsuits that she was photographed in became bestsellers. The stores couldn't get enough of "First Lady swimwear." Jackie did the same thing for the belt industry, simply because she often wore belts.

Mid-September found Jackie and JFK in Newport for the America's Cup races. Jackie was much photographed, especially when she wore her hair in a glamorous French twist at the reception and dinner held at The Breakers on September 14. Jackie wore the same Nattier blue strapless gown she had worn in Mexico. A fringed ten-foot stole and Jackie's sunburst pin completed the outfit.

Also in September, Jackie traveled to New York for the opening of the

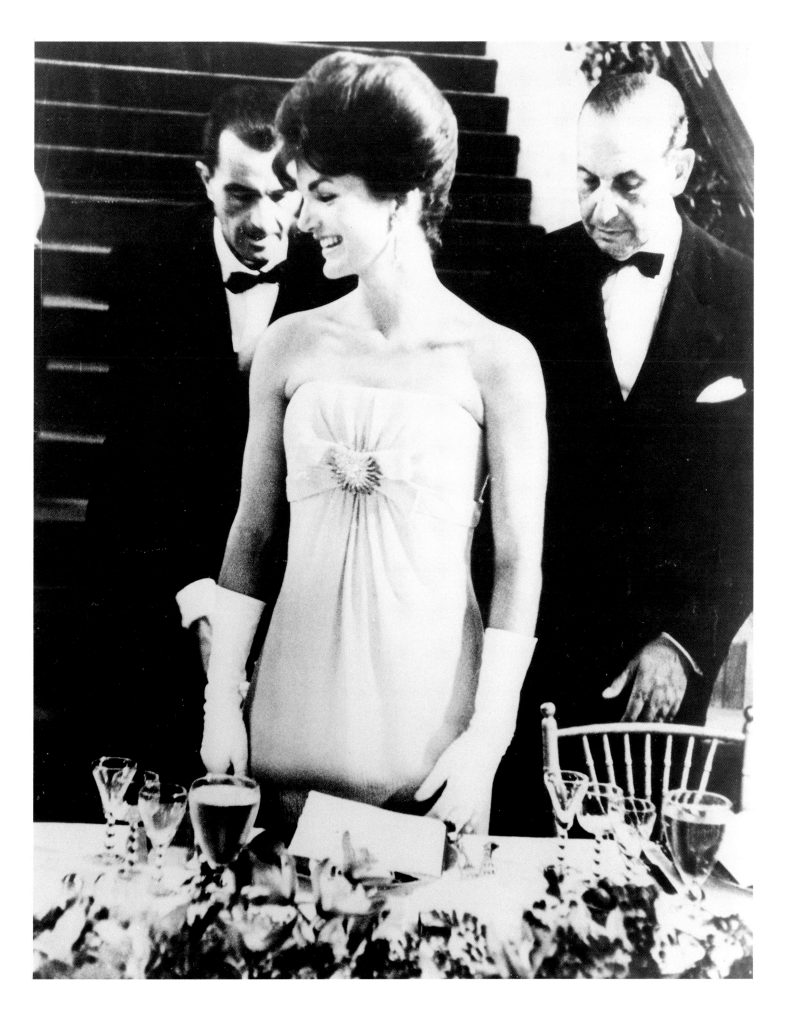

LEFT:
Jackie joined conductor
Leonard Bernstein and
his wife, Felicia, at the
gala opening of
Philharmonic Hall at
Lincoln Center.

RIGHT:
This full-length gown
featured a rounded
neckline and cap
sleeves. The black top
was embroidered with
brilliants and glitter
and contrasted with
the pristine elegance
of the white satin
skirt, tied at the
waistline with a black
satin bow.

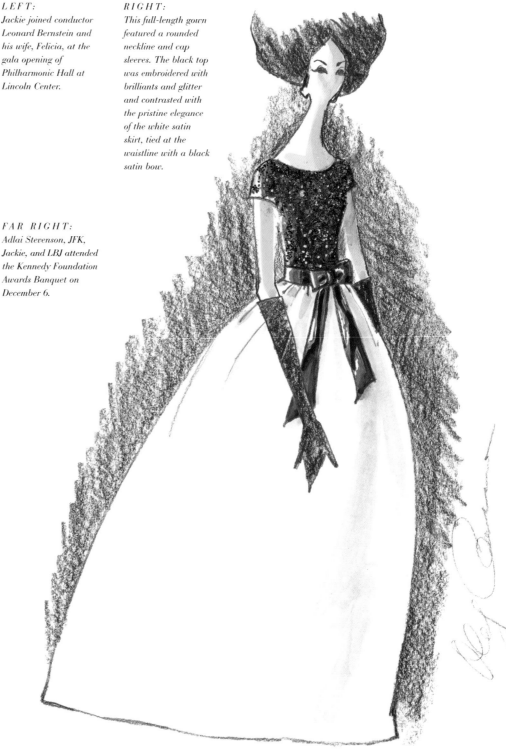

FAR RIGHT:
Adlai Stevenson, JFK,
Jackie, and LBJ attended
the Kennedy Foundation
Awards Banquet on
December 6.

Philharmonic Hall. It was the first of
Lincoln Center's buildings to open and it
was hailed as one of the most important
events of the century. It was certainly
among the most elegant. Accompanied
by John D. Rockfeller 3rd, Jackie wore a
black-and-white gown, another version
of the T-shirt theme. This was the mini-
malist look par excellence, and it was
done in Jackie's two favorite colors—
black and white.

In October 1962, there was a state
dinner that was planned and then can-
celled. Only a few of us were asked to
remain for dinner—the Radziwills,
Bobby and Ethel Kennedy, myself, and
a couple of others. McGeorge Bundy
drifted in and out of the room,
occasionally speaking privately with the
President. The evening was quiet and
somber, befitting the occasion. JFK
refused to seem depressed or over-
whelmed on the brink of disaster, and
behaved with remarkable sangfroid. At
one point, after Bundy told him that the
Russian missile carriers had apparently
stopped en route to Cuba, JFK said to
me, with a puff on his cigar, "Well, we

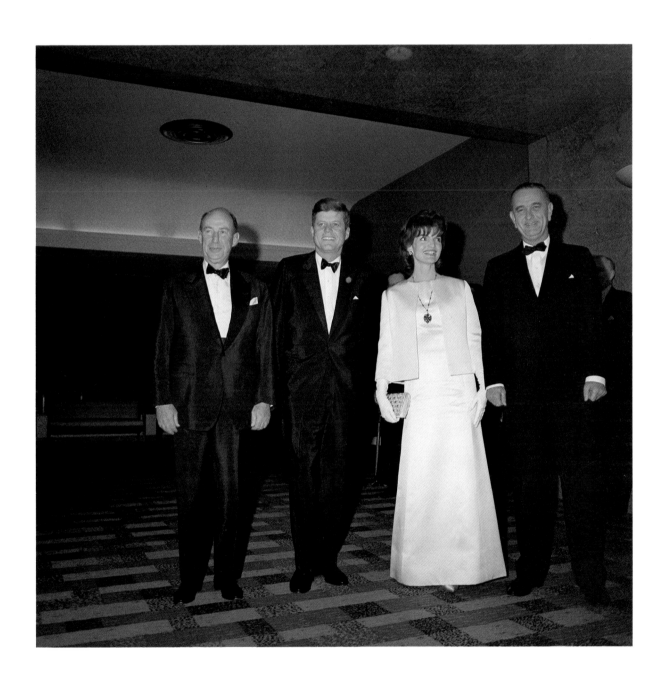

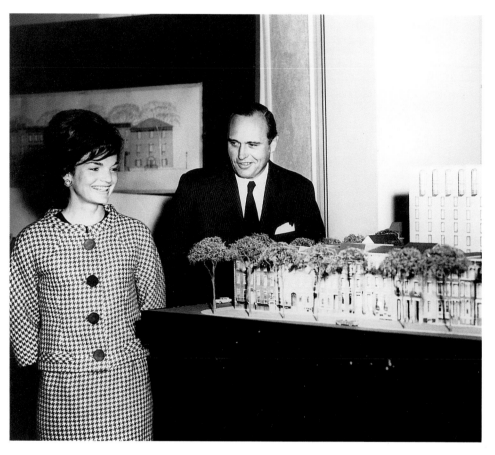

still have 20 chances out of 100 to be at war with Russia."

Jackie tried to be cheerful and upbeat, but it was a tense evening. The world collectively held its breath, but the President made his point and the crisis was averted.

On November 19, Jackie hosted a musical program for young people in the East Room. Among the attendees was Luci Baines Johnson, daughter of the Vice President. Jackie wore a black trompe l'oeil dress with long sleeves and white satin cuffs.

For the Kennedy Foundation Awards Banquet on December 6, Jackie, JFK, and Lyndon Johnson were much photographed. Jackie looked elegant in a long white satin gown with pure minimalist lines.

That year, the White House Christmas tree, located in the main entrance hall, was trimmed with toys and candy. A party was held for the White House staff, and Jackie wore a red dress of dupioni silk for the occasion.

After Christmas festivities at the White House, the Kennedys spent the remainder of the holidays in Palm Beach.

My relationship with JFK was relaxed. He had a great interest in and hunger for news of the world outside the White House. He was never pompous, but always charming and down-to-earth. He was a great listener, was always curious, and could dominate a conversation through his incisive questions and to-the-point comments. He had a tremendous charm, was very clever and witty, and had a great sense of humor.

ABOVE:
Jackie was also involved with the restoration of Lafayette Park, across the street from the White House. Here she views a model of the proposed renovation of the park.

RIGHT:
Here Jackie attends the young people's concert at the White House with Luci Baines Johnson.

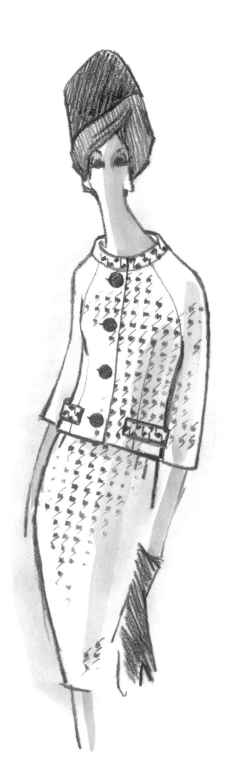

LEFT:
This two-piece houndstooth wool suit from my ready-to-wear collection had dolman three-quarter-length sleeves and rounded shoulders. The jacket featured a slightly raised modified cowl collar and two front pockets.

RIGHT:
For the musical program she hosted for young people on November 19, Jackie wore a black velvet trompe l'oeil dress with long sleeves and white satin cuffs. The V-neck bodice was set off by a white satin collar and a black satin inset at the waist.

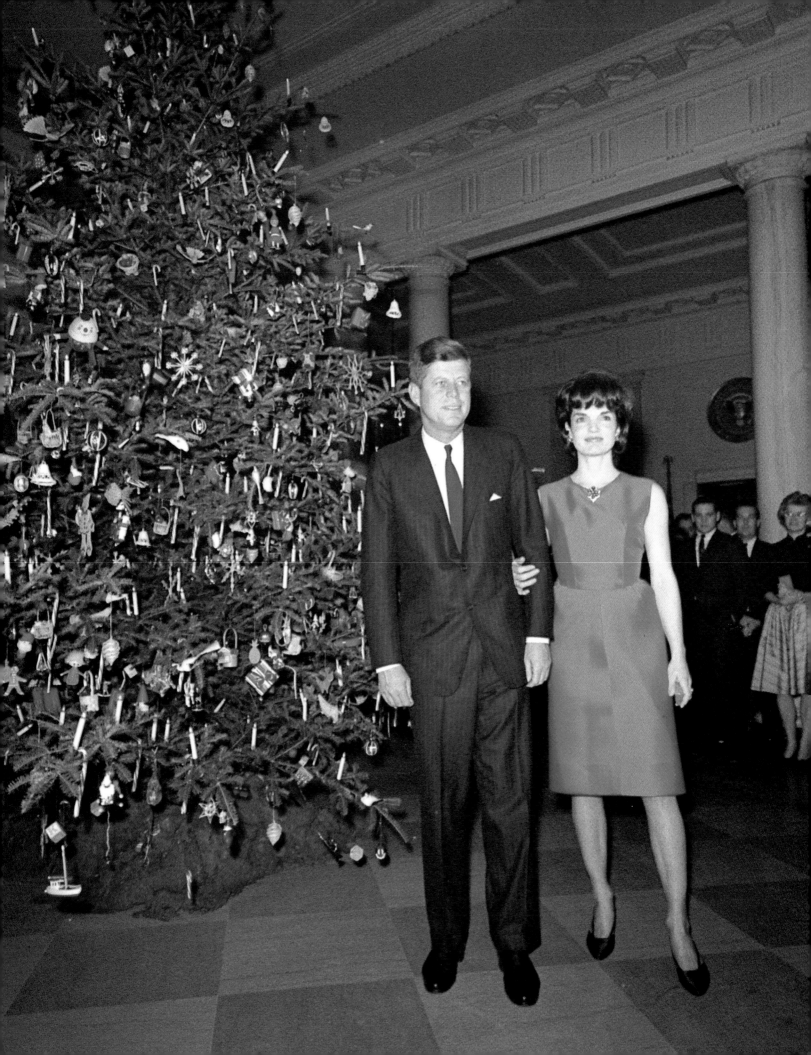

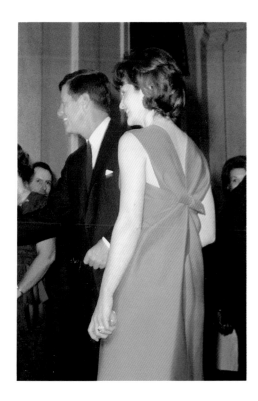

FAR LEFT:
Jackie and the
President posed in
front of the White
House Christmas
tree.

LEFT:
Jackie's red dupioni
silk dress featured
a geometric neck
with a deep V back
gathered in folds
and tied in a knot.

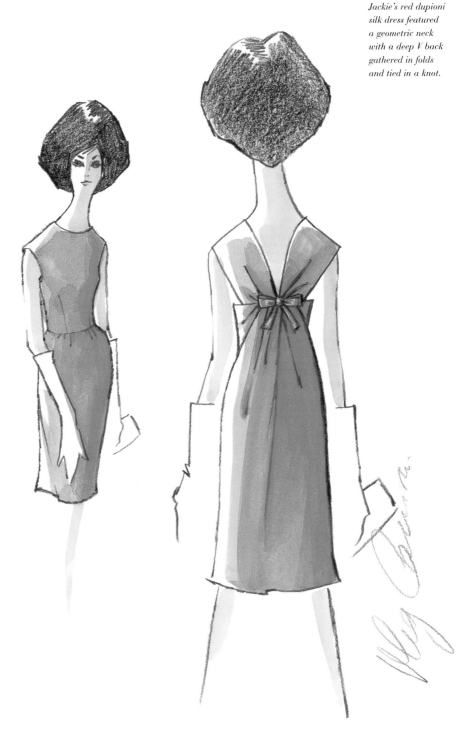

Underneath it all, there was a large dose of fatalism, but he also believed in luck. He was quite devout and believed in God, saying, "The weakness of man should not weaken the image of God." He felt that a leader had a responsibility to set an example.

The President and I had discussions on fashion and how important it was to the economy. I told him that his leadership in men's fashion had a big effect on the men's fashion business.

"Mr. President," I said, "there's only been one truly elegant man in the last 50 years, the Duke of Windsor. You could be the second. You could be as important in the world of fashion as Jackie."

Of course, the President was not only handsome and rich, he also had a nonchalant elegance that transcended fashion. He always had style and a charm that never varied even under the heaviest pressure.

1963

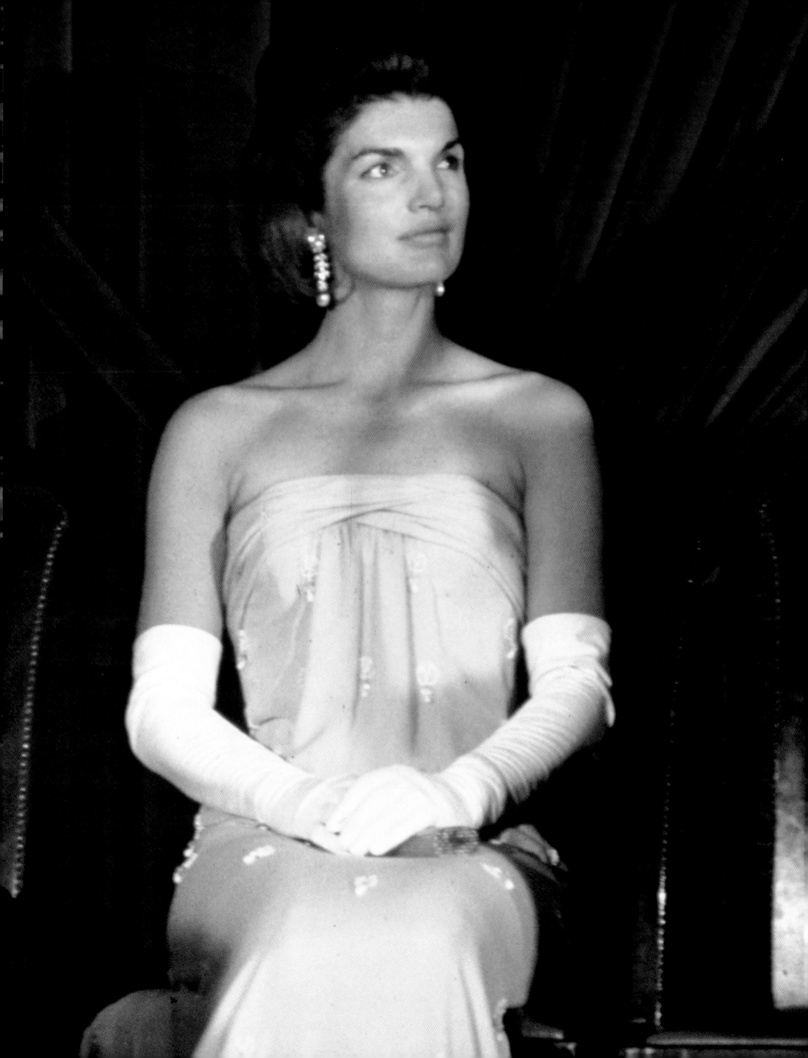

PREVIOUS PAGE:
Jackie listens attentively to the President's speech at the unveiling of the Mona Lisa *at the National Gallery of Art in Washington in January.*

RIGHT:
Jackie and her guests admire the Mona Lisa *at the National Gallery.*

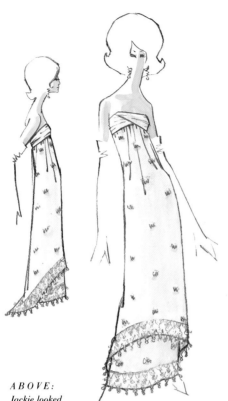

ABOVE:
Jackie looked spectacular in a full-length gown of mauve silk chiffon that featured a wrapped strapless bandeau bodice with gathers of silk chiffon falling to a jeweled hem. The chiffon was patterned with hand-sewn crystal beads. The overskirt had a raised rounded hem in the front that fell to a short, easy train at the back. The hem of the underskirt was bordered with crystal beads to match the train and overskirt. Some dresses are conspicuously successful, and this was one of our favorite gowns.

B y 1963, Jackie was an established international success, continually covered by the media worldwide. The most powerful nation in the world was represented by the most stunning couple imaginable. "Jack and Jackie" had become household words not only in America, but also around the world.

When she first got to the White House, Jackie had taken the hesitant steps of someone who is thrown into a difficult situation. Gradually she began to gain confidence in herself and in her role as First Lady. By 1963, the public adulation had built up to such an extent that in the eyes of most Americans, everything she did was perfect. There was nobody to touch Jackie in using style as a political tool. Success changes people, and I saw Jackie change as she grew in confidence, as did the President. When the whole world is applauding, I think it's natural.

When Jackie met Andre Malraux, the French minister of culture, on her first trip to France as First Lady, they liked each other immediately. The following year, Malraux had visited Washington and had again been charmed by Jackie. Now he had arranged to lend Leonardo da Vinci's masterpiece, *La Gioconda* (the *Mona Lisa)*, for exhibition in America. Instead of lending it directly to the National Gallery of Art, where it would later be shown, Malraux chose to lend his country's most precious masterpiece personally to President Kennedy, who in turn allowed it to be exhibited at the gallery.

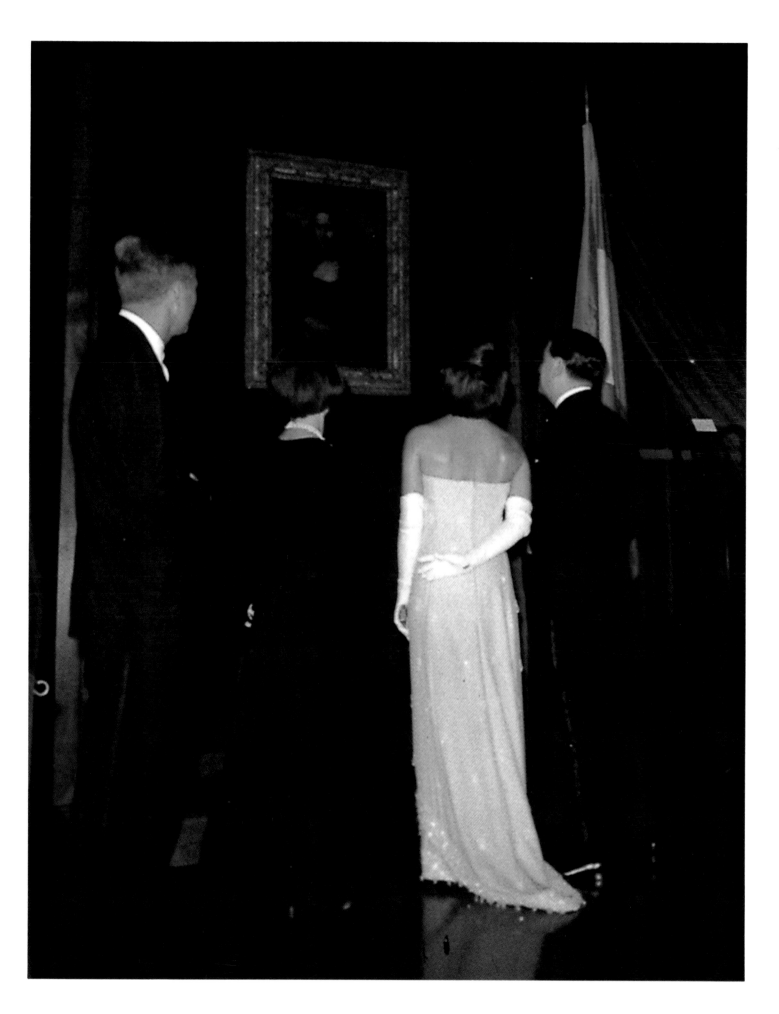

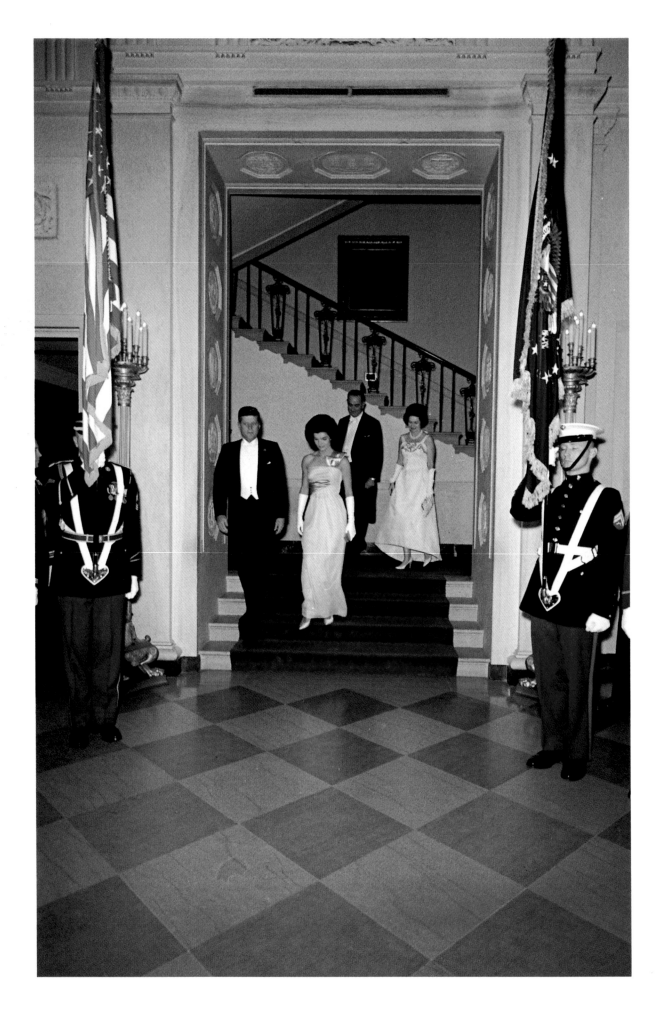

RIGHT:
The President and
Jackie arrive for
the dinner held
in honor of the
executive and
judicial branches
of government.

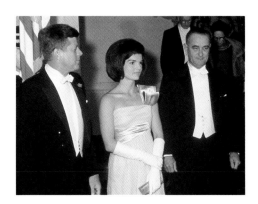

The painting was extremely fragile and extraordinary precautions had to be taken to insure its safety. Upon its arrival in December, it had been put in an air-conditioned vault for safekeeping until the National Gallery exhibit, which opened on January 8. Before the unveiling, the French embassy, with Malraux and his wife in attendance, gave a formal reception in the Kennedys' honor.

We had discussed what Jackie should wear for the reception, which was viewed as the cultural high point of the administration. Recalling Jackie's visit to Empress Josephine's home, Malmaison, in 1961, I suggested something in the Empire style. This was the style popular during the reign of Empress Josephine and one that suited Jackie well because it showed off her shoulders and neckline. The gown I created was a pink chiffon column encrusted with pearls and brilliants. It was strapless—quite a dramatic departure from our first few months in the White House, when Jackie had been so worried about wearing a one-shouldered gown!

On January 21, a dinner was held in honor of the executive and judicial

ABOVE LEFT:
The President, Jackie, and Vice President Lyndon Johnson on the receiving line at the White House. I enjoyed speaking with the Vice President at receptions and private parties. He frequently stood by himself and, perhaps because it was such a young crowd at the White House, he was not often the center of attention. Jackie, of course, always treated LBJ and his family with respect and affection.

branches of gov-
ernment. Among
those honored
were Chief Justice
Earl Warren and
Vice President
Lyndon Johnson.
Jackie wore a cit-
ron chiffon-and-
satin gown that
was inspired by
the turbans worn
by men in
Rajasthan, where
Jackie had visited
the previous year.

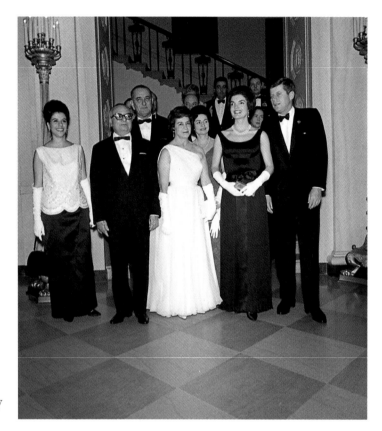

In February, the
president of
Venezuela and his
wife paid a two-day
state visit to
Washington. Jackie wore a stunning black
silk chiffon gown for the evening reception
held in their honor at the White House.

March 27 saw the arrival of King
Hassan of Morocco and his entourage,
including his sister, Lalla Aisha.

The evening with the king was a glit-
tering affair. The princess and her
ladies-in-waiting wore golden caftans
with jeweled belts and exquisite jewelry.
The king was resplendent in his immac-
ulate white dress uniform. Jackie looked
equally wonderful in a floor-length
white silk gown.

JFK made one of his typically memo-
rable toasts, recalling that Morocco had
been the first country to recognize the
United States after the Revolutionary

War. George Washington had sent a
message to the Emperor of Morocco,
which JFK read as part of the toast.

After dinner, the royal guests enjoyed
the music of *Brigadoon*, composed by
Alan Jay Lerner, who was also the com-
poser of *Camelot*, the hit Broadway play
and movie, which came to symbolize the
Kennedy White House.

In thanking Lerner, the President
mentioned that they had been class-
mates at Choate, and quipped that "nei-
ther of us thought the other would
amount to anything," which brought the
house down.

The Kennedys flew to Palm Beach
for the Easter holidays and were
photographed leaving St. Edward's

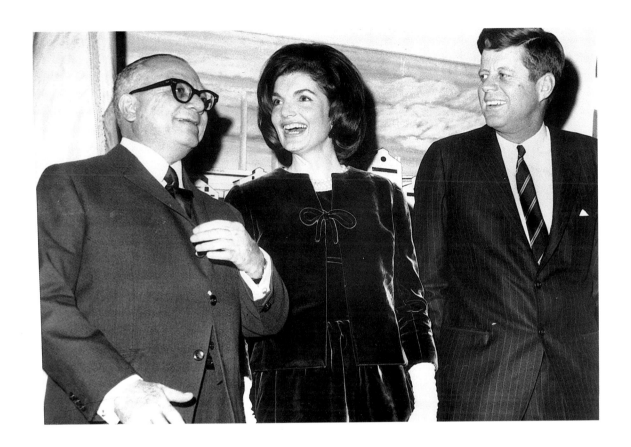

FAR LEFT:
In February, the
Kennedys were visited
by Romulo Betancourt,
president of Venezuela,
and his wife. Their
two-day state visit
included a state dinner
at the White House
and a reception at the
Venezuelan embassy.

LEFT:
This black silk chiffon
gown was softly gath-
ered and pleated into
a narrow column.
The bodice featured a
signature tank top, or
camisole, with a deep
scoop neckline, accent-
ed by black satin rib-
bons under the bust-
line and again at the
narrow waistline. A
center bow of black
satin dropped straight
to the floor.

ABOVE AND
RIGHT:
For the reception
at the Venezuelan
embassy, Jackie wore
a silk velvet suit with
the cardigan jacket
closed by a velvet bow
and the skirt in the
signature A-line.

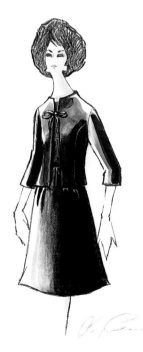

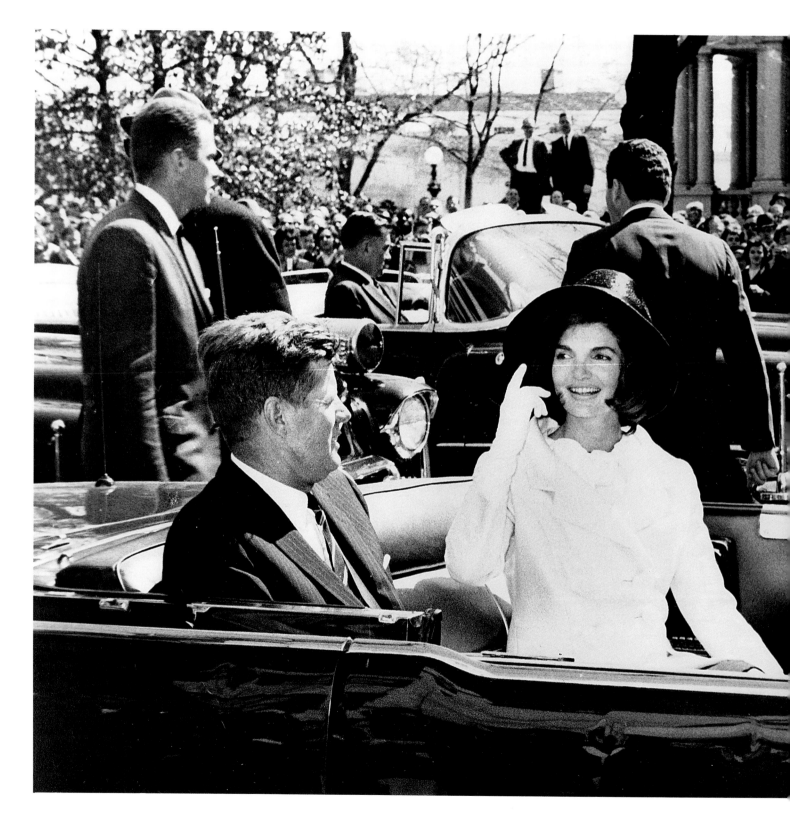

Church on Easter Sunday, April 14.
Jackie wore a sleeveless dress with
overlay embroidery, which created a
floral pattern on the bodice. The
pink linen dress was softly shaped
into the Kennedy signature A-line
by rounded seams.

On April 18, Jackie officially
announced from Palm Beach that she
and the President were expecting their
third child. Jackie was photographed in
a semi-fitted easy sleeveless summer
dress of tangerine-colored silk linen.

A splendid evening reception was
held for the visiting Grand Duchess
Charlotte of Luxembourg on April 30.
Jackie wore a formal gown of sheer silk
gauze in the softest pale Nattier mauve.
This was Jackie's first official appear-
ance since the announcement of the
new baby and she was radiantly happy.

The evening began with an exchange
of gifts in the Oval Room. The
Kennedys gave their guest a paper-
weight made of azurite and malachite
set in golden blades of grass and the
grand duchess presented her hosts with
two beautiful porcelain plates.

After dinner, actor Basil Rathbone
presented dramatic readings, including
the St. Crispin's Day speech from
Henry V. He was joined by Elizabethan
musicians and a chorus of singers and
the evening was billed as "Poetry and
Music of Elizabethan Times."

The grand duchess had only the
highest praise for Jackie, calling her
"America's most potent weapon,
Madame la Presidente."

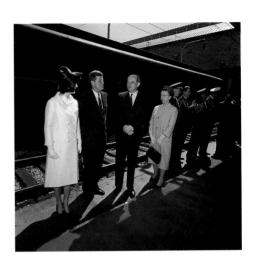

RIGHT:
King Hassan and
his sister, Lalla
Aisha, were greeted
at Washington's
Union Station by
the President and
Mrs. Kennedy.
A special platform
had been built for
greeting the royal
family.

FAR LEFT:
Jackie and the
President traveled
in an open car to
meet the king of
Morocco at the
train station.

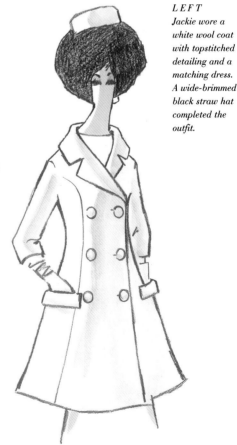

LEFT
Jackie wore a
white wool coat
with topstitched
detailing and a
matching dress.
A wide-brimmed
black straw hat
completed the
outfit.

RIGHT:
Jackie had her favorite
dresses, and this simple
sleeveless silk dress she
wore in March and
May was one of them.
Empire in feeling, the
dress had detailing on
the bodice and was
accented by a signa-
ture bow. The skirt fell
in an A-line shape.

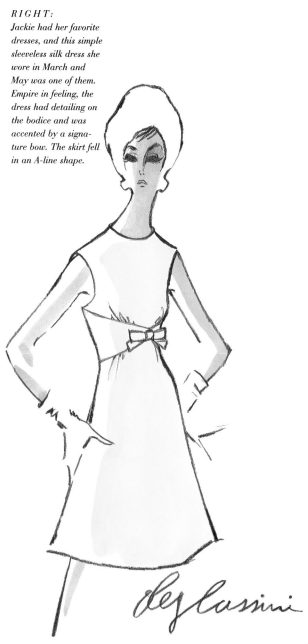

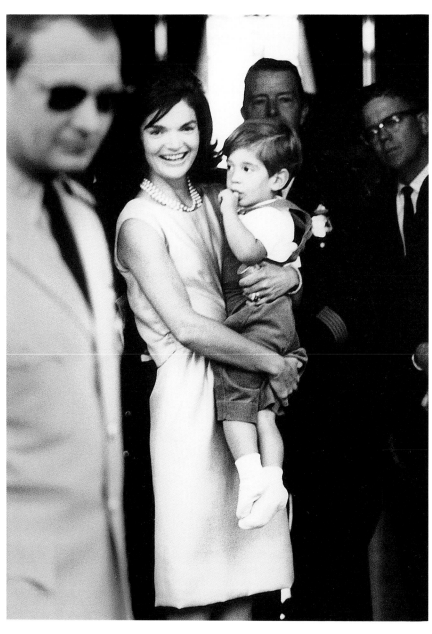

ABOVE:
At an awards
ceremony for
astronaut Cooper
on May 21, Jackie
brought John, Jr.,
along.

RIGHT:
In Palm Beach for
Easter Sunday, Jackie
and her family were
photographed leaving
St. Edward's Church.
Jackie wore a sleeve-
less A-line pink linen
dress.

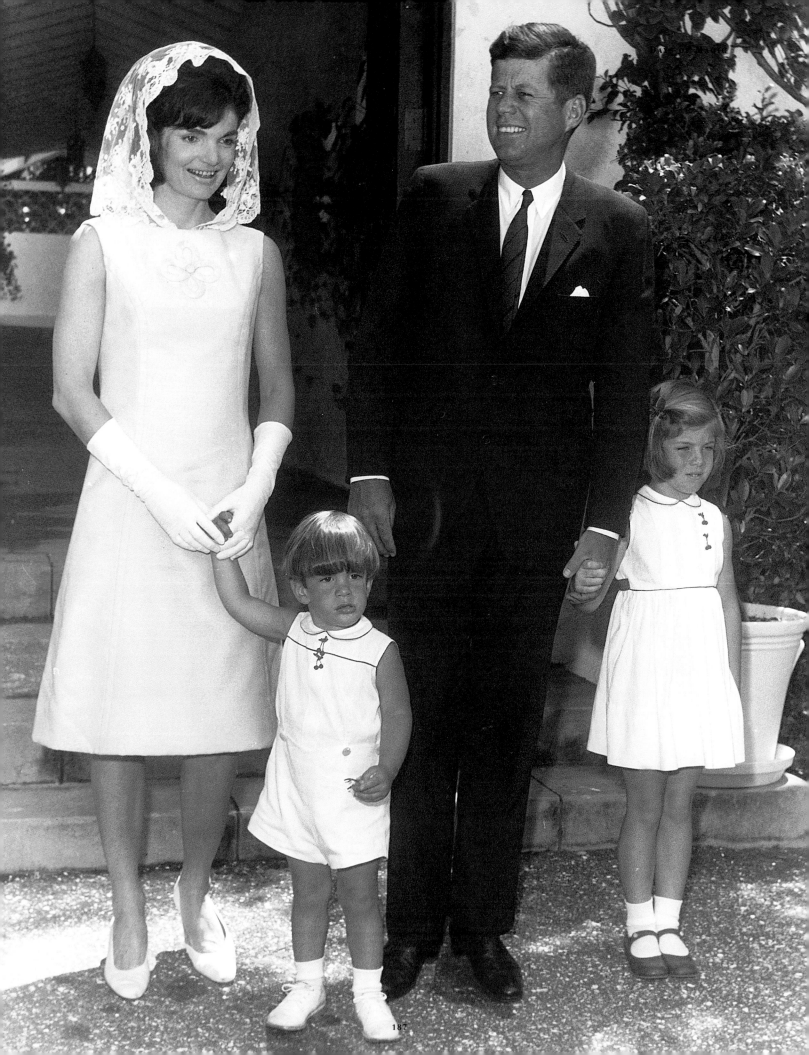

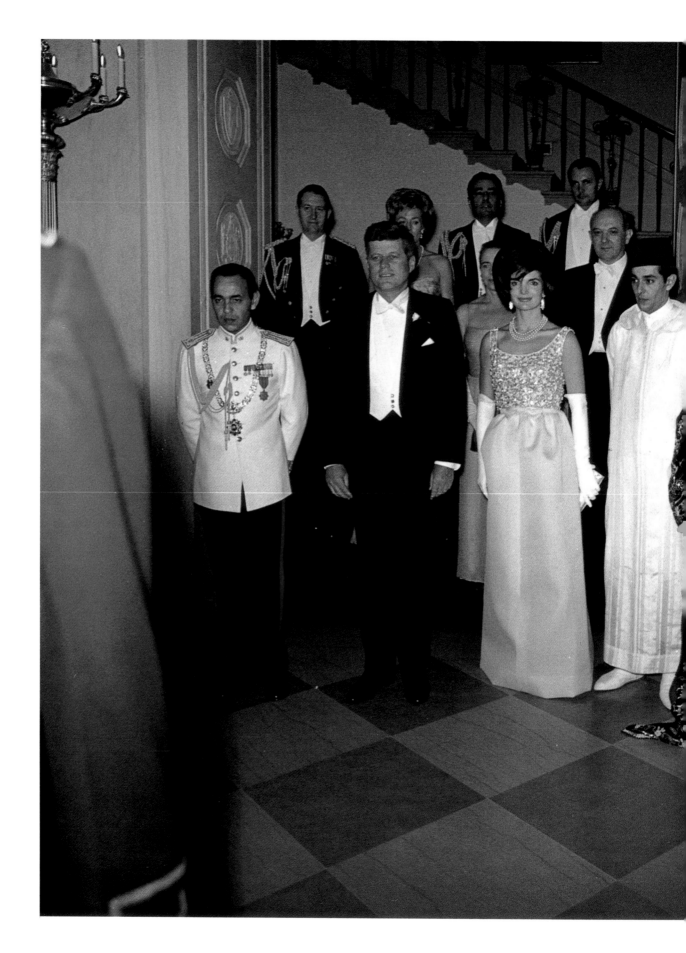

*LEFT AND
ABOVE:*
*Jackie wore a glam-
orous floor-length
white silk gown.
The bodice was
embroidered in bril-
liants and colored
stones, and the skirt
was softly gathered at
waist and accented
with a signature bow.*

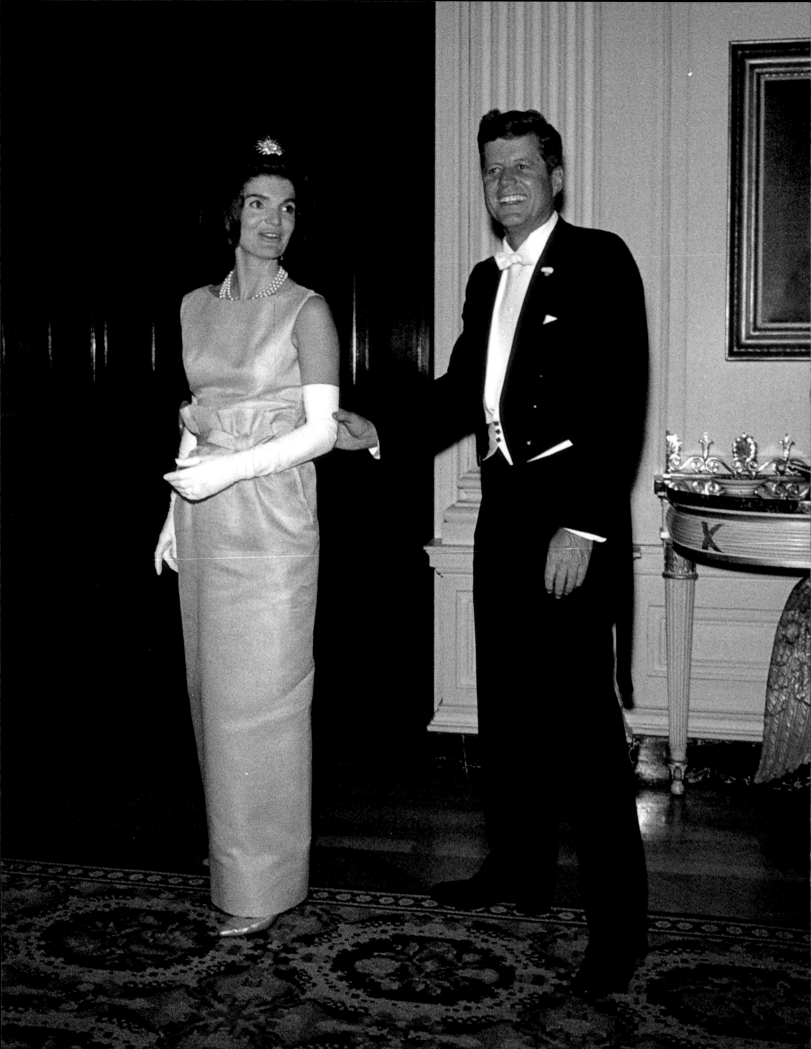

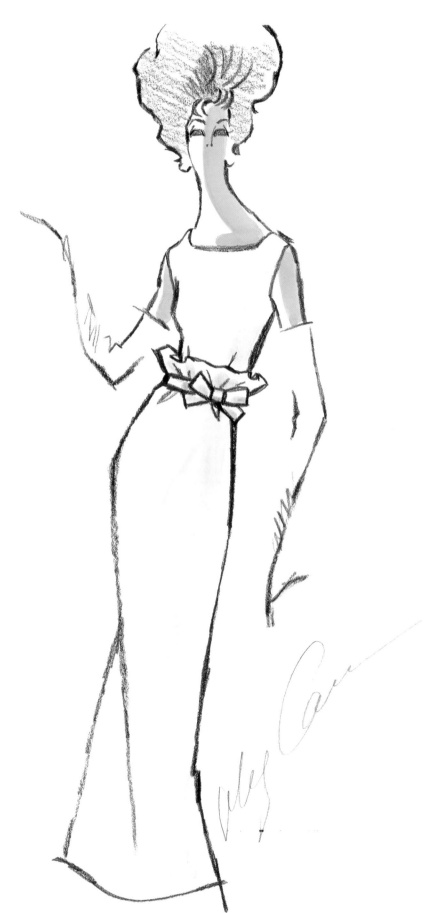

*FAR LEFT
AND BELOW:
At the dinner honoring
Grand Duchess Charlotte
of Luxembourg, Jackie
arrives with the President.
Later she walked to the
East Room to greet the
guests.*

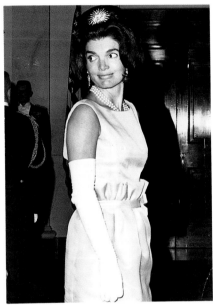

*LEFT:
Jackie's formal gown
was made of the soft-
est pale mauve.
The dress had a
sleeveless geometric
top with a rounded
neckline above a skirt
gathered in ruffles
at the waistline and
banded with a
signature bow.*

When Jackie selected me as her personal couturier, the image of the American designer changed—it became glamorous, just as it was in France, where a designer is viewed as an artist, an intellectual. I entered the White House through the front door, not the tradesman's entrance, wearing a dinner jacket, not pins in my mouth.

A transformation occurred in American fashion as a result of Jackie Kennedy. Because I was the most visible of designers, I became the role model for the American designer of the future: a gentleman designer, a celebrity.

As her personal couturier, we were doing a haute couture concept at the highest level. Couture meaning one garment particularly designed for one person and no one else. Real couture is knowing what lines are right for a person and designing for that person exclusively. Designing for a collection, you create things that appeal to you, so it's a completely different creative process.

One topic I discussed often with Jackie was what made a person attractive. Among the qualities she and I valued were good clothes, posture, and a pleasant aroma. I have always been intrigued by a woman's scent. Jackie was very aware of the particular power of fragrance and was interested in ancient formulas of perfume. Cassini, the fragrance I launched in the 1990s, was inspired by the fragrance we worked on for Jackie.

Jackie never specifically wore maternity clothes, and I never created anything that was a maternity dress. She did, however, wear my clothes all during her last pregnancy. Some clothes just lent themselves to being used in that way, especially the A-line or princess-line dresses.

Jackie was receiving hundreds of letters a day on various subjects: the restoration of the White House, recipes, her clothing. We also received quite a few letters about the length of Jackie's dresses—they were either too long or too short. Many letters were highly complimentary about how the First Lady looked and thanked me.

Jackie was trying to attain the unattainable—to be the best-dressed woman in the world without appearing to be the best-dressed woman in the world.

Many of our conversations were about fashion, but not about clothes. She would want to know who I thought had style—real style—without discussing the details of the dress or fabric. Sometimes, we discussed my looks, my girlfriends, and what Jack should do about his clothes. She would often say, "You're better than if you were good-looking, because you have a face—you're somebody—and all your living comes through your face."

There was a lot of the little girl in Jackie, and that was undoubtedly part of her charm. If you looked carefully, you could see when her problems appeared on her face, as she would suddenly look bewildered. Other times

RIGHT:
Jackie often ordered dresses from my collections to round out her wardrobe and for certain events that were not state occasions. However, I always had them made in special fabrics for her so that she could still have an exclusive look.

ABOVE
A tired Jackie rests her head on the President's shoulder during an afternoon dance recital at Caroline's ballet school on May 29.

BELOW LEFT:
Jackie, with young John, always arranged her schedule around her children and scheduled very specific times to be with them.

RIGHT:
An afternoon tea
was held to
celebrate the
President's birth-
day on May 29.

RIGHT:
A private birthday
celebration was held
for the President
that evening. The
guests included
Peter Lawford,
David Niven, and
members of the
Kennedy family.
Jackie gave the
President a lovely
framed photograph
of himself as a
young boy with his
dog.

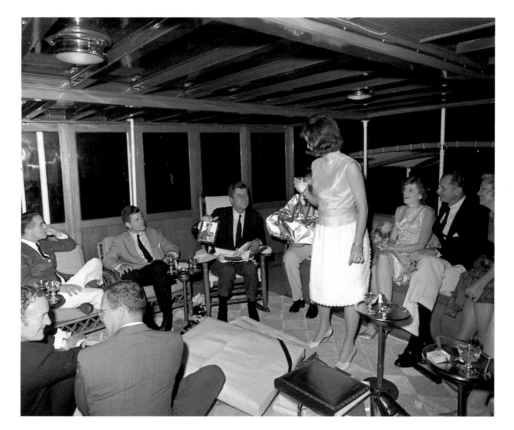

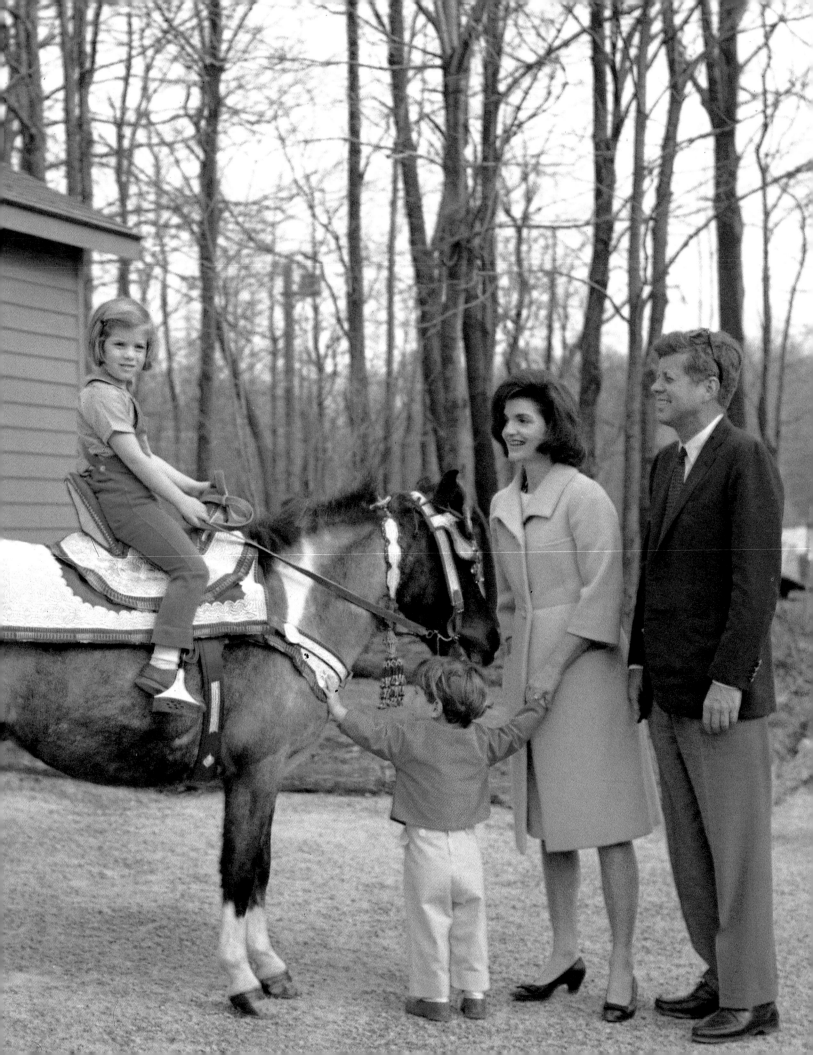

LEFT:
This trompe-l'oeil
dress in muted earth
tones, seamed and
shaped to the body
with mock cowl neck-
line, was belted and
bowed at the waist
with a thin leather
belt. The skirt was
eased with inseam
front pockets.

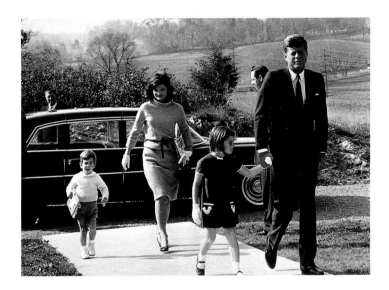

she was completely confident, a power-house. She could be authoritative, witty, and decisive. Even after knowing her for many years, I never knew which of the two Jackies to expect.

In June, the President made his own incredibly successful international trip to Germany, Ireland, England, and Rome. Jackie didn't go with him because it was difficult for her to travel at that time. There weren't many events planned for the First Lady, and Jackie was spending time on the Cape, relax-ing, awaiting the arrival of the new baby, and planning her fall wardrobe. We sent quite a few air freight packages to Squaw Island that summer.

In early August, I heard the tragic news that Jackie's baby, Patrick, had died. The Kennedys were devastated, as they both loved children and felt the loss very deeply. Afterward, Jackie needed

time to recuperate both mentally and physically. She and Lee took a trip to Greece, where they were the guests of Aristotle Onassis, the Greek shipping magnate. Onassis was very sympathetic, and Jackie always remembered how kind he had been to her during that visit.

In October, Jackie's White House routine went back to normal and plans were made for Jackie to travel with the President. They were planning a trip to Texas and we talked about the clothes.

President Kennedy was very interested in Jackie's appearance, and, of course, very proud of her. She often put on impromptu fashion shows for him and he had definite opinions about what he liked and didn't like. If he didn't like something, she never wore it again. He always had a touch of humor when he made comments. Even when he didn't like something, it was always cleverly said.

In early November of 1963, Stephen and Jean Smith had a dinner party in their Fifth Avenue apartment in New York. Bobby and Ethel Kennedy were there, as was Adlai Stevenson. I heard Stevenson advising the President not to go to Texas. Just before I left the party that night, I said to the President, "Why do you go? Your own people are saying you should not." He shrugged and smiled. I didn't think anything of it at the time, of course. It was a comment made in passing. We shook hands and I left. That was the last time I saw the President.

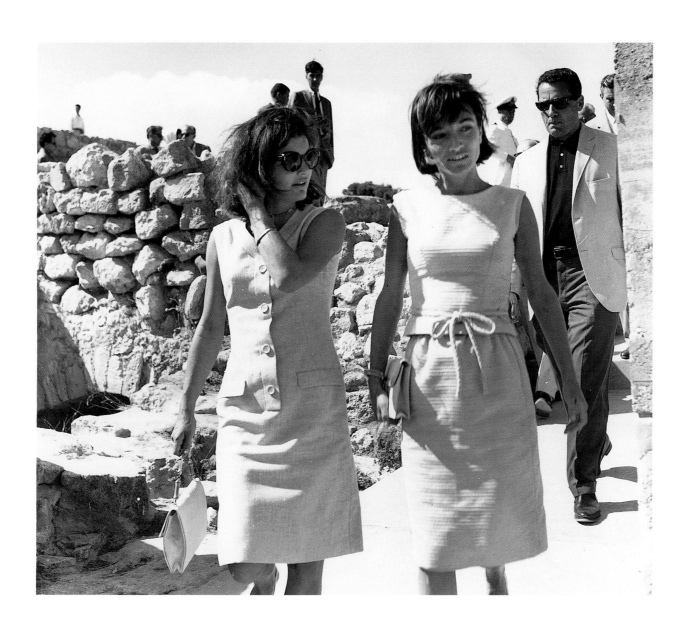

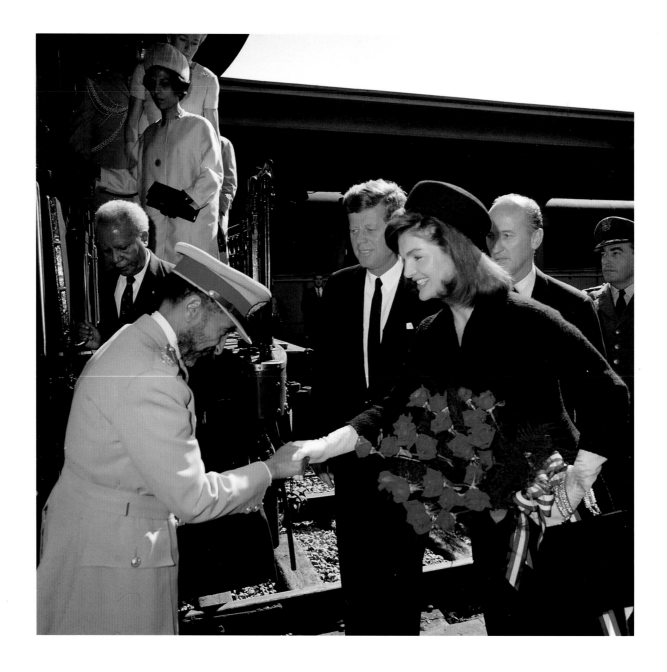

LEFT:
*Jackie greets
Ethiopian emperor
Haile Selassie upon
his arrival in
Washington. She wore
a slim suit in light-
weight black wool,
double-breasted,
with a jaunty hat set
back on her head.
This was one of her
first official functions
after the loss of the
baby, and she was
still recovering. At the
evening reception at
the White House in
honor of the emperor,
Rose Kennedy was the
hostess.*

RIGHT:
*Jackie's claret silk
velvet two-piece
evening suit had a
narrow single-
breasted jacket of
hip length. The skirt
ended in a softly
shaped A-line.
Underneath the jack-
et, Jackie wore a
white silk charmeuse
T-shirt.*

ABOVE:
*At a judicial reception
on November 20,
Jackie wore this
simple suit. This was
one of the few times
Jackie wore a short
costume for an
evening reception.*

RIGHT AND
FAR RIGHT:
Jackie and Lyndon
Johnson accompa-
nied the President
to Fort Worth.

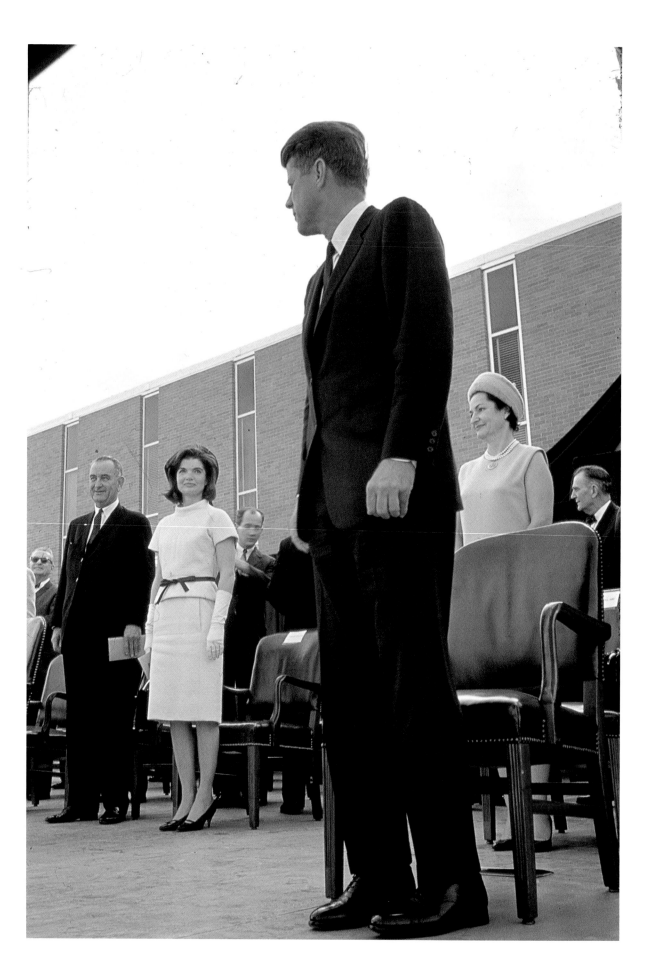

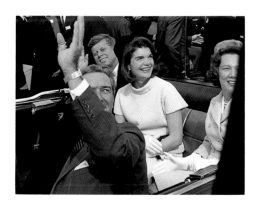

A week later, while I was having lunch near my showroom, someone mentioned that the President had been shot in Dallas. At the time, I did not react; I don't know why. It could have been that the thought was too overwhelming. When I returned to my studio, I found everyone listening to the news on the radio. The President was dead. I went to my office, closed the door, and just sat there; the feeling was much the same as when Mother died—an overpowering numbness. Eventually, there would be moments when the sadness would overtake me. It was hard to believe that he was gone. It was hard to believe then, and, in some ways, it still is.

The image of the President remains very strong with me. The thousand days of the Kennedy administration was a magical moment in time. There will never be another Jack.

ABOVE:
Jackie, with
Caroline and John,
leave the church
after JFK's funeral
service. Robert
Kennedy, his wife,
and Pat Lawford
are behind them.

FAR LEFT:
The funeral
procession.

BELOW:
It was Jackie's idea to emulate Lincoln's funeral by having
a riderless horse accompany her husband's funeral
procession through the streets of Washington to Arlington
National Cemetery.

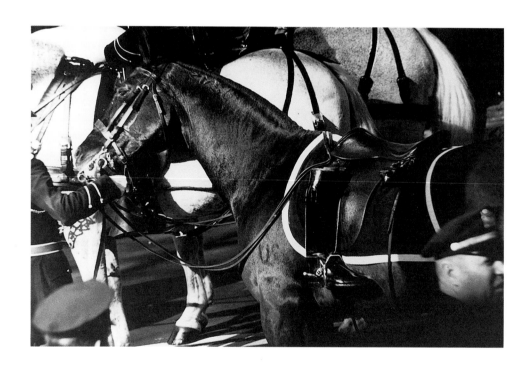

ABOVE:
Despite her grief, Jackie sent out the planned White House
Christmas presents to family and friends—a framed
autographed photograph of President Andrew Jackson.

the

later

years

RIGHT:
Police locked arms to
hold back the crowds
as Jackie and her
sister-in-law Pat
Lawford left the
St. Regis Hotel in
New York on June
16, 1964, after
attending a dinner
for the John
Fitzgerald Kennedy
Memorial Library.
President and Mrs.
Lyndon Johnson and
a host of dignitaries
were also present.

T he first few years after the assassination, I didn't
see very much of Jackie. She was still wearing many of the
clothes I had designed for her when she was in the White
House. In fact, her first public appearance after the President's
death was in 1964, when she went to the Metropolitan Opera
wearing one of her favorite gowns—the Nattier blue Empire-
style dress I had designed in 1962.

I continued to send her things from time to time and we
maintained our relationship through letters and phone calls.
But it was hard for her to be with people who had been part
of her life in the White House. She said to me once that she
didn't want to remember anything from that time, and that
seeing certain people brought back painful memories and
unbearable sorrow. That probably eased a little as the years
went by, but I think it was always hard for her. She put that
part of her life away forever after the President was killed. It
was the only way for her to survive.

Once she was out of the White House and on her own,
there was no reason why she should have only one designer.
Her life was much less structured and formal, no longer con-
trolled by protocol. Her time was no longer dictated by her
position as First Lady. Shopping was something she now had
time to do.

A lovely tribute was paid to me and Jackie by *Women's*

RIGHT:
Jackie with Princess
Grace and Prince
Rainier of Monaco in
Seville in 1966.
Jackie wore one of
her favorite dresses,
the Nattier blue
gown I had designed
for her. This was the
same dress she wore
at The Breakers in
Newport in 1962.
Here she had added
a red stole to com-
plete her costume.

Wear Daily on April 7, 1964, when Ted James wrote the following in his column:

The Kennedy era in Washington was one of elegance, glamour, and good taste which affected the entire nation and probably the entire world. Elegance and taste surrounded every movement of the first family and America watched, learned, absorbed, and copied. There is no doubt that Mrs. Jacqueline Kennedy probably did more to uplift taste levels in the United States than any woman in the history of our country. And, there is no doubt that the entire fashion industry received a major shot in the arm as a result of the constant stream of reports on what Mrs. Kennedy was wearing and where she wore it.

Among the clothes she wore, there are many which certainly can be considered important in fashion as well as historical interest. There was her official wardrobe by Oleg Cassini which she wore on her state visit to India and Pakistan, the Cassini gowns she wore when she met Premier Khrushchev in Vienna, Queen Elizabeth at Buckingham Palace, the long black dress she wore when she visited the Vatican, the pink straw lace dress she wore in Paris at Versailles . . . the one General de Gaulle liked so much, and the gown she wore when the Shah of Iran and other heads of state visited the White House and Mount Vernon.

There are in existence original sketches and undoubtedly the corre-

spondence which the former First Lady had with Mr. Cassini about her wardrobe. In all humility, I suggest that these historical designs, correspondence and gowns of historical importance be placed in either the Kennedy Museum in Boston, the Costume Institute of the Metropolitan Museum of Art, or the Smithsonian Institute in Washington.

I have quoted freely from Mr. James' column because I feel that it reflects the judgment of history on the magic that Mrs. Kennedy and I created during that period. It was a special collaboration, a powerful partnership between a woman of refined taste and a designer who intuitively understood her needs.

When I heard the news that Jackie was going to marry Aristotle Onassis, I thought it was a good way for her to get back into the world of international society. It also provided financial security. Jackie made the announcement just a few months after Robert Kennedy had been assassinated in 1968.

I hadn't seen very much of her since the President's death. After she married Onassis, she was in Manhattan to mark their fourth wedding anniversary and she invited me to a party she was giving for Ari in a private room at El Morocco.

Jackie looked radiant in a black silk T-shirt, white charmeuse skirt, and a jeweled belt given to her, I believe, by the king of Morocco. The lineup of paparazzi and the flashing cameras outside the club were quite formidable.

TOP:
Sportscaster
Howard Cosell
interviewed me in
front of 20 million
viewers after my
tennis win.

At Ethel Kennedy's request, I had designed the clothing for the participants in the Robert F. Kennedy Pro-Celeb Tennis Tournament in New York City. The red silky warm-up suits were particularly well received. They were a breakthrough in sports attire because they were made of a lightweight elasticized fabric with a soft sheen, similar to the fabrics used in clothing for downhill skiers today.

Another evening, we had dinner together at my Gramercy Park townhouse. The party was small and cozy. It was a relaxed evening, with Jackie looking happy and Ari having a good time.

We talked, and Jackie told me that the past was like a dream to her and that she tried not to think about it, as it was too painful.

Onassis told me he liked my house because it was so European. It reminded him of a fifteenth-century Florentine castle. He also read the Greek inscription that is embedded in the entry-hall floor. Translating, he said with a laugh, "I have reached the point in my life where I can invite only the people I like."

I had known Onassis for years, having first met him through a mutual acquaintance who called me one day and invited me to lunch with a friend she wanted me to meet. "He's a very interesting man," she said. "Self-made and fantastic." So I met him at lunch, and we got along very well. At that time he was living on Long Island and buying Liberty ships. It was the beginning of his fortune. He was an entrepreneur on his way up.

What people didn't realize about Onassis was that he was very intelligent, with a lot of charisma and a devastating sense of humor. He could be overpowering to women because of his charm and the strength of his personality.

Onassis saw the world as being very small, and he wanted to make it smaller. He said the way to make it smaller was

to live, work, and travel in your house. So his yacht *Christina* was his house. He brought his house anywhere he wanted to do business. Once people came aboard, they were captivated and obliged to notice his wealth and power. Onassis was a man of very simple tastes in spite of the fact that he was extremely wealthy and lived in luxury.

I saw Jackie from time to time after Onassis died. In particular, I remember the Robert F. Kennedy Pro-Celeb Tennis Tournament in New York City in August of 1976. Traditionally, the Friday night before the competition, Ethel Kennedy gave a huge party at the Rainbow Room. Teams were picked by drawing names from a hat and the party went on until late into the night. The one-day marathon of games began early on Saturday morning. It was a very competitive group—everyone wanted to win, including me.

All of the celebrities who played good tennis were invited—Frank Gifford, Andy Williams, Chevy Chase, Charlton Heston, Alan King, Walter Cronkite, George Plimpton, Lloyd Bridges, Rosey Grier, Buddy Hackett. Teddy Kennedy always participated and we played against each other.

The tournament was held at Forest Hills, just before the U.S. Open, so all of

ABOVE:
I was pleased that both Jackie and Ethel were there when I won the Robert F. Kennedy tennis tournament in 1976.

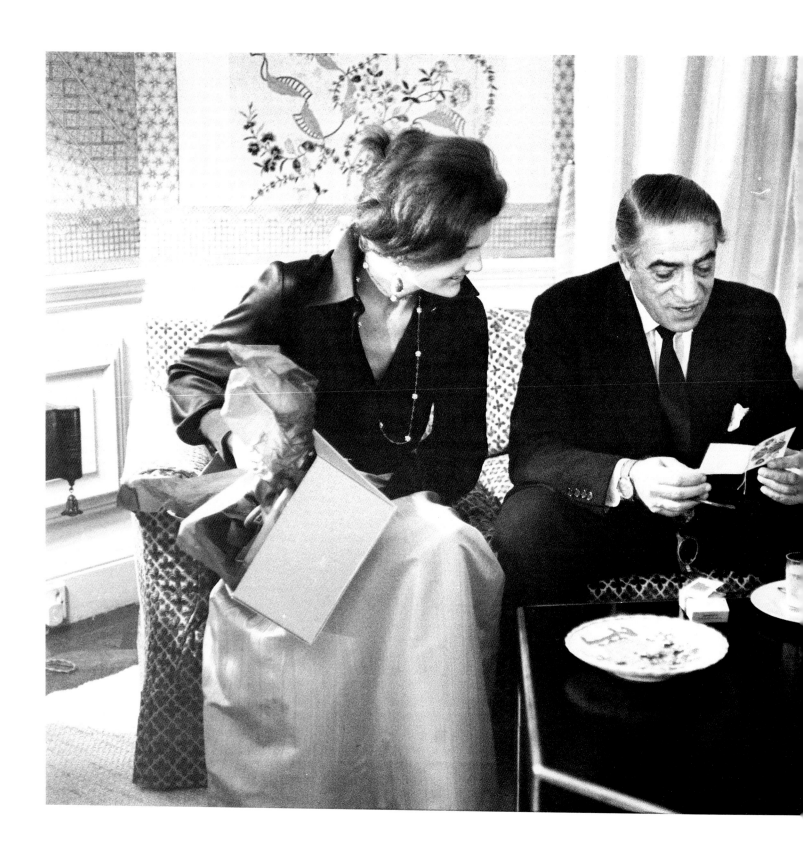

the best professionals played along with the amateur celebrities—Arthur Ashe, Jimmy Connors, John Lloyd, Ilie Nastase, Raul Ramirez, Jaime Fillol. The prize for the professional was a generous check along with a new car, and they played to win.

I won the tournament that year and it was a great thrill to get the victory cup and be congratulated by Ethel and Jackie in front of 20,000 spectators. I enjoyed being with Jackie again and we had a wonderful time that day.

I saw Jackie a few more times when she moved back to New York. We went to the movies a couple of times. She was trying to design a life for herself the best she could. I saw her at the Stephen Smiths' annual Christmas party and at other social events, as well as at various fund-raisers.

During this last phase of her life, she dressed much more casually. She wore mostly sweaters and pants. That was her lifestyle. I continued to send her some things from time to time, which she liked.

In 1986, there was a display at the Museum of the City of New York about First Lady fashions throughout history. It featured some of the gowns I had created for Jackie and she was upset that my name wasn't mentioned. She had her assistant call the museum and the curator to make sure that due credit was given. Frankly, I was touched by her thoughtfulness. That she would notice and care so deeply meant a lot to me.

LEFT:
Jackie watches as Aristotle Onassis unwraps a gift.

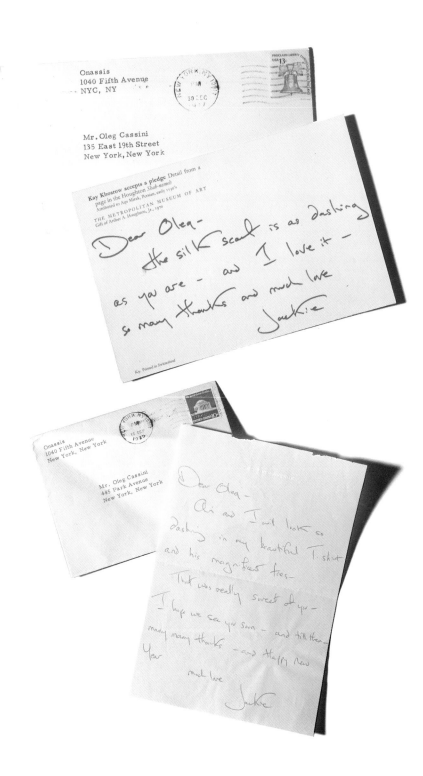

Onassis
1040 Fifth Avenue
NYC, NY

Mr. Oleg Cassini
135 East 19th Street
New York, New York

Kay Khosrow accepts a pledge Detail from a
page in the Houghton *Shah-nameh*
Attributed to Aqa Mirak, Persian, early 1530's

THE METROPOLITAN MUSEUM OF ART
Gift of Arthur A. Houghton, Jr., 1970

Dear Oleg —
the silk scarf is as dashing
as you are — and I love it —
So many thanks and much love
Jackie

Onassis
1040 Fifth Avenue
New York, New York

Mr. Oleg Cassini
445 Park Avenue
New York, New York

Dear Oleg —
Ari and I will look so
dashing in my beautiful T-shirt
and his magnificent ties —
That was really sweet of you —
I hope we see you soon — and till then —
many many thanks — and Happy New
Year
much love
Jackie

The last time I saw her was when I went to see her in her apartment on Fifth Avenue. I had sent her some clothes, and she said, "I want you to meet somebody." That was when I met Maurice Tempelsman. In Tempelsman she had a cultured escort, a confidante, a business adviser, and someone she cared about emotionally. She had her children nearby and she was enjoying her work. She seemed happy and at peace.

In early 1994, I knew that she was ill, but I had no idea it was so serious. I refused to look on the black side and kept remembering how she'd always been a strong lady.

To me there were four Jackies: 1) the inquiring reporter and pre-White House wife and mother; 2) Jackie the First Lady of the World; 3) Jackie of the Onassis international jet set; and 4) Jackie the working mother.

Nothing in her nature had prepared her for the role—she was insecure, secretive, shy. But she changed herself, using those very same elements, into the ultimate cultural icon. Over time, Jackie gained the poise and influence of a major political force. She was able to turn elegance into power.

History will grant her the prestige and respect it accords to other famous stateswomen, such as Cleopatra, Catherine the Great, Queen Elizabeth I, and Empress Josephine.

In one exquisite moment, Jackie Kennedy became the epitome of glamour and elegance—the uncrowned Queen of America. Her legacy is one of beauty, grace, and charm.

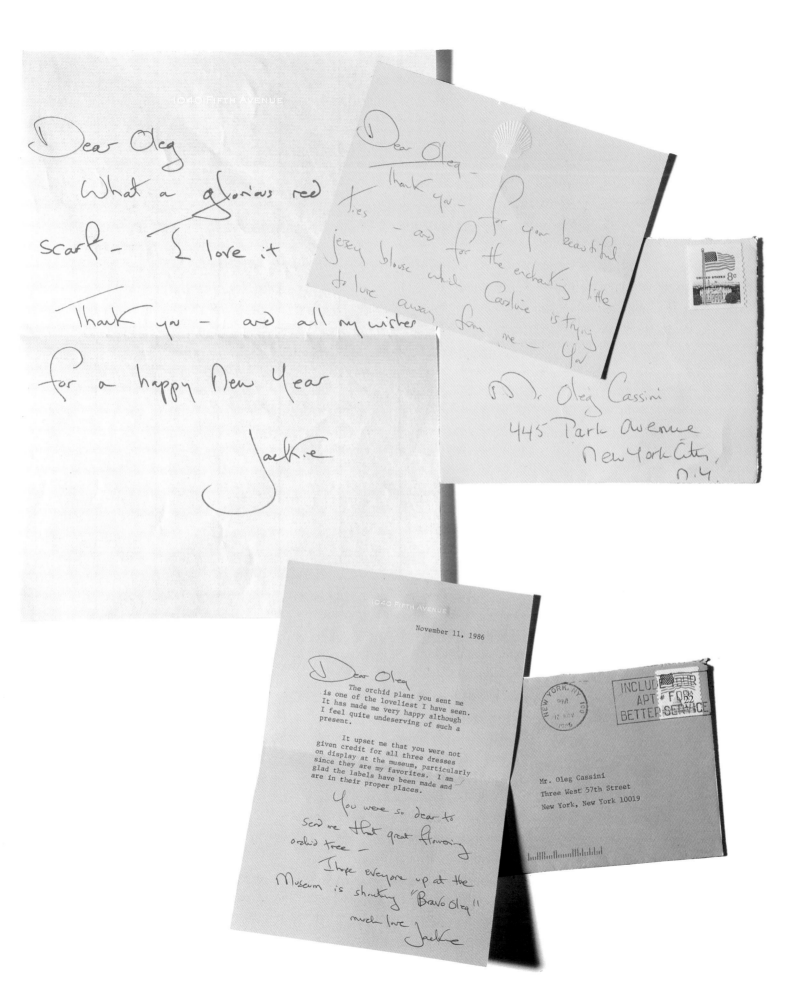

1040 FIFTH AVENUE

Dear Oleg

What a glorious red
scarf — I love it

Thank you — and all my wishes

for a happy New Year

Jackie

Dear Oleg —
Thank you —
for your beautiful
ties — and for the enchanting little
jersey blouse which Caroline is trying
to lure away from me — You

Mr. Oleg Cassini
445 Park Avenue
New York City,
N.Y.

November 11, 1986

Dear Oleg
The orchid plant you sent me
is one of the loveliest I have seen.
It has made me very happy although
I feel quite undeserving of such a
present.

It upset me that you were not
given credit for all three dresses
on display at the museum, particularly
since they are my favorites. I am
glad the labels have been made and
are in their proper places.

You were so dear to
send me that great flowering
orchid tree —
I hope everyone up at the
Museum is shouting "Bravo Oleg"
much love Jackie

Mr. Oleg Cassini
Three West 57th Street
New York, New York 10019

219

Here is a sampling of some of the correspondence between me and Jackie over the years.

DECEMBER 8, 1960
DIANA VREELAND
HARPER'S BAZAAR MAGAZINE
PLEASE CONTACT OLEG CASSINI FOR
DRESS FOR AVEDON PICTURE. HAVE
JUST CHOSEN ALL MY EVENING
CLOTHES FROM HIM AND THEY ARE
HEAVEN. HE COULD DO WHATEVER
YOU HAVE IN MIND AS HE KNOWS
WHAT I LIKE.

Much love,
Jackie

DECEMBER 14, 1960
HAVE TOLD BERGDORF'S TO SEND
YOU MY MEASUREMENTS. LONG LET-
TER FOLLOWS.

Jackie

December 13, 1960
Dear Oleg,

Thank heavens all the furor is over—and done without breaking my word to you or Bergdorf's. Now I know how poor Jack feels when he has told 3 people they can be Secy. of State.

But I do think it turned out nicely for you—no?—and you were charming & gallant & a gentleman & everything you should be and are.

This letter is just a series of incoherent thoughts that I must get settled so I can spend these next weeks truly recuperating & not have to think about details, otherwise I will be a wreck & not strong enough to do everything I have to do.

1) I wired Bergdorf to send you my measurements so you can go ahead with clothes...

2) For every evening dress I order from you, will you please send a color swatch to a) Mario—at Eugenia of Florence to have evening shoes made—State if shoes should be satin or faille—if necessary send material to make shoes in—& tell him to hurry. b) to KORET—some man there...makes me matching evening bags simple envelopes or

squares...Send him same material as dress—If you can do these 2 things you don't know the headaches it will save me. c) also to Marita—Custom Hats at Bergdorf Goodman's—send color swatch...She does my hats and gloves—tell her what color for each.

3) Diana Vreeland will call you about...dress she wants for Bazaar—If I can't have fitting before they can always pin it in with clothes pegs for marvelous Avedon picture.

4) Do send me sketches of cape or coat to wear with your white dress for Inaugural Gala Jan 19. It must be just as pure and regal as the dress.

5) Check with me before you cut orange organza dress—It is the only one I am not completely sure of—remember I thought of pink...

6) I seem to be all set for evening. Now would you put your brilliant mind to work for day—Coats—dresses for public appearances—lunch & afternoon that I would wear if Jack were President of FRANCE—tres Princesse de Rethy mais jeune...

ARE YOU SURE YOU ARE UP TO IT, OLEG? Please say yes—There is so much detail about one's wardrobe once one is in the public eye. I simply cannot spend the time on it any more than I have this fall—I will never see my children or my husband or be able to do the million things I'll have to do—I am counting on you to be a superb Wardrobe Mistress—every glove, shoe, hat, etc.—& all delivered on time. You are organized for that—being in New York—better than I—If you need to hire another secretary just for me do it and we'll settle the financial end together.

7) PUBLICITY—One reason I am so happy to be working with you is that I have some control over my fashion publicity which has gotten so vulgarly out of hand—I don't mind your saying now the dresses I have chosen from you—as I am so happy if it has done you any good—& proud to have you, a gentleman, doing clothes for the wife of the President. I will never become stuffy—but there is dignity to the office which suddenly hits one...

BUT—you realize I know that I am so much more of fashion interest than other First Ladies—I refuse to have Jack's administration plagued by fashion stories of a sensational nature—& to be the Marie Antoinette or Josephine of the 1960's—So I will have to go over it with you before we release future things—because I don't want to seem to be buying too much—You can make the stories available—but with my approval first—There just may be a few things we won't tell them about! But if I look impeccable the next four years everyone will know it is you...

8) COPIES—Just make sure no one has exactly the same dress I do—the same color or material—Imagine you will want to put some of my dresses in your collection—but I want all mine to be original. You know better than I how to protect yourself against other manufacturers running up cheap copies—I really don't care what happens later as long as when I wear it first it is new & the only one in the room...

Now poor Oleg you don't have to read any more—Just some tiny last things to say to you.

1) Forgive me for not coming to you from the very beginning. I am so happy now.

2) Protect me—as I seem so mercilessly exposed & don't know how to cope with it (I read tonight I dye my hair because it is mousy gray!)

3) Be efficient—by getting everything on time & relieving me of worry about detail.

4) Plan to stay for dinner every time you come to D.C. with sketches—& amuse the poor President & his wife in that dreary Maison Blanche—& be discreet about us—though I don't have to tell you that—you have too much tact to be any other way.

5) I always thought if Jack & I went on an official trip to France I would secretly get Givenchy to design my clothes so I wouldn't be ashamed—but now I know I won't have to—yours will be so beautiful—That is le plus grand compliment I can give you—as a designer anyway!

XO
Jackie

DECEMBER 14, 1960
PLEASE RELEASE NOTHING MORE TO
PRESS WITHOUT CHECKING WITH ME
Victor 85501. ALSO KEEP INAUGURAL
DRESS GREATEST SECRET.
Jackie

DECEMBER 15, 1961
DEAR OLEG IT WAS PERFECTLY ALL
RIGHT WHAT YOU SAID TO PRESS. WE
ALL EXPECTED AND HOPED YOU
WOULD I JUST MEANT ABOUT FUTURE.
IF ANYTHING VITAL IS ON YOUR MIND
CALL ME HERE VI 85501 OTHERWISE I
LEAVE EVERYTHING IN YOUR HANDS
Jackie

JANUARY 31, 1961
MRS. JOHN F. KENNEDY
THE WHITE HOUSE
BLUE WOOL AND VELVET DRESSES
ARRIVING THURSDAY WITH MARIE ALSO
YOUR BLACK SUIT AND HAT ALSO
SKETCHES AND SWATCHES FOR YOU
TO SELECT AND APPROVE. RED HUNT-
ING PINK COAT AND BLACK SILK
DRESSY SILK SUIT READY EARLY NEXT
WEEK. BLACK BROADTAIL FUR COAT
READY END OF WEEK. STARTING FEB-
RUARY 13 YOU CAN RECEIVE FOUR
OUTFITS PER WEEK. THUS COMPLET-
ING GROUP IN SHORT TIME. HATS AND
BAGS WITH CORRECTED MEASURE-
MENTS BEING COORDINATED FOR
YOUR APPROVAL. EVERYTHING IS SHAP-
ING UP VERY WELL SO HOPE YOU WILL
BE SATISFIED.
Devotedly Yours,
Oleg Cassini

February 1961
Dear Oleg,
I loved the memoirs, and now know
why you wanted me to read them.
Casanova reminds me of you.
Best, J

February 1961
Dear Oleg,
The clothes and sketches were divine. I
was so happy and excited. Now for
Spring, let's get 1 beautiful wool suit—

bright color, 1 with reversible jacket, a
daytime tailored coat, wool, but not too
heavy—to wear over anything—maybe
pale yellow fleece or gray? Three daytime
linen or shantung (dresses) one with a
jacket, one with nothing, one with a coat?
Or maybe two with jackets? Or three
dressier afternoon dresses 2 pc shantung
with straw hat, white with black polka
dots, another not too decollete, 1 flowered
chiffon for garden party or short evening,
1 lace dress with matching coat, another
fabulous long evening dress. What will I
wear over the straw one and ribbed
organdie when I go out—stole? nothing?
Send me sketches then I'll be set till fall,
except for a couple of Summer things to
wear at the cape.
XO
Jackie

February 17, 1961
Dear Oleg,
It seems your collection is a smash.
We were so amused by the story in the
Herald Tribune, which was charming, and
Diana Vreeland called to say how good
she heard it was.
The 2 little pictures in the Tribune
looked devine. Its true Bohan did every-
thing you said I should do way before the
Inauguration.
I sent you the pictures today just for
fun—not for any other reason—as I adore
all the things John brought down. What a
saint you are. You never told anyone it
was the day of your opening you were
sending John and Marie. You must never
do that again as any day is all right with
me and I hate to think of the difficulties
you had without them.
Jack ADORES his ties—they are so
perfect. I thought I would never be able to
get him pretty ties again—now that I
can't go to my old haunts—but these are
better than any I ever saw.
You were so sweet about your horse. I
was very touched. It is so difficult now
because the place we have rented has so
few stalls and they are all filled with
pigs—it is a pig farm which I never
knew—but the farmer will be cleaning

things out soon. Someday it just might be
lovely—but right now I can't even shelter
a pony for Caroline—much less my own
horse. Maybe next Fall and you could
come and hunt.
Congratulations. I am so proud of
you.
Jackie

March 20, 1961
Dear Oleg,
I love the gray dress and blue bro-
cade—both of which I wore today. I return
you the jackets to make more skimpy.
Could I have them both back soon.
I return the other costume you made
me for Canada—as the color is not so
good for me.
But I adore the model of the dress so
you can make it for me as much as you
like—for day also—it fits so well—the
gray.
Jackie

May 25, 1961
Dear Oleg,
Just a note in the midst of packing all
your clothes for Paris!
They have really been prettier than I
ever dreamed clothes could be and never a
tiny alteration needed. So I want to tell
you in the midst of all this furor lately—
that I think you have been just great.
What you said in answer to Schuboth
today was perfect.
You saw what everyone said about my
clothes in Canada and I hope it made you
happy. In a way, Mr. Fairchild has been a
blessing in disguise—because everyone is
on your side now. So do keep calm the
way you have been.
It took a while for us to coordinate for
me to know what clothes I needed and for
you to get them ready. Now we have our
little system working perfectly and people
know much more than they would have
without Mr. Fairchild—how really lovely
your clothes are.
There really isn't any point to this let-
ter except I felt so out of touch these hectic
days and I wanted you to know a) I am
delighted with <u>everything</u> you've made for

me. b) The way you answer the press is so good—so don't ever panic again as you now are in too dignified and respected a position to ever have to.

You may end up the darling at 7th Avenue, a kindly mellow gentleman who Galanos will say is his best friend!!

I don't need anything more now. So when you go to see the Fall collections, just plan ahead so I'll have a couple of suits, coats, dresses. 2 theatre or reception things and a couple of evening dresses and I'll be set for next winter always in advance of my deadline.

I do hope you'll be here when I get back—we can play Never on Sunday and recreate that evening chez Wrightsman!

And I don't mind if Charlene or anyone has the same dresses—but just don't let them wear them before I do.

Thank Kay for me—she is a marvel and all the best to you dear friendly couturier!

Jackie

In 1961 Givenchy leaked the spurious story that Lee Radziwill was covertly buying his dresses for her sister and I was taking the credit. When Jackie learned of this, she sent me a note in July, which read in part:

Before you explode with a cry that can be heard echoing all down 7th Avenue...(I should explode—isn't it breaking the law what Givenchy said I supposedly did!)... Just realize...it makes him look so absurd to be feeding out these petty stories about lee & me. I thought he was too grand to show annoyance—so this is rather pleasant.

I have not gotten anything from him since last June—Versailles. If anyone asks you about the story just smile rather patronizingly and say; "Mr. Givenchy must be feeling the heat wave in Paris," or something very light & unconcerned— Also you could say, "A look at Mrs. K's clothes for India & Mexico, for example, will show you that they were not Givenchy inspired."

This writing paper was especially designed for writing heads of state—do

you think it is good enough?

It was lovely to see you if only for a minute—

Until September.

Love,
Jackie

July 31, 1961
Dear Oleg,

Thanks for your letter from Europe. I hope you have had fun seeing all the collections.

I'm sorry Mike upset you—we won't discuss it all any more. Just one last suggestion—what you did in the Ladies Home Journal was fine. I never objected to that—just your pretty clothes.

The one thing you were mistaken about is when you said "if I don't tell the press something they will cut me up." But they won't if you just say one phrase over and over "I'm so sorry, but with respect for Mrs. K's privacy, I'd rather not discuss her. I know you understand." Then they'll think you are so chivalrous and just write about your clothes and not about where we met or what I said in the hospital. Do let us know when you get home as we would love to have you come for a weekend.

Best,
Jackie

September 25, 1961
Dear Oleg,

We were so very sorry to hear about your mother. I know how much you loved her.

She must have been a wonderful woman to have two sons who adored her so.

You have our deepest, deepest sympathy. I am so sad. I wish I knew of some better way to tell you that we are thinking of you with all affection in this unhappy time.

Love,
Jackie

OCTOBER 13, 1961
CARITAS SHOULD BE CONGRATULATED FOR HAVING CHOSEN YOU TO PUT ON THE FASHION SHOW THIS YEAR. IT ASSURES THE SUCCESS OF THE

OCCASION. . . MRS. KENNEDY AND I HOPE THE SUPPLY OF DRESSES IS NOT EXHAUSTED SO THAT ONE CAN BE SENT TO HER AT THE WHITE HOUSE.

John F. Kennedy

November 21, 1961
Dear Oleg,
The roses were absolutely beautiful. Many thanks for sending them, and it was great fun having you down for the party.

All the best,
Affectionately,
Jackie

January 25, 1962
Dear Oleg,

Your clothes are all lovely—really perfect—all those pretty coats and dresses and the best of all was the white satin evening dress with panel I wore last Sat.

It turns out India is so hot, one has to change clothes about 3 times a day. I am not going to fuss with clothes anymore for there—but I thought if you had any washable cotton dresses in your new collection—suitable for public appearance—a couple of them would be great. Just send me the regular size 10.

Also, I have a lovely idea for an evening dress sometime. You must see Les Derniere Années à Marienbad—all chanelish chiffons. I saw a picture of Bardot in one—in Match or Elle—in black, but mine could be red—covered up long sleeves—transparent.

That and a drapey dress like jersey would be fun for a change. I'm sorry about Galway Ghost and glad that you weren't riding him then!

Best,
Jackie

1970
Dear Oleg,
Thank you for your sweet thought and beautiful flowers.

It was so lovely to see you again after such a long time. Much love from us both.

Jackie

December 1970
Dear Oleg,
Thank you— for your beautiful ties and for the enchanting little jersey blouse which Caroline is trying to lure away from me— You were so sweet and thoughtful to remember us.
Happy New Year and I hope we see you soon—
Jackie

January 1972
Dear Oleg,
Ari and I will look so dashing in my beautiful t-shirt and his magnificent ties—
That was really sweet of you— I hope we see you soon— and till then— many many thanks—and Happy New Year.
Much love,
Jackie

September 15, 1975
Dear Oleg,
Thanks so much for my red outfit which I received on my return to New York. It is great and I will wear it when I run around the reservoir.
You were wonderful to remember me.
All the best,
Jackie

November 11, 1986
Dear Oleg,
The orchid plant you sent me is one of the loveliest I have seen. It has made me very happy although I feel quite undeserving of such a present.
It upset me that you were not given credit for all three dresses on display at the museum, particularly since they are my favorites. I am glad the labels have been made and are in their proper places.
You were so dear to send me that great flowering orchid tree—
I hope everyone up at the Museum is shouting "Bravo Oleg."
Much love,
Jackie

November 18, 1986
Dear Oleg,
Promise not to send me another fabulous present in answer to this letter!
Your sweaters are absolutely glorious. I will have the greatest joy and fun wearing them. And it will mean all the more because they come from you, my dear and old friend.
with affection,
Jackie

January 17, 1991
Dear Oleg,
It was most thoughtful of you to send me your perfume for Christmas. A wonderful present which I will certainly enjoy.
With my thanks and best wishes for the New Year,
as ever,
Jackie

PHOTO CREDITS

3)

NORTH OCEAN BOULEVARD
PALM BEACH, FLORIDA

She does m—
gloves — tell
color for each —
c) also to Marita
at *Bergdorf Goodma*
color swatch — she kn—
call you about downtr—
Bazaar — If I
always get it in w—
Avedon picture —

headaches — I will save me —

3) Diana V—

Phone Victor 8 — 5501

Re 13 — 1960

— on coat — to wear
Nary Gala Jan 19
equal as the dress —

nge organza dress —
sure d — remember

Also maybe we —

NORTH OCEAN BOULEVARD
PALM BEACH, FLORIDA

NORTH OCEAN BOULEVARD
PALM BEACH, FLORIDA

Venice in— all the —— is ave—

——— wants to you or ———

———— poor Jack he's ———

——— Also —— be Sec——

—— ternoon —

official trip to France — I would secretly
get Givenchy to design my clothes — so
— I wouldn't be ashamed — but now I
know I won't have to — yours will be so
beautiful — That is le plus grand
compliment I can give you — as a
designer anyway!

XO

Jackie

The Carlyle
MADISON AVENUE AT 76TH STREET
NEW YORK 21, N.Y.

Sept 25

Dear Oleg —
We were so very sorry to
hear about your mother — I know how
much you loved her —
She must have been a wonderful
woman to have two sons who adored
her so —

You have our deepest
— get settled
weeks duly respecting